PACIFIC NORTHWEST

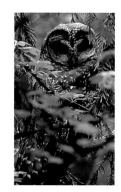

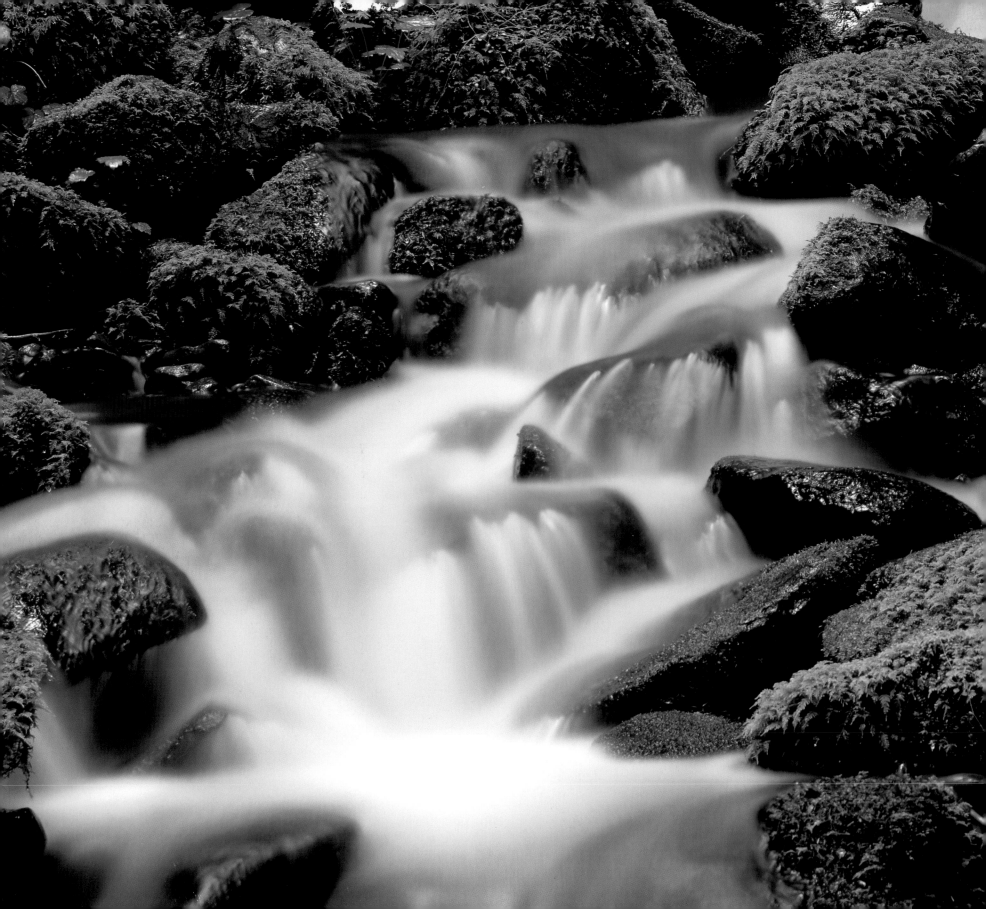

PACIFIC NORTHWEST

ART WOLFE

Land of Light and Water

TEXT BY BRENDA PETERSON

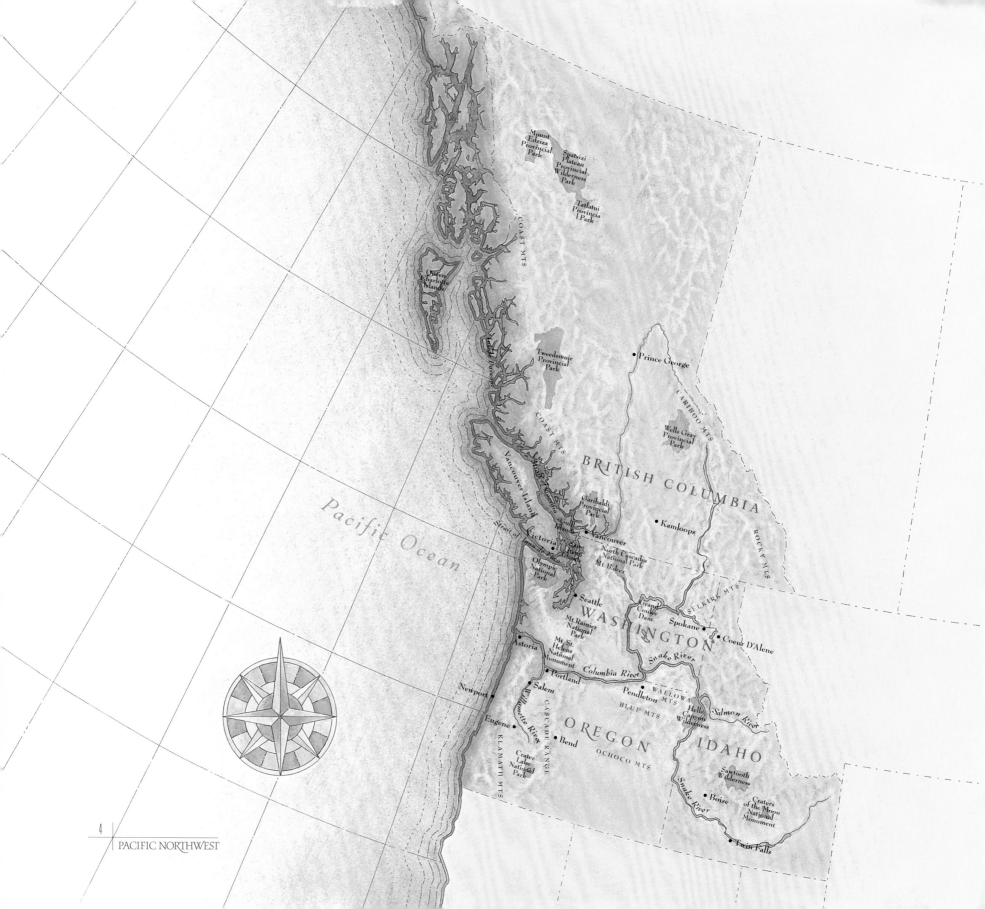

Mount
Edziza
Provincial
Park

Spatsizi
Plateau
Provincial
Wilderness
Park

Tatlatui
Provincial
Park

COAST MTS

Queen
Charlotte
Islands

Tweedsmuir
Provincial
Park

Prince George

CARIBOO MTS

Wells Gray
Provincial
Park

COAST MTS

BRITISH COLUMBIA

ROCKY MTS

Pacific Ocean

Vancouver Island

Strait of Georgia

Garibaldi
Provincial
Park

Kamloops

Strait of Juan de Fuca

Victoria

Gulf
Islands

Vancouver

North Cascades
National Park

SELKIRK MTS

San Juan
Islands

Mt Baker

Olympic
National
Park

Seattle

WASHINGTON

Grand
Coulee
Dam

Spokane

Coeur D'Alene

Mt Rainier
National
Park

Astoria

Mt St.
Helens
National
Monument

Columbia River

Snake River

Portland

Newport

Salem

WALLOWA
MTS

Pendleton

Hells
Canyon
Wilderness

Salmon River

Eugene

Willamette River

BLUE MTS

IDAHO

OREGON

CASCADE RANGE

Bend

OCHOCO MTS

KLAMATH MTS

Crater
Lake
National
Park

Sawtooth
Wilderness

Snake River

Boise

Craters
of the Moon
National
Monument

Twin Falls

CONTENTS

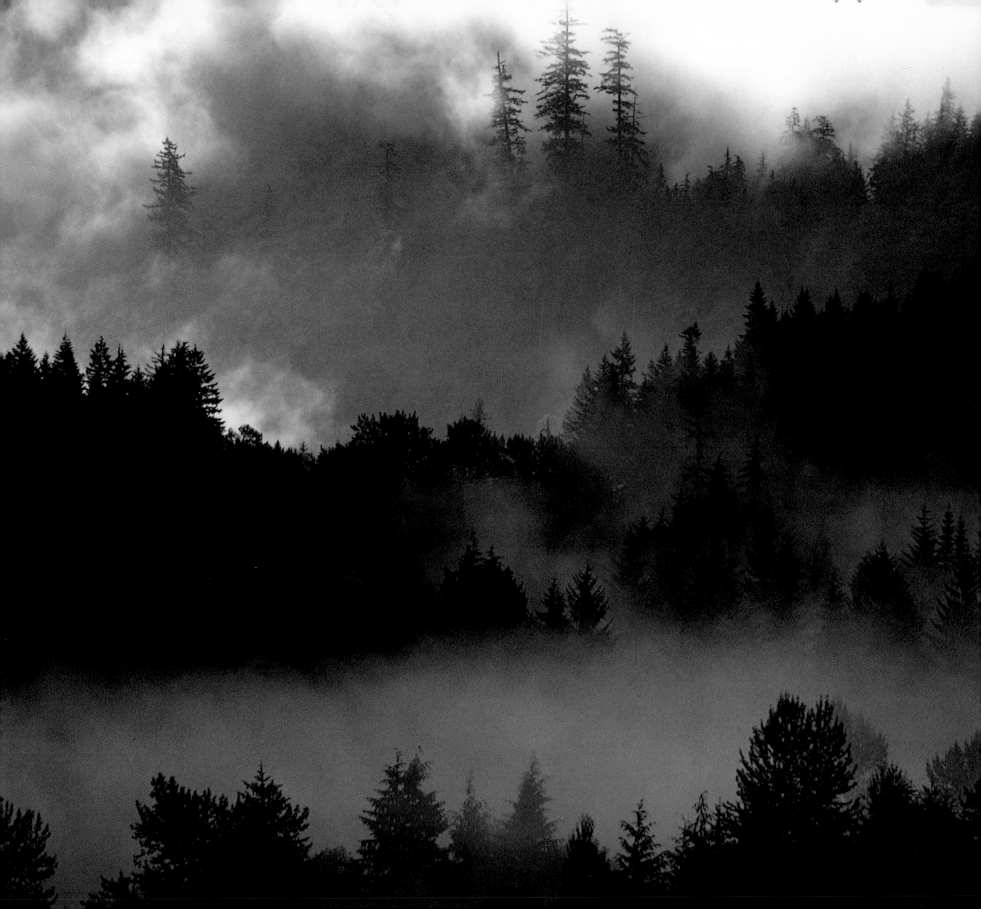

DEDICATION & ACKNOWLEDGMENTS

To my mother and father, Ellinor and Dick,
who together imbued me with a lifetime's worth
of love and caring for my Pacific Northwest

I wish to thank Gary Stolz, Chief Naturalist, U.S. Fish and Wildlife Service and Associate Professor, University of Idaho, for yet again offering his invaluable expertise, as well as the gracious staffs at the University of Washington Elisabeth C. Miller Library at the Center for Urban Horticulture, the University of Washington Fisheries-Oceanography Library, and the Seattle Aquarium, for their tireless assistance in verifying caption information. Thanks also to all of those in my office: Mel Calvan, Heather Donlon, Chris Eckhoff, Ray Pfortner, Angela Kwan, Deirdre Skillman, and Lisa Woods—all transplants to the Northwest—and Craig Scheak—our only native—for their combined talents that do so much to make my dreams a reality over and over again.

—A. W.

For Puget Sound, teacher and daily inspiration

Thanks to Gary Luke for his passionate sense of place, my agent, Elizabeth Wales, for her visionary ideas, and my assistant on this project, Bill McHalffey. And in praise of Joyce Russo, Vanessa Adams, Carla Bennet, Don Wall, Christine Lamb, Eve Anthony, Will Anderson, Stan Butler, orca researchers Dr. Paul Spong and Helena Symonds, marine mammal biologist Dr. Toni Frohoff, and Makah elder Alberta Thompson—Northwest neighbors, keepers of the beach and the other animals.

—B. P.

PREFACE

IT SHOULD BE no great surprise that my favorite childhood memories are not of Disneyland or parades or circuses, but rather of camping with my family in the Cascades along Nason Creek, or exploring the Oregon coast, or taking a simple day trip around Mount Rainier. Forest, mountain, and ocean were the themes that defined my travel experiences well into my young adulthood. For the most part, they form what I am today—a nature photographer traveling the globe.

Although I love the Antarctic and the plains of Africa, I have to admit my favorite places lie in the Pacific Northwest. This is precisely why I have lived here all my life. With all the traveling that I do, it is very grounding to live in the same place where I was born, reared, and began my life of natural exploration. The Northwest is a terrific place to live.

I studied art and art education at the University of Washington. In those years, most weekends were spent hiking along the Washington coast. One winter, over the course of about five or six weekends, several friends and I hiked from the very tip of the Olympic Peninsula all the way down to Kalaloch. On Friday afternoons we headed out to the coast, picked up where we had left off the previous week, and camped overnight. During the shortest days of the year we hiked each weekend's leg, making headway through the blustery winds and rains whipping off the ocean. We built wonderful driftwood fires to ward off the cold and damp of the winter nights, wrapping half-cooked chickens in foil and searing them on the coals. Baked potatoes and a little wine rounded out those memorable meals. On Sundays we returned to Seattle and attended our classes during the week. This routine proved so much fun that we did it two years running.

In the summer months, my attention turned to the lofty Cascades or the Olympic Mountains, where I climbed as many peaks as I could. One year I scaled fifty-six mountains, including all five volcanoes in Washington state. I was climbing not so much to get the exercise as to gain the views. All the while I was honing my skills as a serious photographer—or at least I thought I was. Years later I realized I had not been all that skillful with the camera back then.

Although I now find myself traveling to Africa, Australia, China, or wherever, leaving precious little time to explore these spectacular Northwest locations, the thought lingers in the back of my mind that someday I will be able to hike those peaks again.

When I think of the Northwest as a whole, it is often analogous to sitting down to a table at a fine restaurant, having several great desserts offered to you, and having to choose from among them. On that rare summer weekend at home, I find myself deciding among hiking in the Columbia River plateau region to watch golden eagles hovering along the basalt cliffs; or ascending one of the many peaks in the northern Cascades where one can look into true wilderness and marvel at the wondrous symmetry of pinnacles, glaciers, and alpine meadows; or simply heading west into the dense forests, jagged mountains, and wild seashores of the Olympic Peninsula. It is a wondrous opportunity to live here and be able to see such a striking variety of ecosystems so close to home.

I have also watched over the years as other people have discovered what the Northwest is all about. It is no longer a secret, and there are many forces that undermine the integrity of its diverse environments. Without some forward-thinking politicians who can guide strong environmental legislation, I fear that every acre of unprotected forest, every mile of unprotected riverside and lakeshore, will eventually be covered with homes and businesses. If that is the case, then I am afraid we may be looking at pristine wilderness only within the tenuous boundaries of national and state parks. That would be devastating to the region. Good stewardship of the land must be a main element of the public and political agenda. I think of William O. Douglas and his efforts to preserve the Washington coast. Thanks to him, it has been kept free of much of the development that would otherwise have occurred. Douglas' foresight and energy is a testimony to the Northwest and to what is worth preserving.

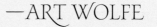

—ART WOLFE

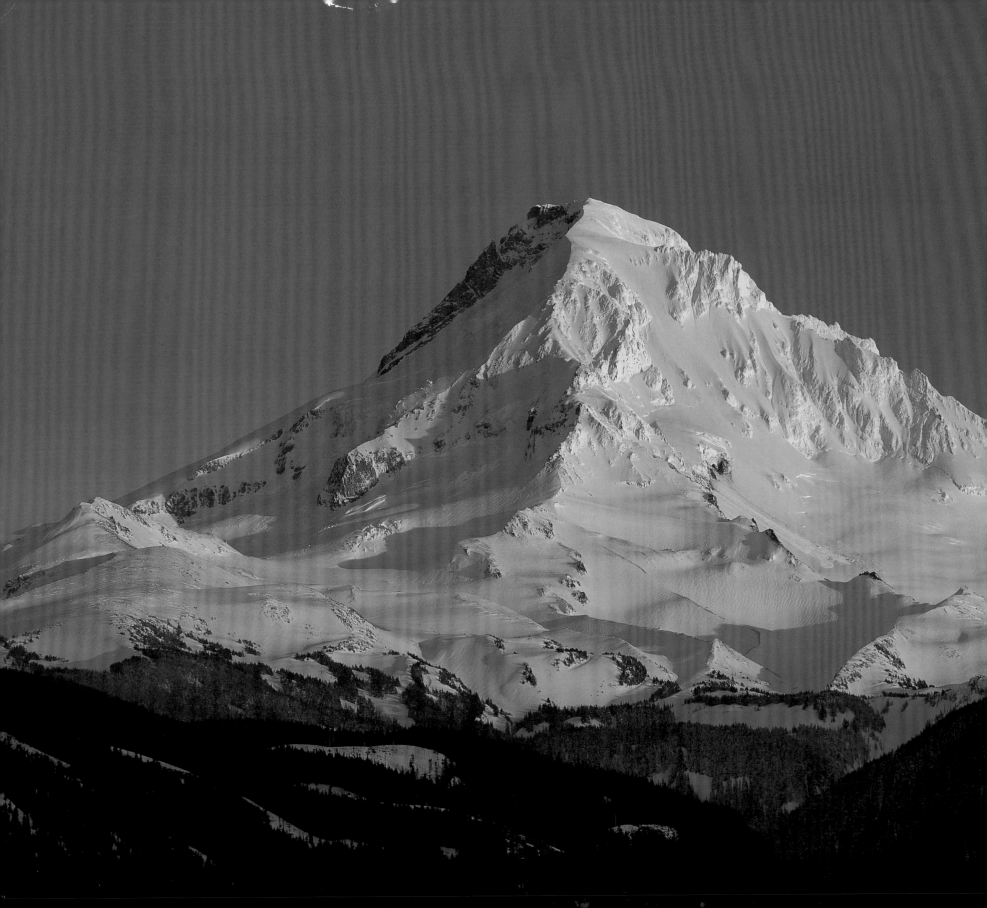

MOUNTAIN

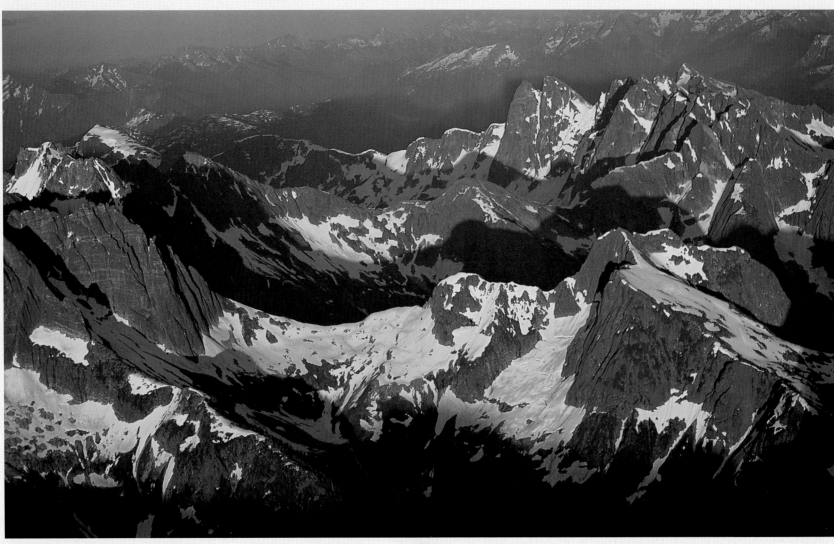

THE MIND, MIND HAS MOUNTAINS

IN THE MOUNTAIN forests of this Pacific Northwest rim of crater lakes and sleeping volcanoes, I began my life. And it is here that I hope one day to finally rest. I returned here to the Northwest after some twenty-six years away from these lush coastal mountains

and mist-ridden rainforests—to snow-shrouded Olympics and Cascades, to brooding fire mountains and marine fog mysteries.

Pacific Northwest landscapes and lives are dominated more by mountains than by skyscrapers, and this perspective keeps us humble. I remember a winter morning, after my move to Seattle in 1981, when I first saw "The Mountain," as we call it here. Mount Rainier 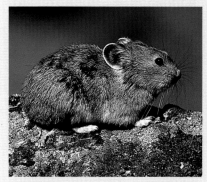 is seen and not seen, but this most majestic of volcanic peaks is always present and felt. I'd heard Rainier spoken of with the reverence and awe usually reserved for great spiritual teachers, visionary leaders, and artists.

From January through March I had not once seen The Mountain. Then one day while driving across the Mercer Island bridge from Seattle, I glanced southward. What rose up over the water was nothing less than a blazing cloud-goddess whose pink and violet skirts floated above the lake like divine revelation. I gasped and let go the steering wheel, turning to meet this mountain full face. It wasn't faith or terror that made my whole body move toward Mount Rainier; it was more instinctive, like what draws us into the light or toward a radiant presence. My car swerved, tires thump-thumping against the cement guardrails, then bounced back to dart into the oncoming lane. "You never get used to Mount Rainier," my friend said, reaching across to right my steering wheel.

I still count that moment with this divine mother of a mountain as the fixed point by which I have navigated my Northwest life. Just as Mountain Rainier broke through her months of mist, I discovered another world there on the horizon—a healing, mystical presence beside my everyday life. Rainier reminded me of what the Lakota visionary Black Elk said, that "the central mountain of the world is where you are."

Nisqually and Yakama stories begin, "Long ago when mountains were people . . ." The Salish tale of Mount Rainier (also known as Tahoma, or "the great mountain, which gives thunder and lightning, having great unseen powers") tells of how the earth goddess Tahoma swallowed up so much rock and water that she at last burst open, and lava, like hot blood, flowed down her sides. Changer then made her into a volcanic peak, the incandescent icon that we in the Pacific Northwest all but worship.

On my birthdays I often journey to Paradise, Mount Rainier's alpine gardens. I find saffron glacier lilies, pink heather, and blazing red paintbrush in summer meadows mesmerizing. In Paradise Valley, I can practice a contemplative's vision of these Cascade and Olympic Mountains that encircle my daily life like guardian giants. "O the mind, mind has

mountains," Gerard Manley Hopkins wrote. And these Pacific Northwest mountains—from Mount Olympus on the Olympic Peninsula, to the Cascades' volcanic chain of Mount Shuksan, Mount Rainier, and Mount St. Helens, down to Oregon's Mount Hood and Mount McLoughlin—all remind us of our proper place in glacial and geologic time.

Northwesterners revere their mountains, these peaks we share with diverse wildlife, from the returning wolves and grizzlies to the once-abundant bobcats and elusive cougars. Each morning as I gaze over Puget Sound to the craggy, snow-clad Olympic peaks, glowing pastel-rose and lavender in the early light, I imagine these mountains are a long beluga whale, breaching right above the horizon—surfacing and surviving, and lasting longer than all my days.

Left: Male blue grouse (Dendragapus obscurus), in courtship display

Right: Seasonal pond with Mount Shuksan (0,127 feet) in the distance, North Cascades National Park, Washington

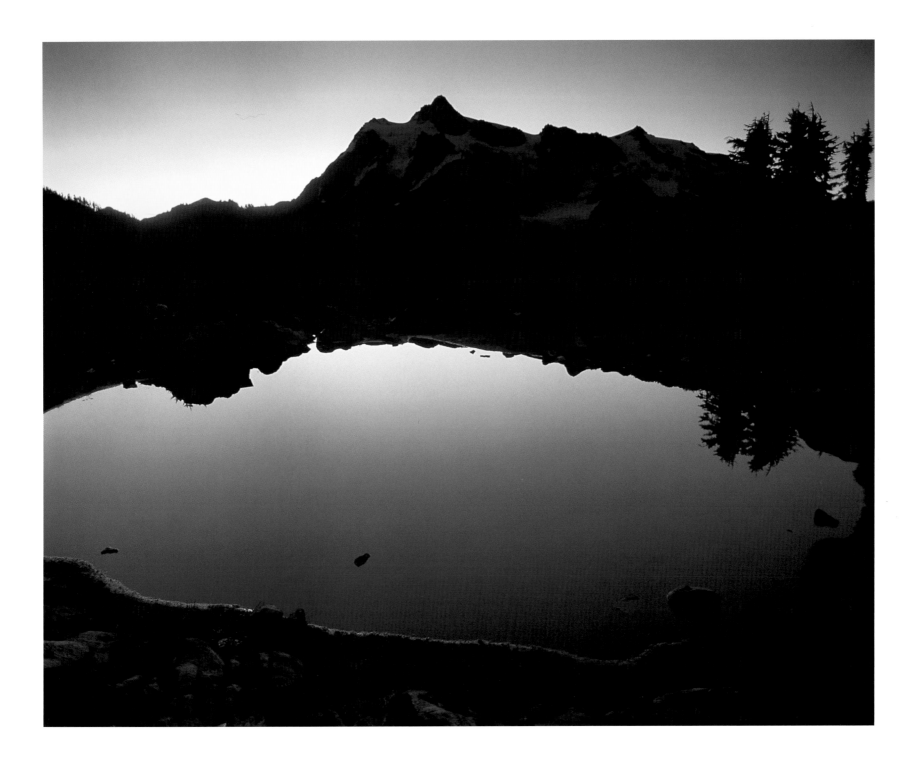

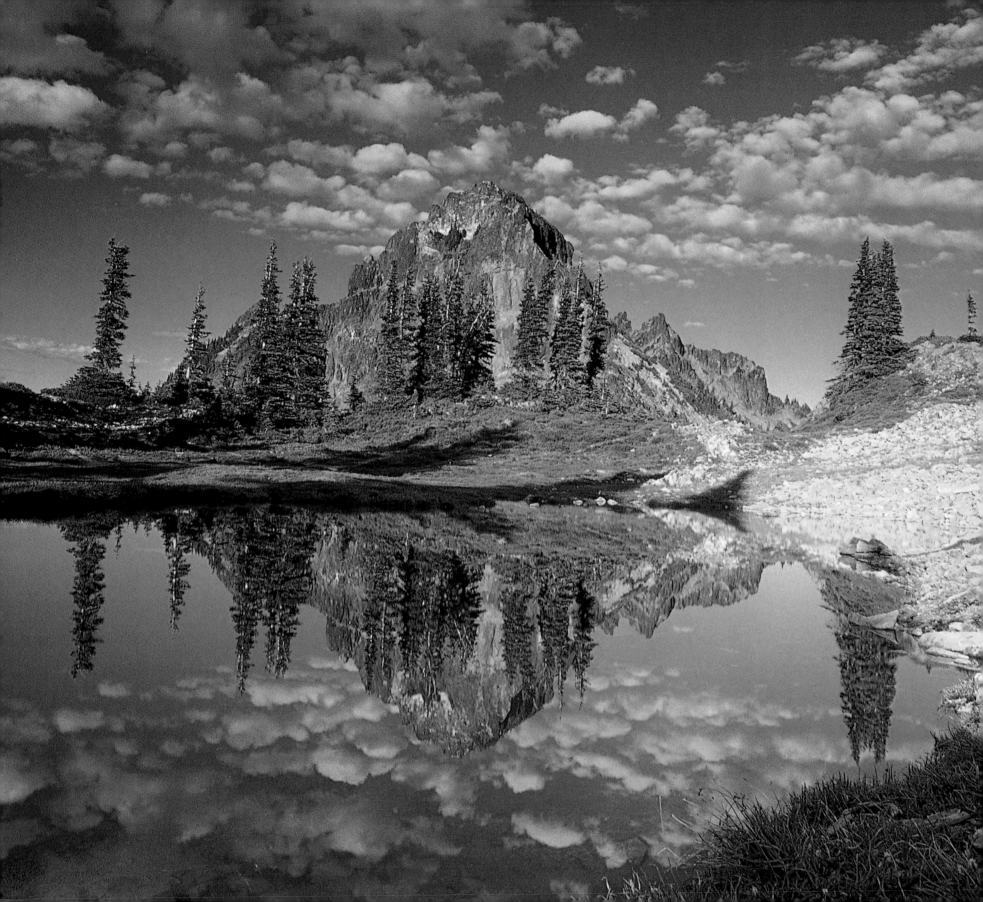

*Left: Pinnacle Peak, Mount Rainier
National Park, Washington*

*Right: Prusik Peak, Enchantment Lakes Basin,
Alpine Lakes Wilderness, Washington*

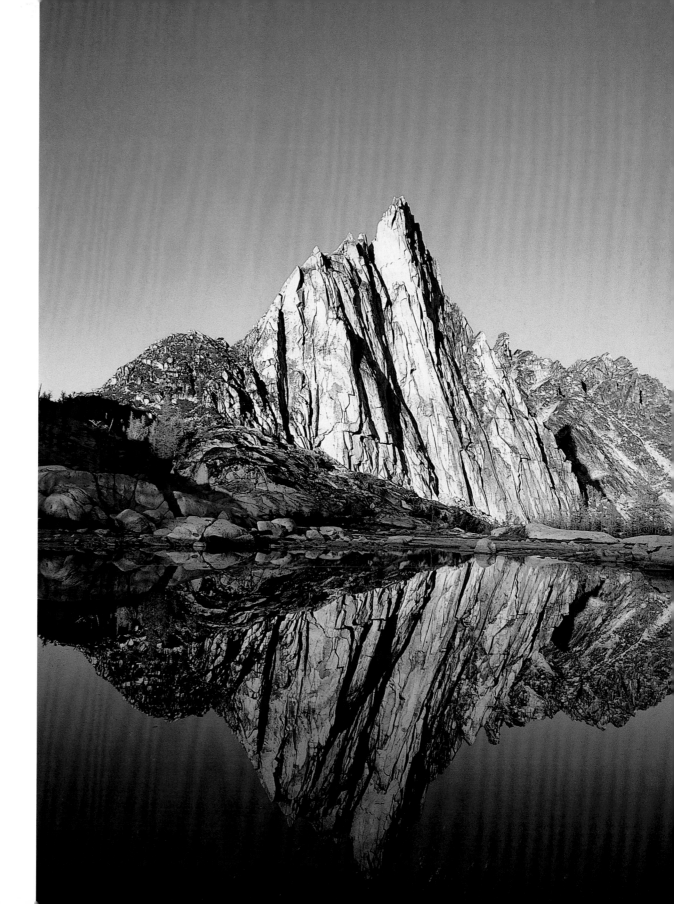

Western larches (Larix occidentalis) *in autumn, Enchantment Lakes, Alpine Lakes Wilderness*

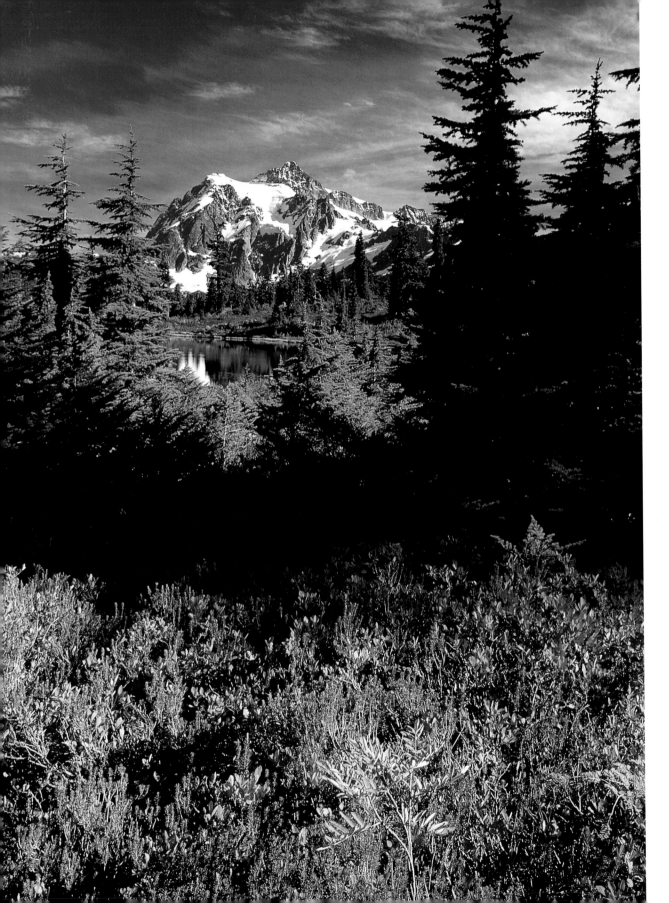

Left: *Mount Shuksan and fall foliage, North Cascades National Park*

Right: *Quaking aspens (Populus tremuloides), east slope of the Cascade Mountains, Oregon*

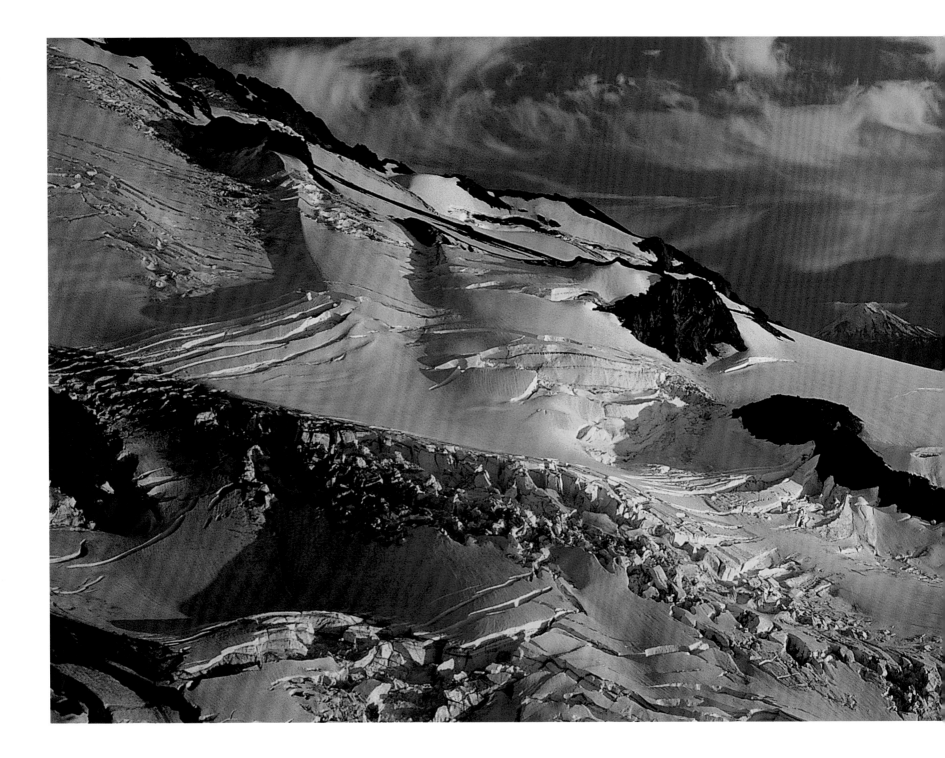

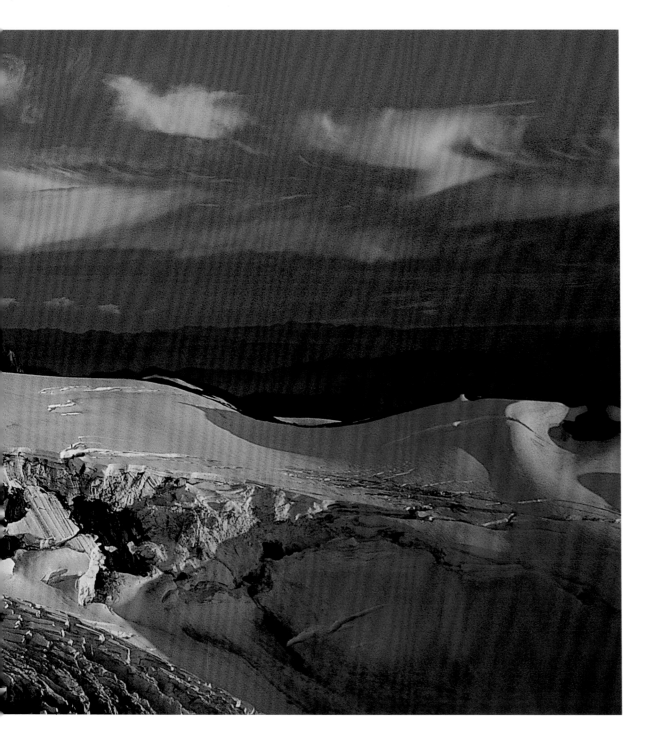

Glaciated slopes of Mount Rainier (14,410 feet), with pre-eruption Mount St Helens in the distance

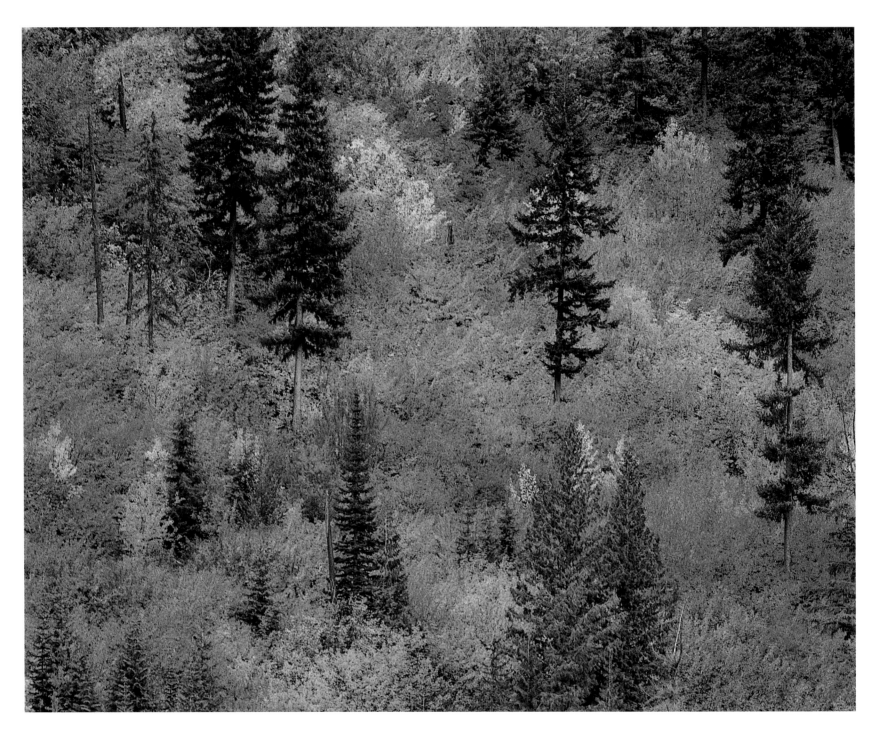

Vine maples (Acer circinatum) *in fall foliage display, Washington Cascades*

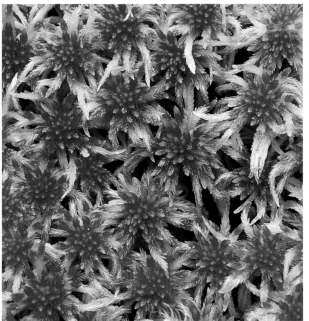

Left: *Sphagnum moss* (Sphagnum *spp.*) *growing in a Cascade Mountains bog*

Right: *A mass of ladybird beetles* (Hippodamia convergens) *overwintering*

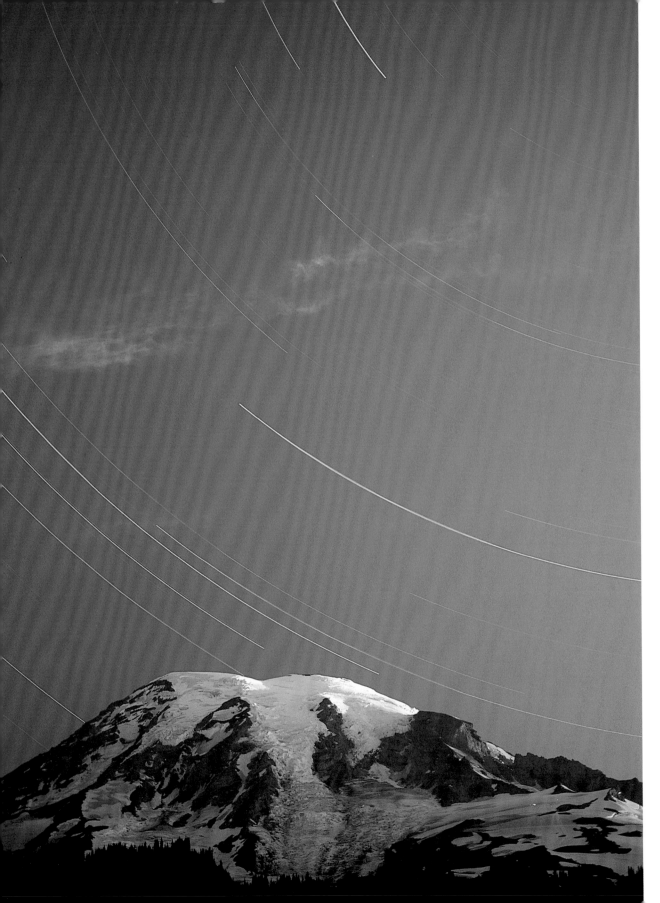

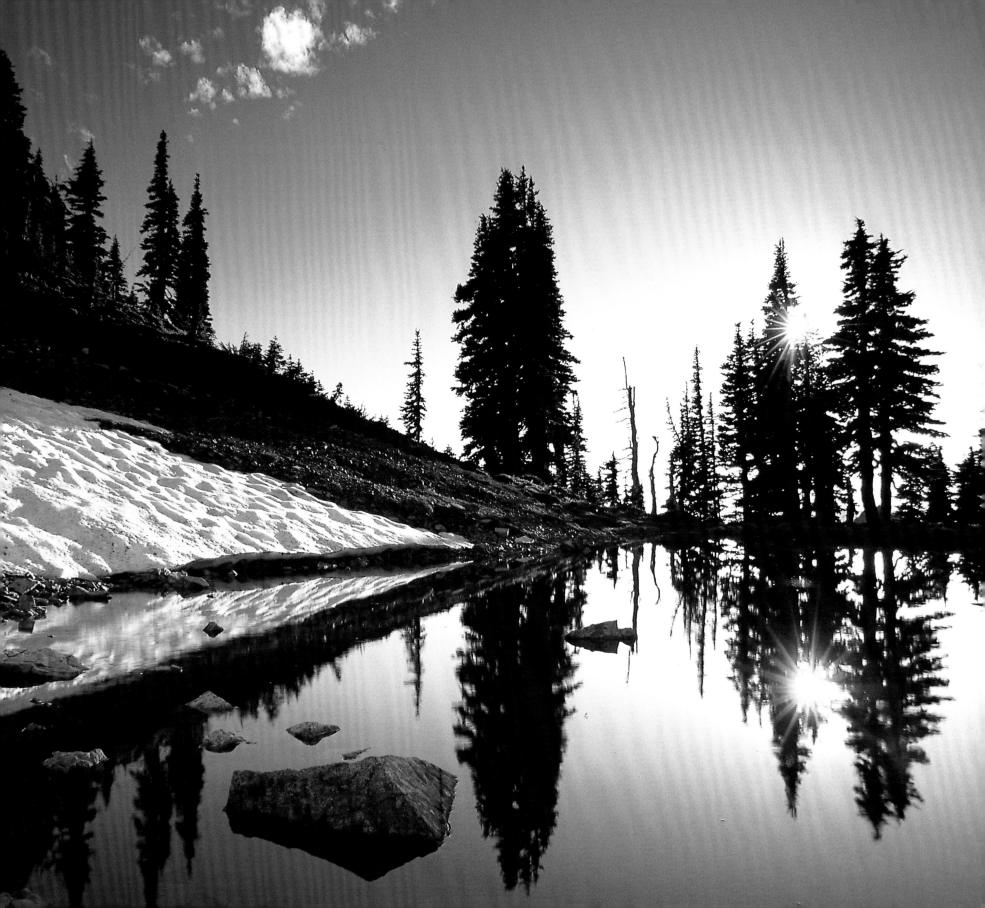

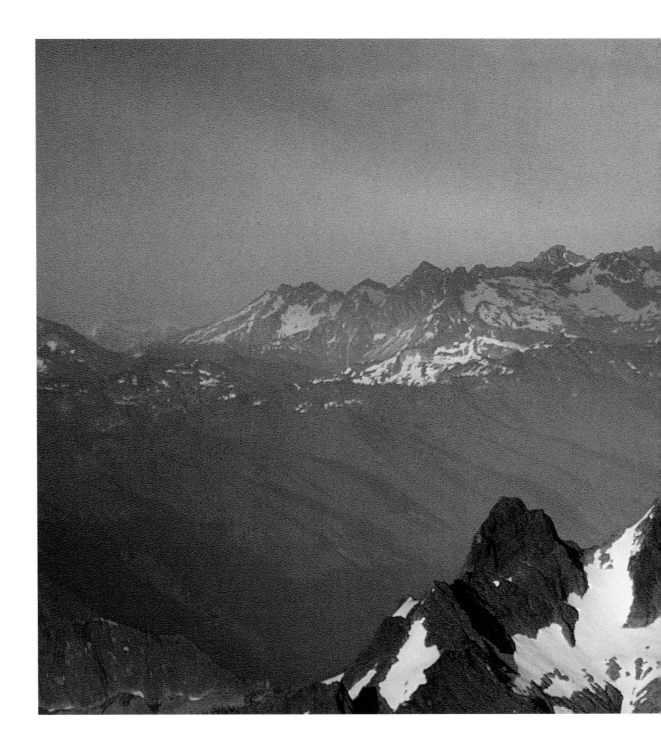

Summit of Three Fingers Mountain (6,854 feet), with Glacier Peak (10,568 feet) in the distance, Washington Cascades

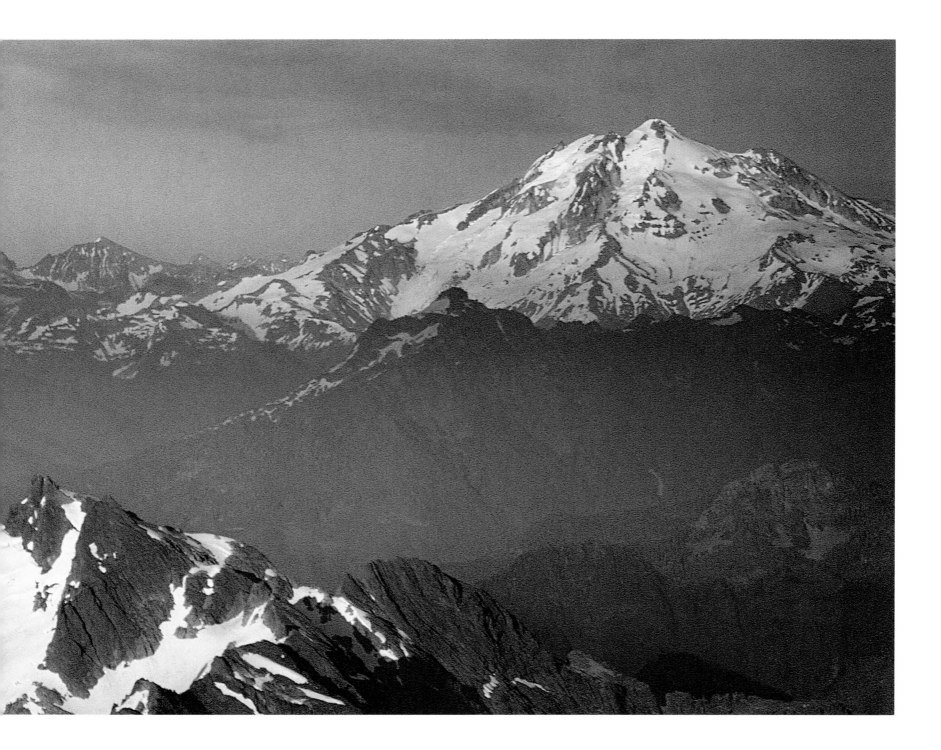

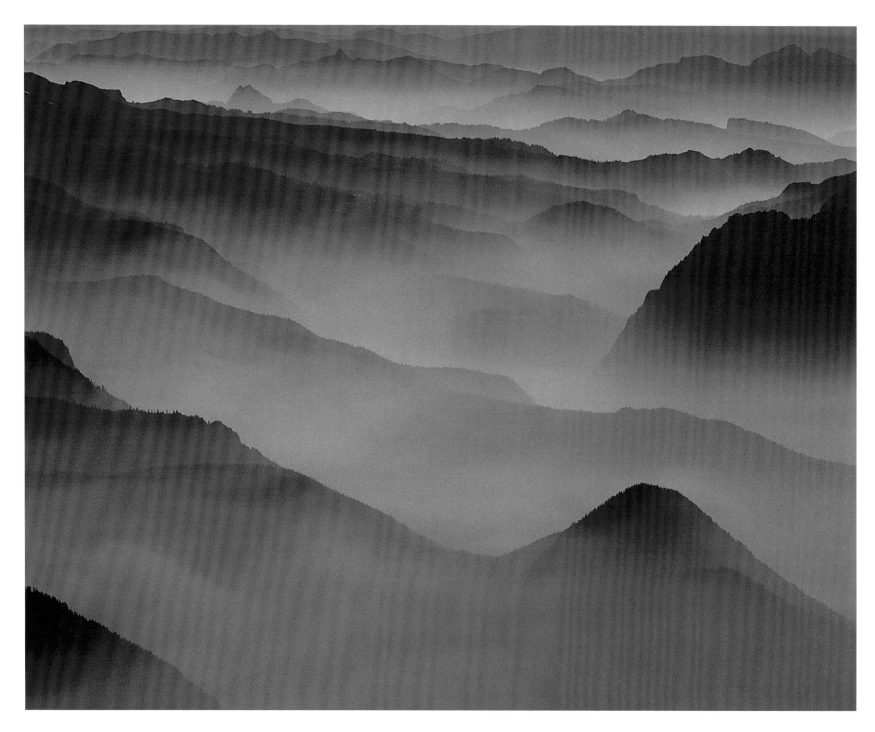

Forested ridges and fog-enshrouded valleys of the
Cascade Mountains

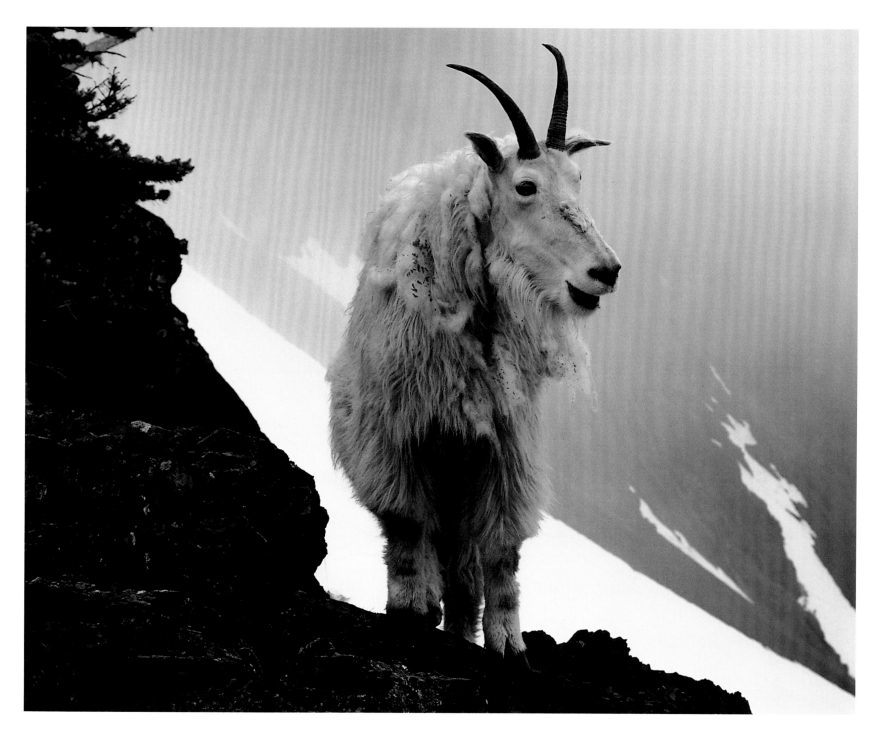

Mountain goat (Oreamnos americanus), *native to the Cascade and Rocky Mountains, now widespread in the Olympics*

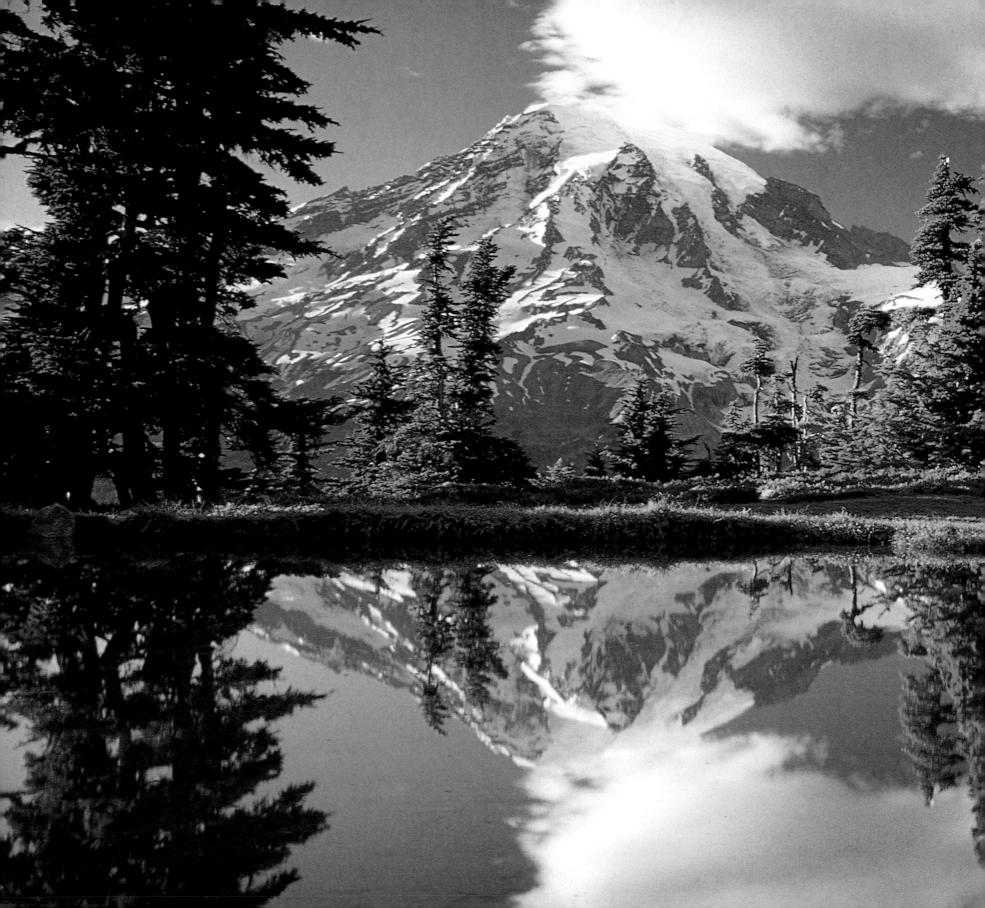

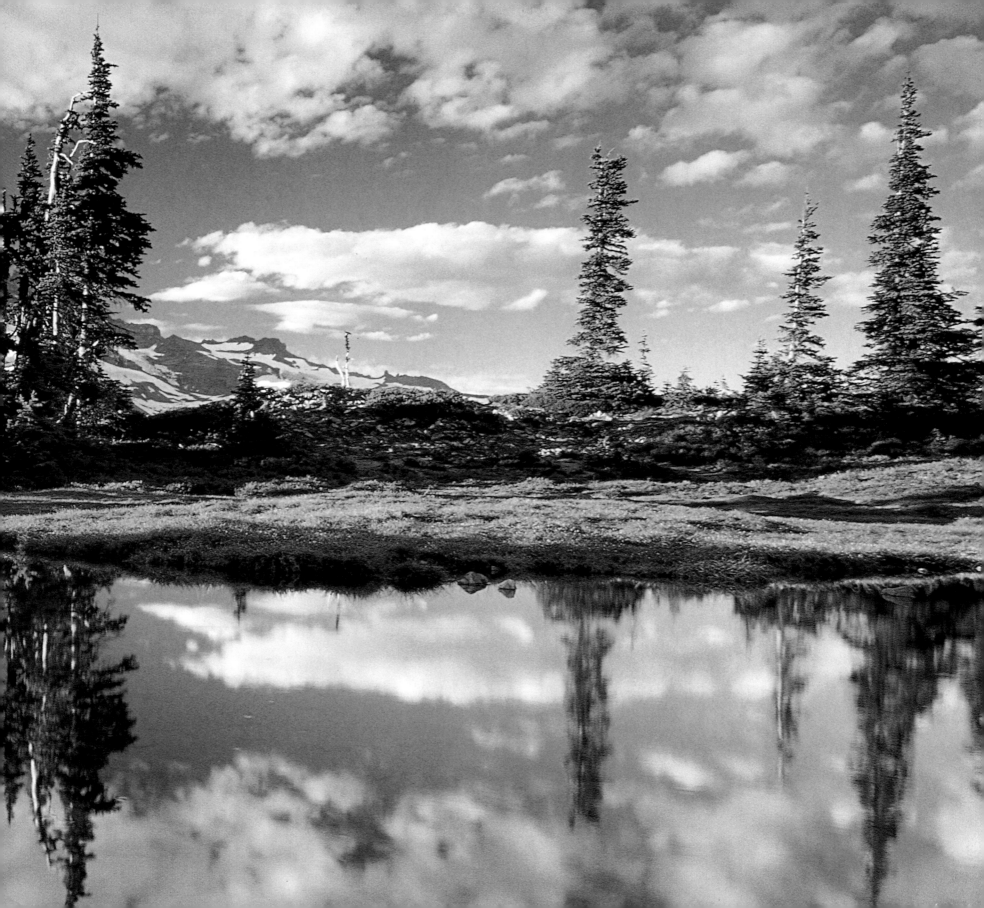

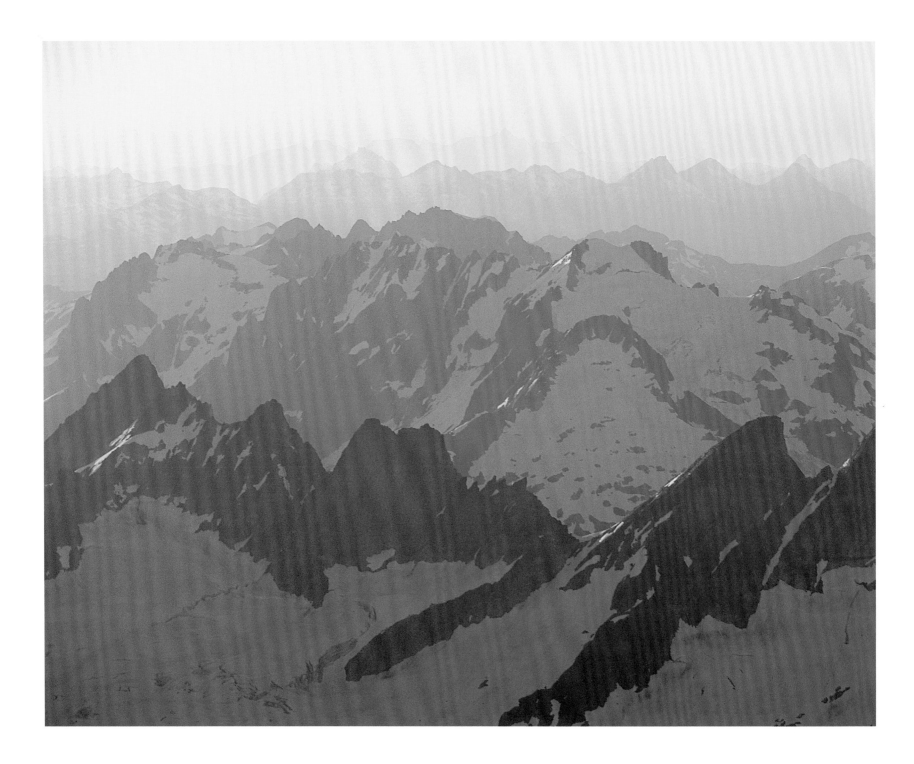

PACIFIC NORTHWEST

Overleaf: *Mount Rainier reflected in a tarn*

Left: *Jagged peaks of the northern Cascades*

Right: *Alpine meadow, Mount Rainier National Park*

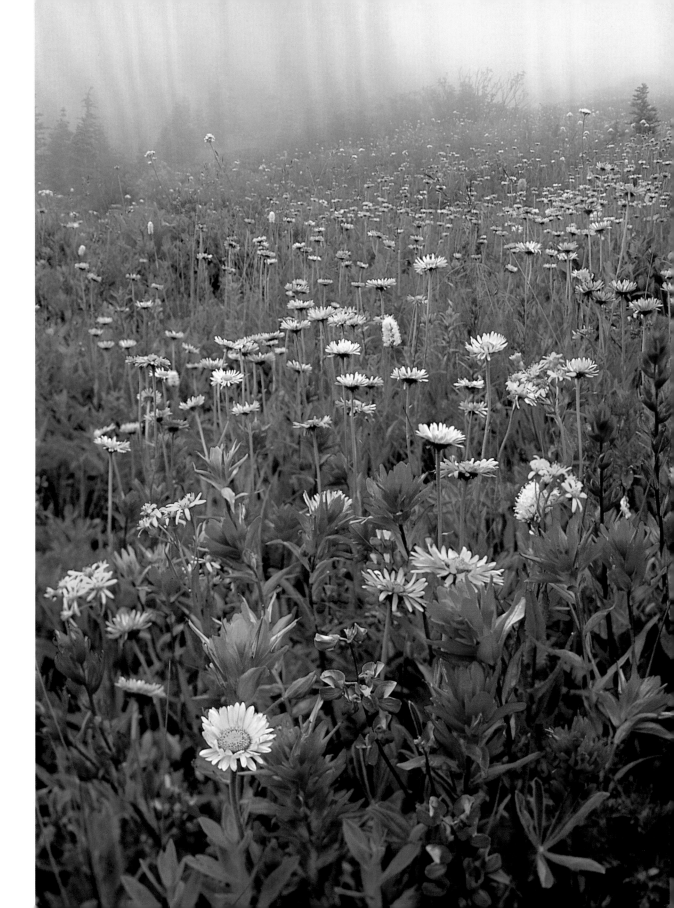

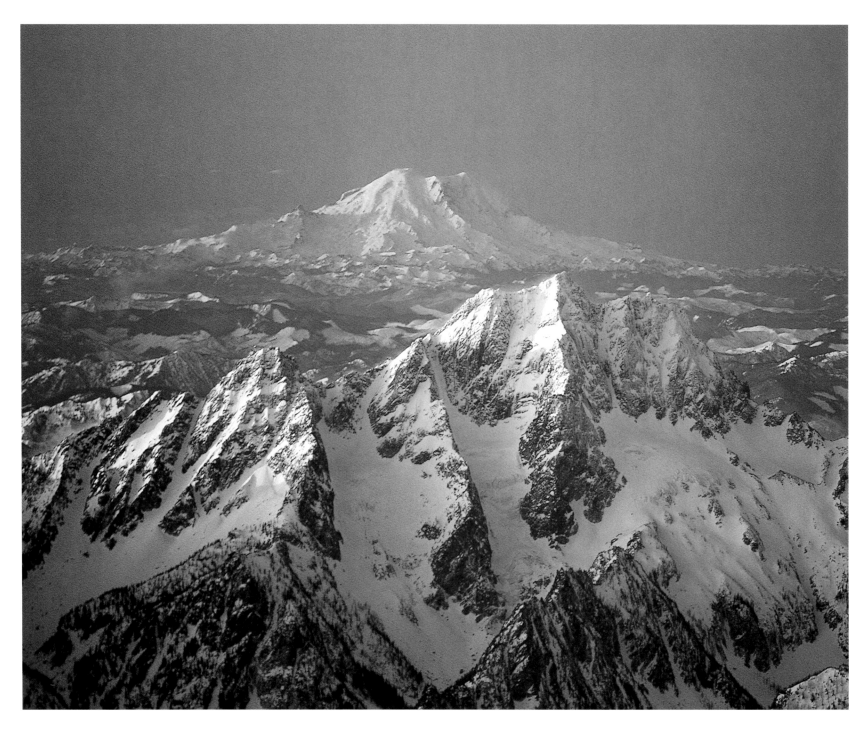

*Looking south from the northern Cascades
to Mount Rainier*

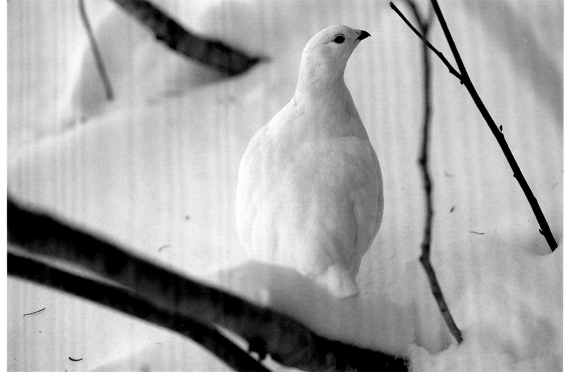

Right: *Female rock ptarmigan* (Lagopus mutus) *in winter plumage*

Below: *Snow-encased trees, Cascade Mountains*

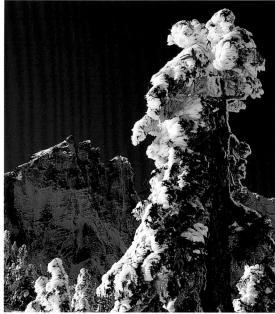

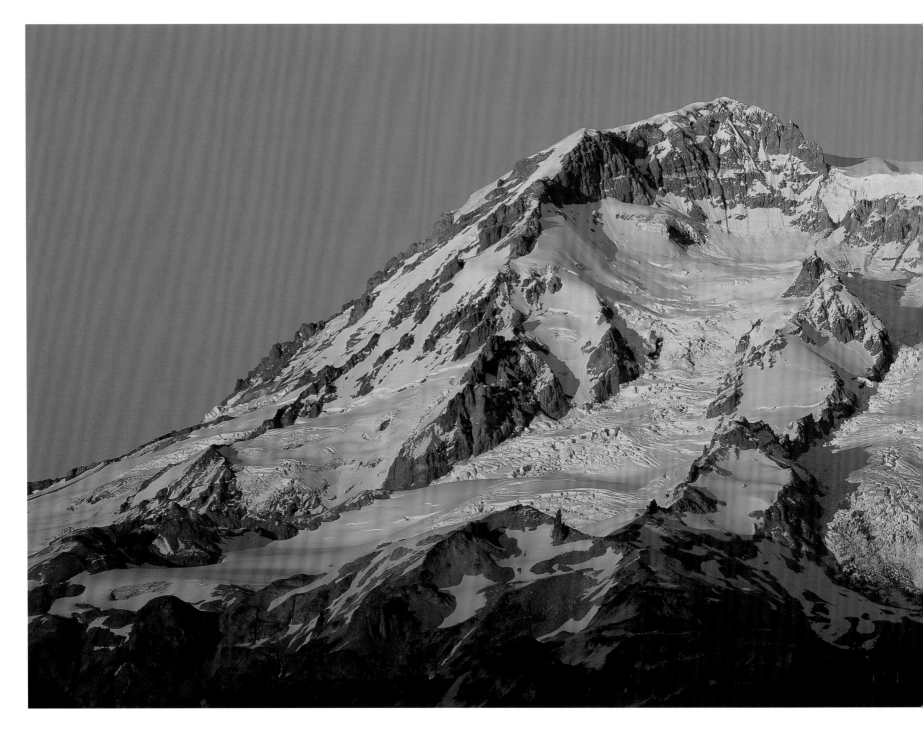

Mount Rainier at sunrise

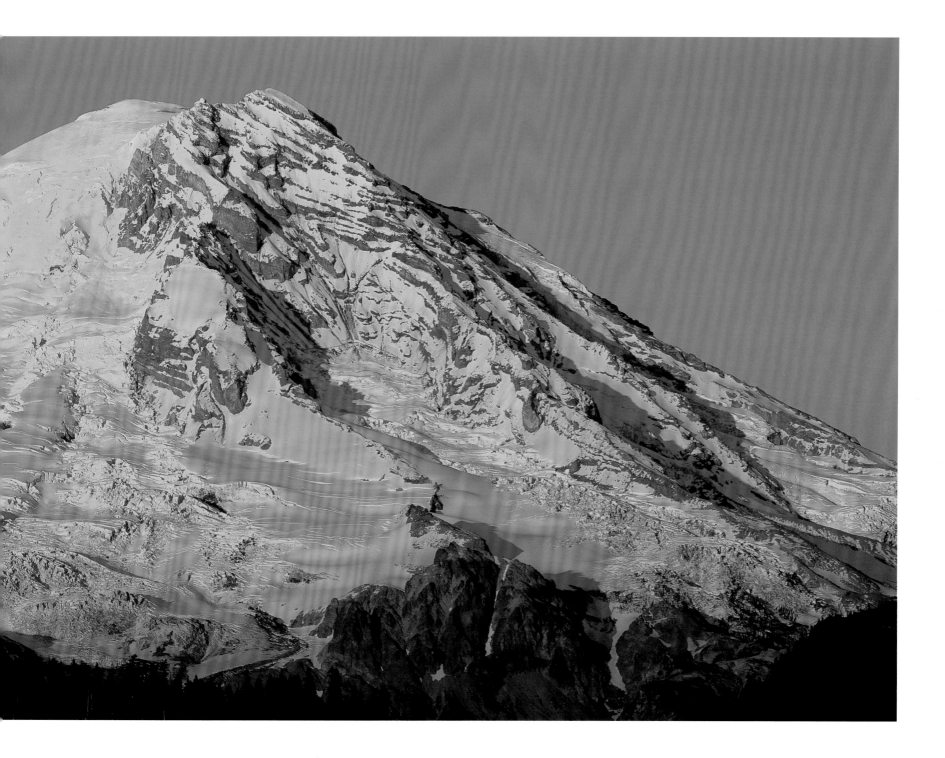

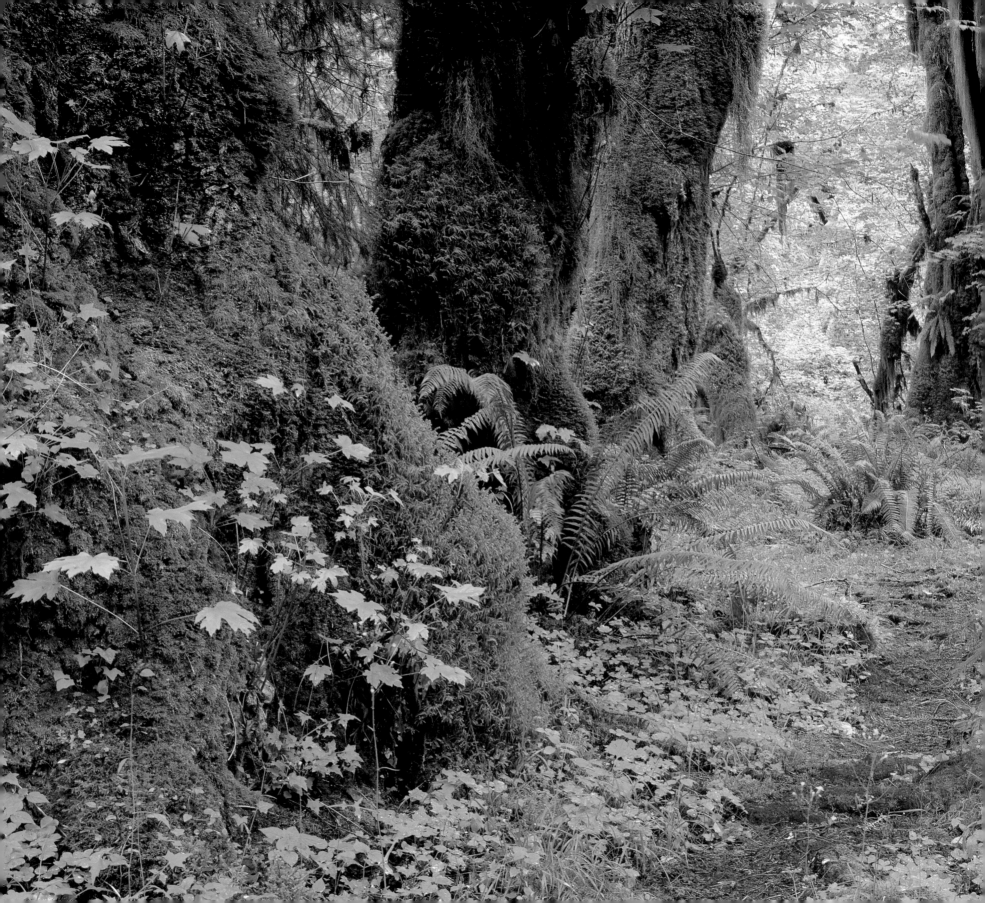

FOREST

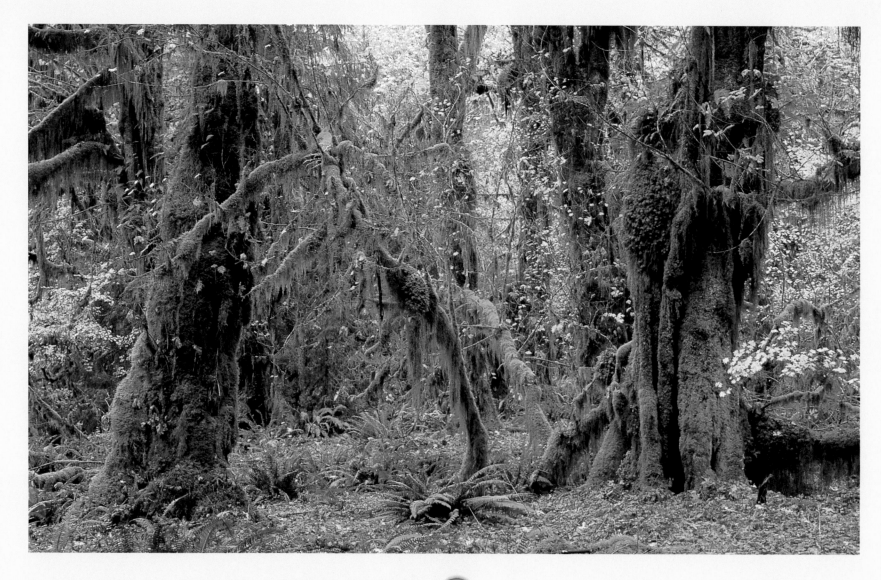

LET US NOW PRAISE FAMOUS TREES ◎

IN MY ONE LIFETIME, many of the massive, moss-hung old-growth forests of my Pacific Northwest have fallen. These Standing People—as my father called them—are heroes making their last stand. Let us now praise these famous trees: Douglas fir and western redcedar,

western hemlock and Pacific madrone and Oregon ash, Sitka spruce and quaking aspen, lodgepole pine and bitter cherry, red alder and whitebark pine, Engelmann spruce and common choke-cherry, white oak, Pacific willow, and Pacific yew. These many and mighty trees have offered us shelter, shade, and oxygen. And if we listen deeply enough to let them live, they lend the elders' wisdom of longevity. Generations of trees have stood here in Northwest forests like statesmen, witnessing our perpetual motion and sending their own roots deeper into the earth. These forests hold us and our memories. They are our ancestors and our future.

From the Hoh and Quinault rainforests of the Olympic Peninsula to thousand-year-old Douglas firs bordering British Columbia's Clayoquot Sound, the Pacific Northwest's

forests hold some of the most treasured old-growth stands in the world. They are also among the most endangered.

Several summers ago, I drove from the High Sierras up through Cascade forests on a road trip home to Seattle. In one four-hour drive from the old mining town of Yreka in northern California to Eugene, Oregon, I counted fifty logging trucks, roughly one every four minutes. Many of the flatbeds were loaded with only one or two trees. On the mountain-sides surrounding the highway, I was shocked to see so many miles of clear-cuts, where once flourished ancient trees. Thousands of tree stumps bobbed across the barren hills like morning-after champagne corks.

I don't know when I started crying. Possibly at the sight of those crazy-quilt scars of clear-cutting, or maybe later when I telephoned a

Overleaf: *Moss-covered trees in the Hoh River Valley, Olympic National Park, Washington*

Left: *Quinault River Valley rainforest, Olympic National Park*

Right: *Skeletized black cottonwood leaf* (Populus trichocarpa), *Olympic Peninsula*

friend's cabin on Oregon's Snake River, and he told me about the daily, dawn-to-dusk parade of logging trucks. "It's like a funeral procession out of the forest," he said. "It's panic logging; they're running shifts night and day before the winter or the Congress closes in on them."

Consider then: Who are the trees to us? What is our connection to forests on a deeper level than just product? In ancient Europe, the pagans worshipped trees. Cutting down a sacred oak was punishable by death: to those folk, trees were more important than people because the old forests survived and contributed to the whole for much more than one human lifetime. Today, we pay homage to the massive General Sherman Tree in Sequoia National Park. That towering giant is estimated to be more than 3,800 years old. And in southernmost Oregon, off Highway 101, is the world's largest cypress tree, which has become another mecca for forest lovers.

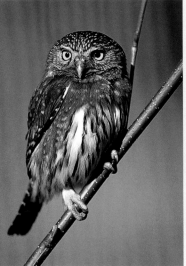

Old trees, like old people, are never replaced by planting saplings. Old trees survive the ravages of middle-age competition for light or limelight; they give back to their generations more oxygen, more stories. They are tall and farsighted enough to see the future because they are so firmly rooted in the past. Old growth, whether tree or person, gives nurturing; young saplings need their support.

A Nez Perce woman from Oregon once told me that there was a time when the ancient trees were living burial tombs for her people. Upon the death of a tribal elder, a great tree was scooped out enough to hold the folded body. Then the bark was laid back to grow over the small bones like a rough-hewn skin graft.

Left: *Northern pygmy owl* (Glaucidium gnoma), *6¾ inches in height*

"The old trees held our old people for thousands of years," she said softly. "If you cut those ancient trees, you lose all your own ancestors, everyone who came before you. Such loneliness is unbearable."

On a physical and spiritual level, we are linked to these breathing trees. And every time a great tree is cut, our kind die, too—lost and lonely and longing for what we may someday recognize as akin to ourselves.

So let us now praise famous trees who still stand tall and nourishing in our Northwest forests. Let us preserve our elders so that our own children may have more breath and beauty. We have let the spotted owl and the marbled murrelets be the indicator species who show us the health of our forests. Our species must now indicate that the rapacious and furtive felling of our forests is forever over. What trees we have left we must cherish, for we cannot recreate or replant the diverse and ancient web of life that the forest gives us. For how can we restore a Quinault rainforest with its verdant maidenhair and licorice ferns, its hanging chubmoss and nurse logs bejeweled with emerald bracken and almost medieval sword fern? In the high canopies of misty tree tops, how can we bring back the flying squirrels and spotted owls who thrive only on vast acreages of ancient forest?

Every breath we take may well have been given us by a Northwest tree. May we now restore and praise, not only those who stand tall and famous among humankind, but also those Standing People whose legacy we leave for the trees and people who follow.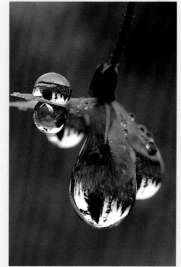

Right: Dewdrop-coated flower, Cascade Mountains

Coastal Sitka spruce (Picea sitchensis) and western hemlock (Tsuga heterophylla), Olympic Peninsula

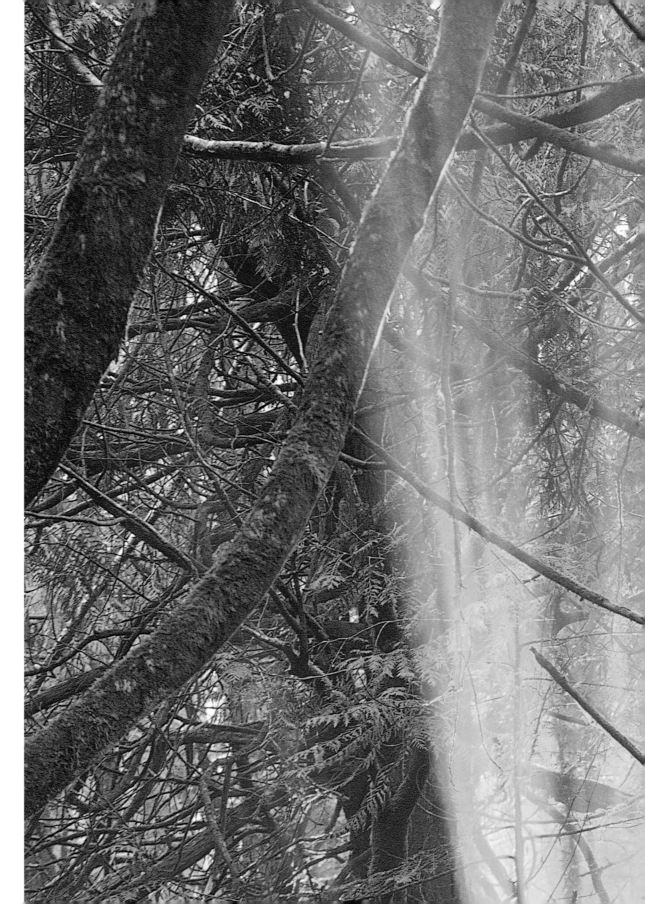

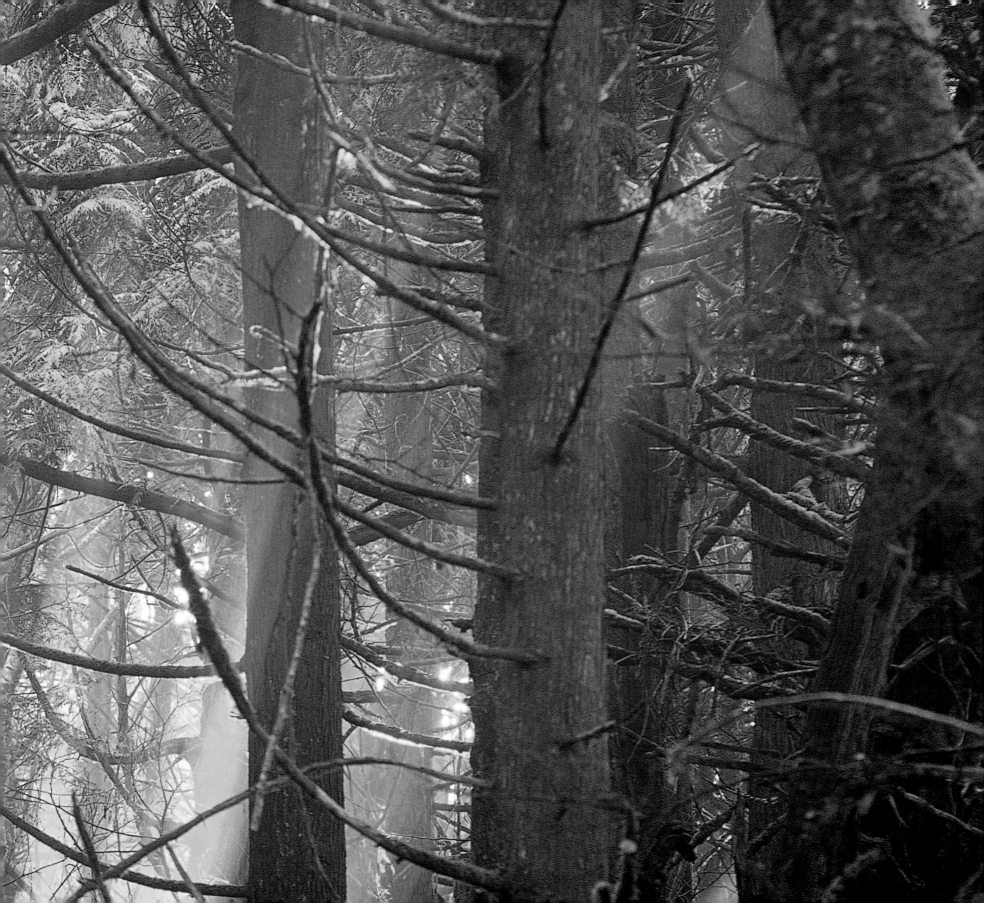

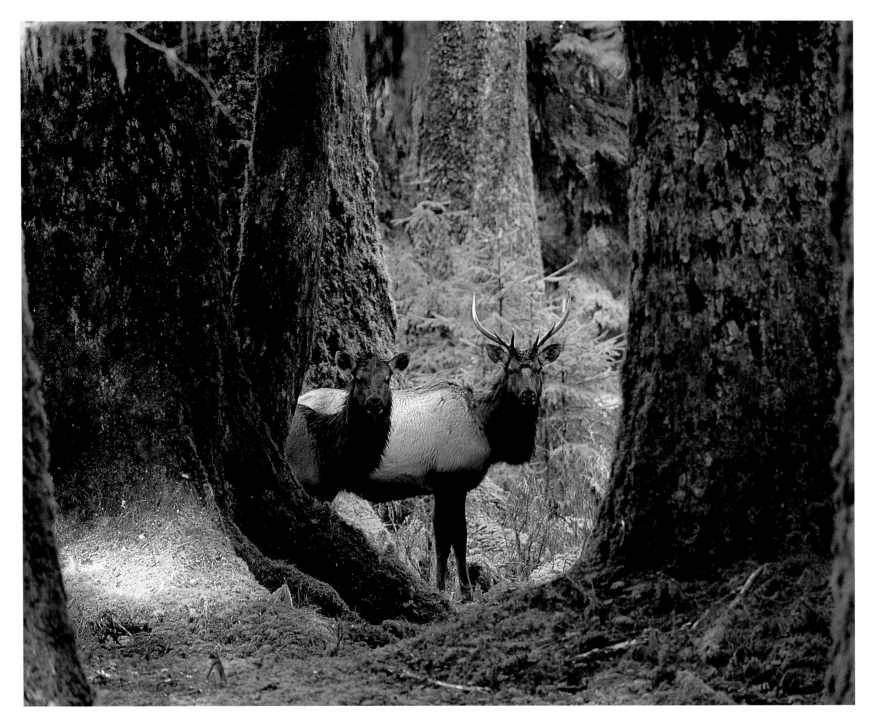

Roosevelt elk (Cervus elaphus), *native to the*
Olympic Peninsula rainforests

 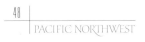

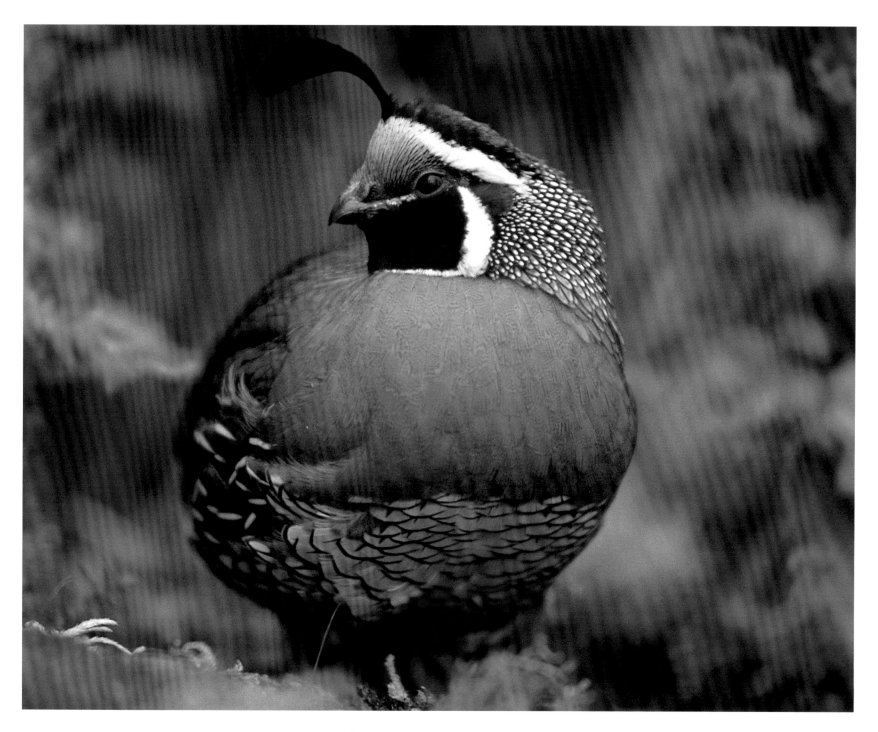

Male California quail (Callipepla californica),
Coast Range, Oregon

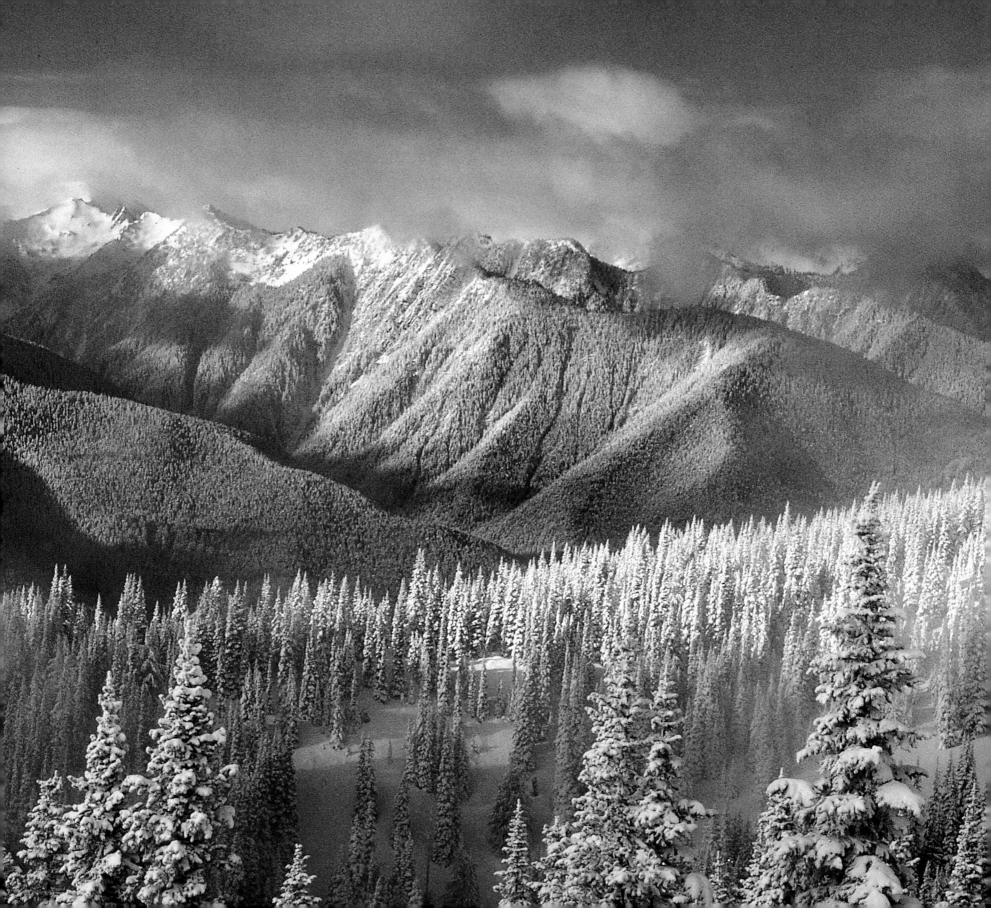

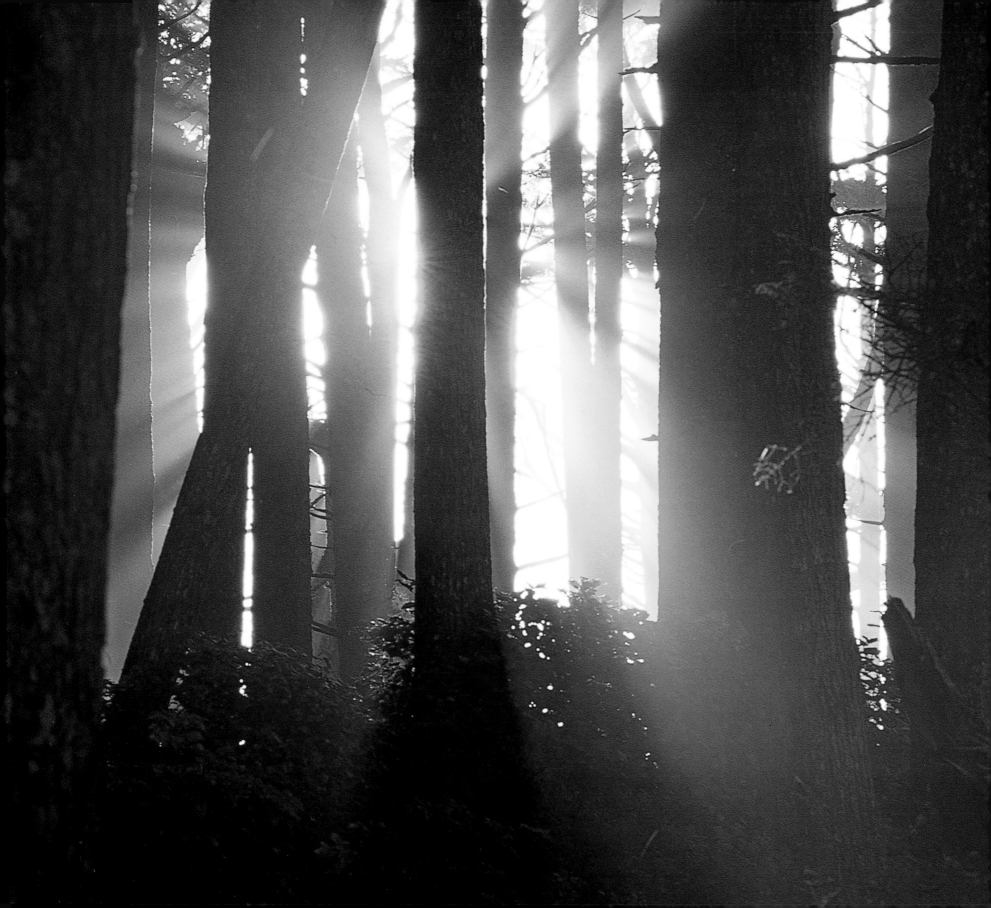

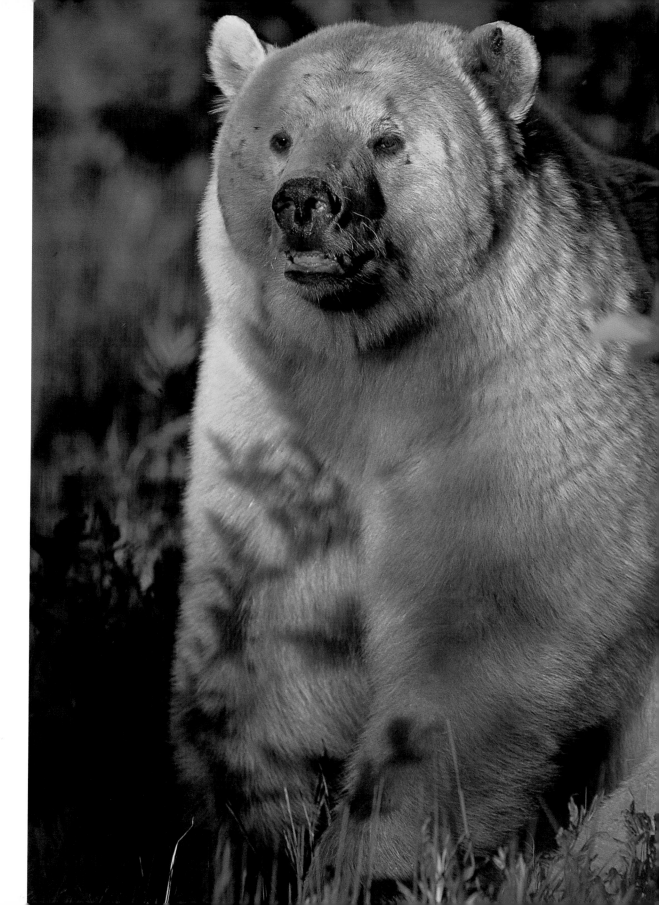

Overleaf: Hurricane Ridge coated with fresh snow, Olympic National Park

Left: Sunlight shafting through a Sitka spruce forest, Washington

Right: Kermodei bear (Ursus americanus), a rare white phase of the American black bear found most commonly along the coast of central British Columbia

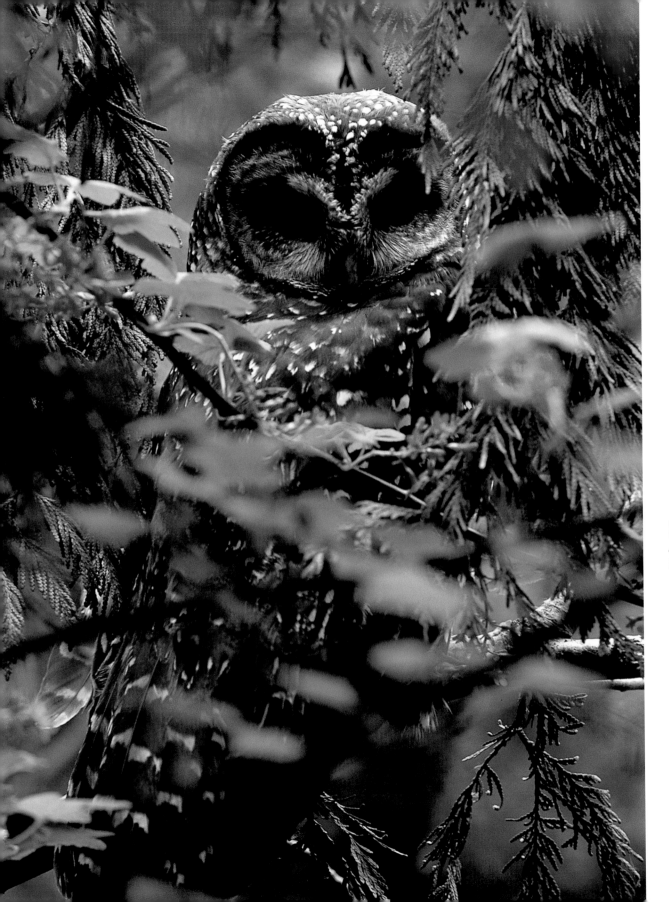

Left: *Northern spotted owl (Strix occidentalis), denizen of the old-growth forests of the Pacific Northwest*

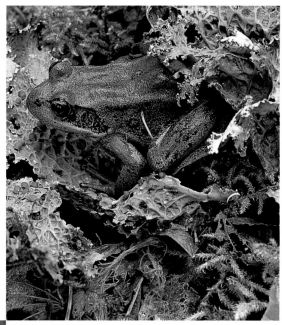

Right: Red-legged frog (Rana aurora), *Hoh River Valley, Olympic National Park*

Below: Bunchberry (Cornus canadensis), *common to low elevation forests in the Pacific Northwest*

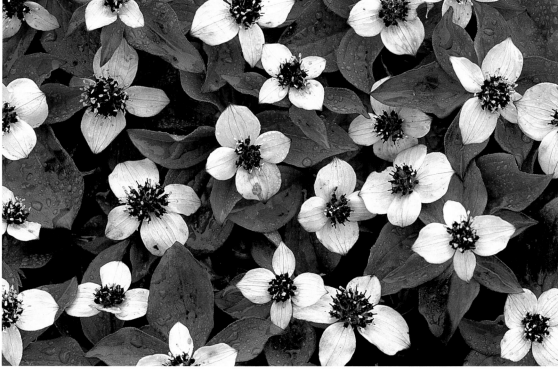

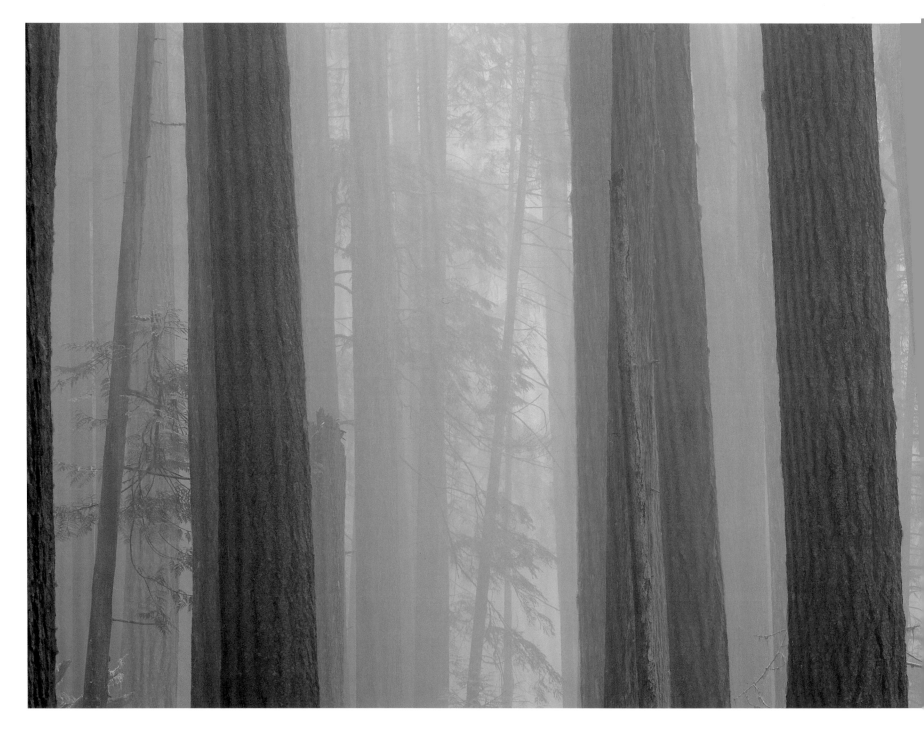

Trunks of western hemlock (Tsuga heterophylla) *and western redcedar* (Thuja plicata), *Olympic Peninsula*

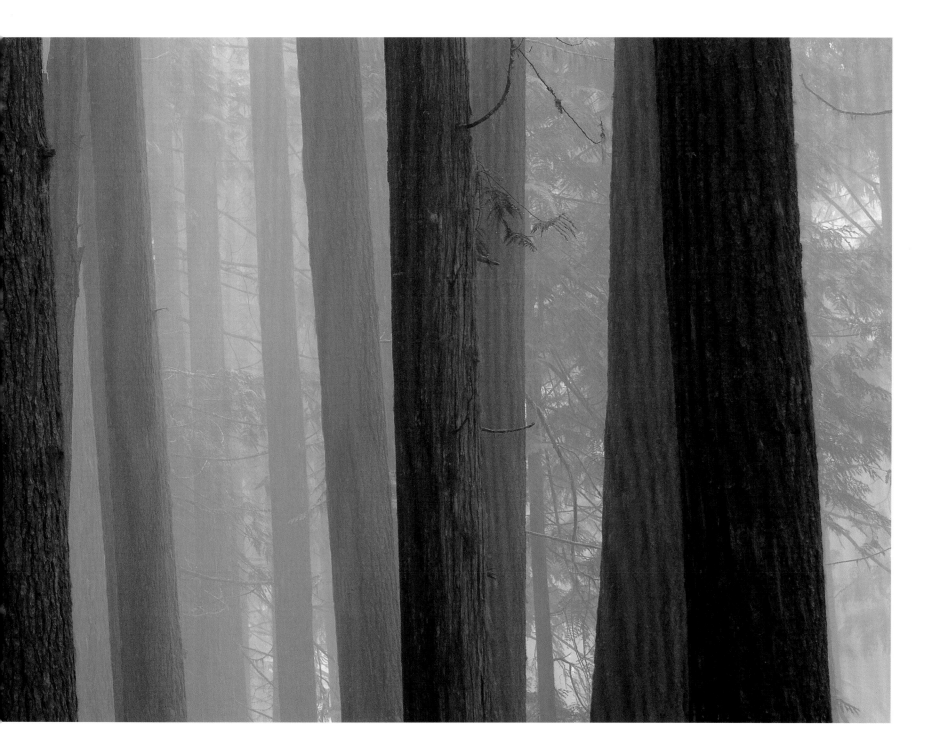

Left: *Ponderosa pine cones* (Pinus ponderosa), *east side of the Cascades*

Below: *Bracket fungi* (Stereum ostrea) *flourishing on a decomposing log, Olympic National Park*

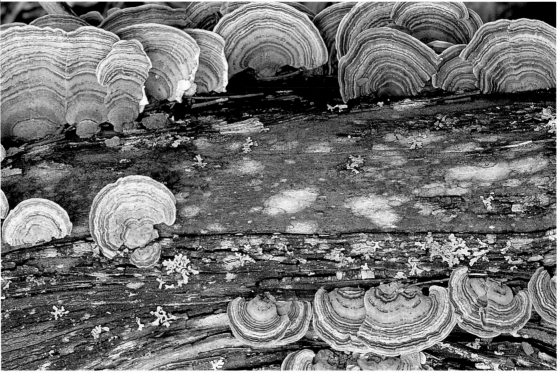

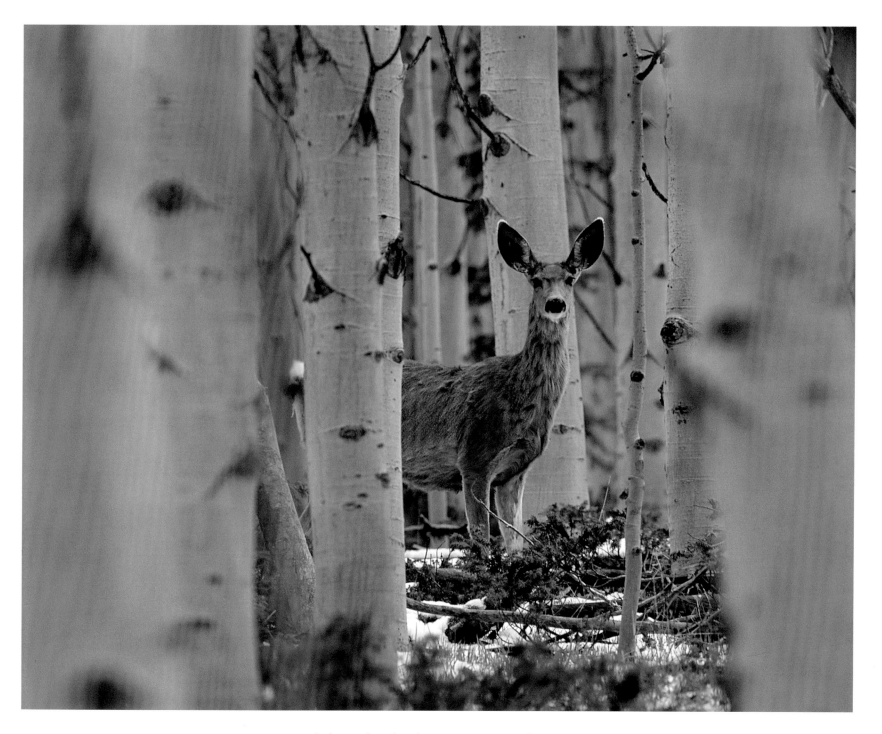

Mule deer (Odocoileus hemionus) *among quaking aspens*
(Populus tremuloides), *Cascade Mountains, Oregon*

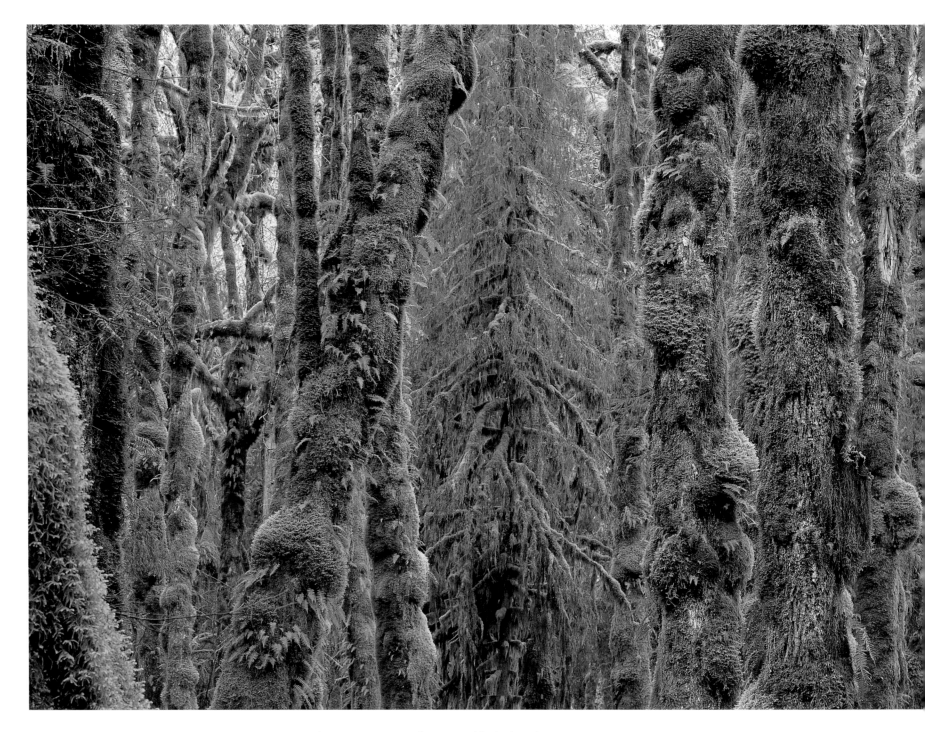

Sitka spruce (Picea sitchensis) *and bigleaf maples* (Acer macrophyllum)*, Quinault River Valley, Olympic National Park*

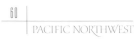

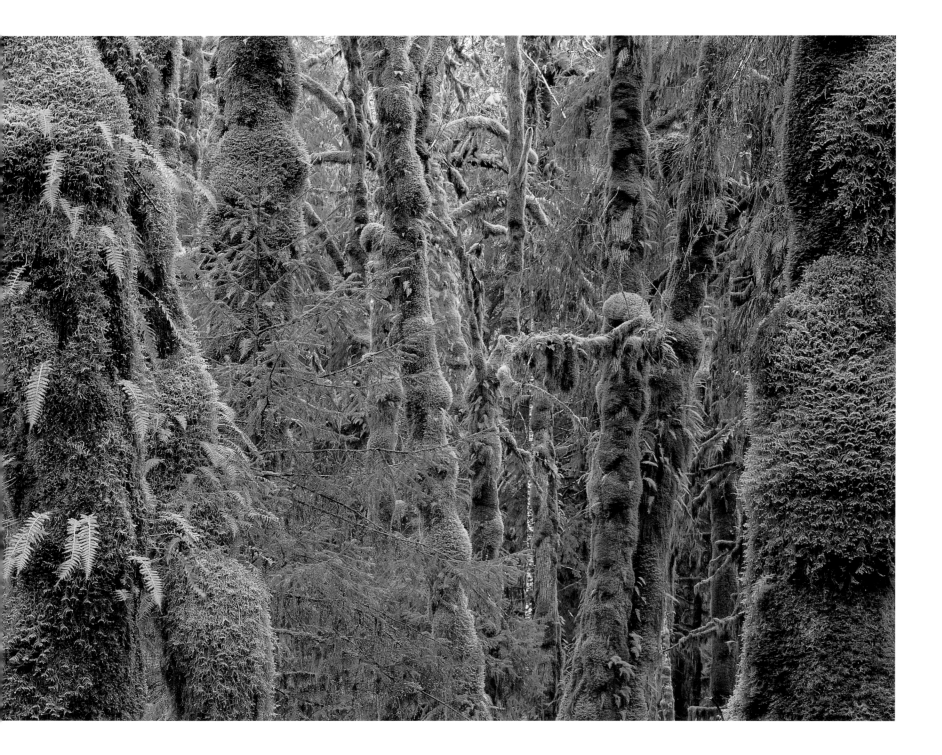

Left: *Western larch* (Larix occidentalis) *in autumn, Selkirk Mountains, Idaho*

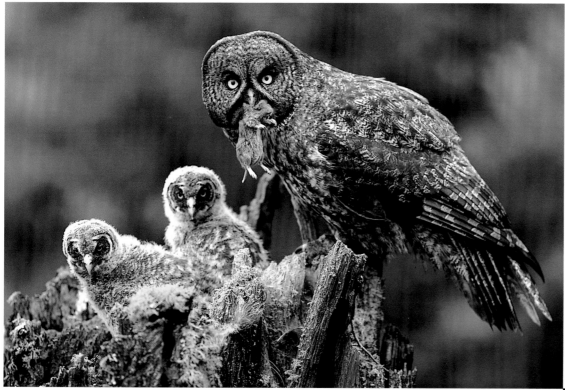

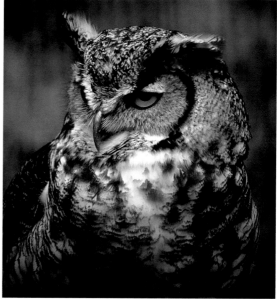

Above: *Great gray owl* (Strix nebulosa) *and owlets, Idaho*

Right: *Great horned owl* (Bubo virginianus), *common to Pacific Northwest forests*

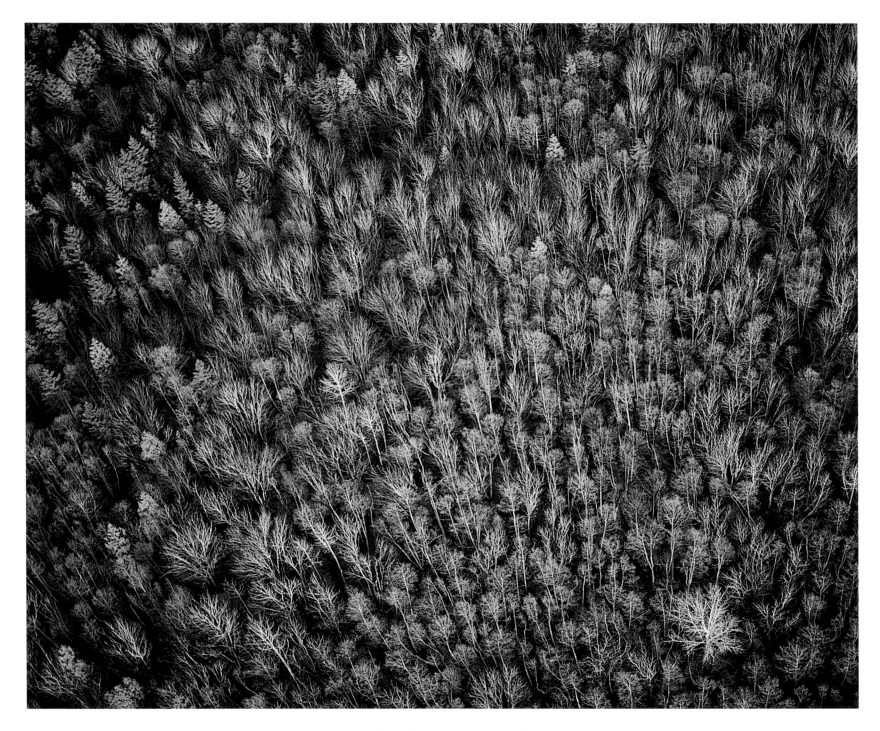

Forest of red alder (Alnus rubra), *Douglas fir*
(Pseudotsuga menziesii), *and black cottonwood*
(Populus trichocarpa), *western Washington*

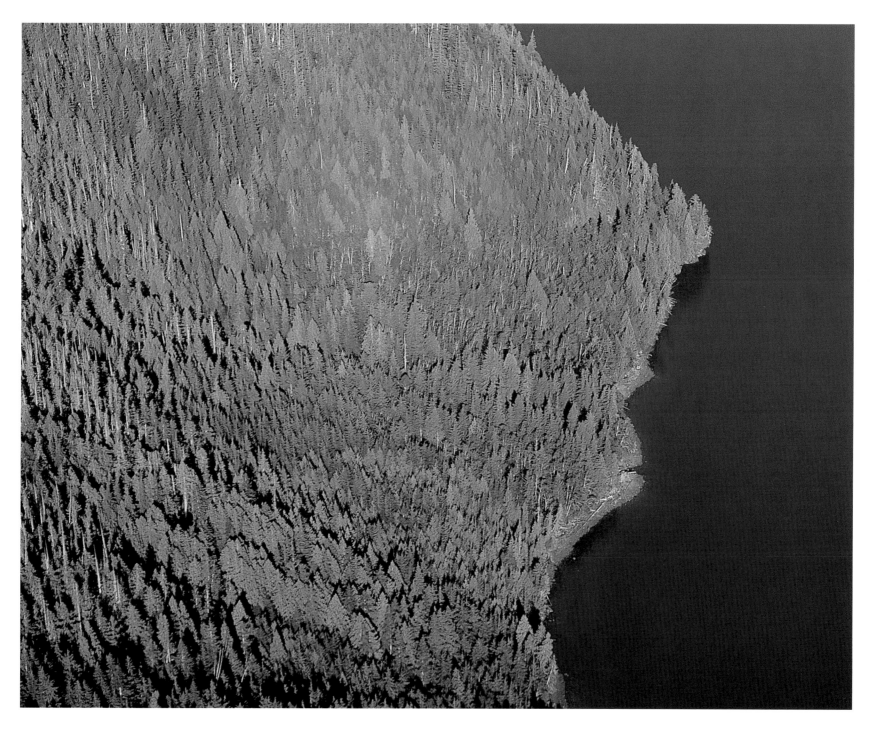

*Evergreen forest edged by water, Johnstone
Strait, British Columbia*

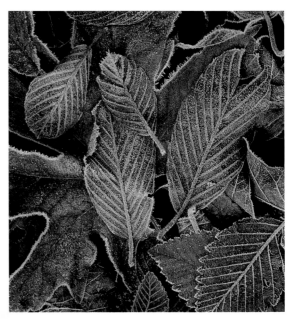

Right: *Frost-covered red alder leaves* (Alnus rubra), *Olympic Peninsula*

Below: *Lake Crescent, Olympic National Park*

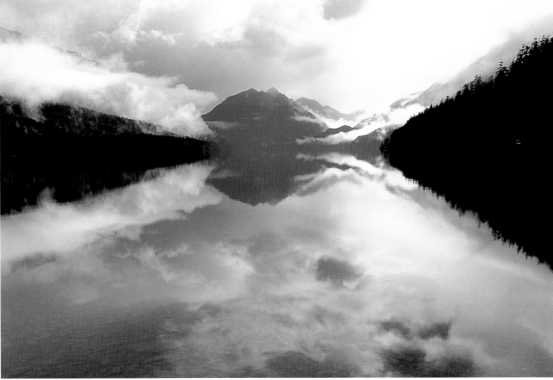

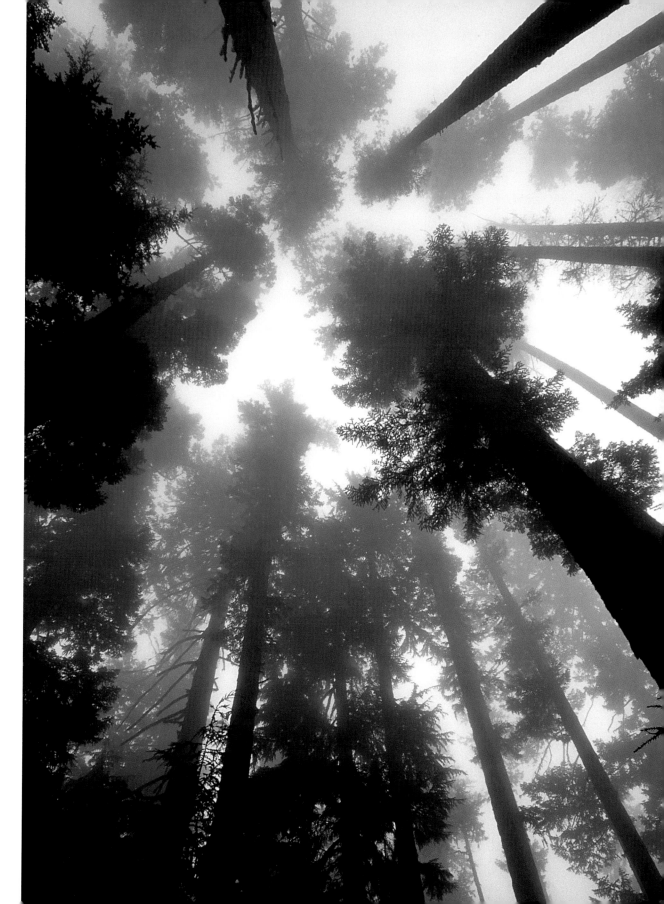

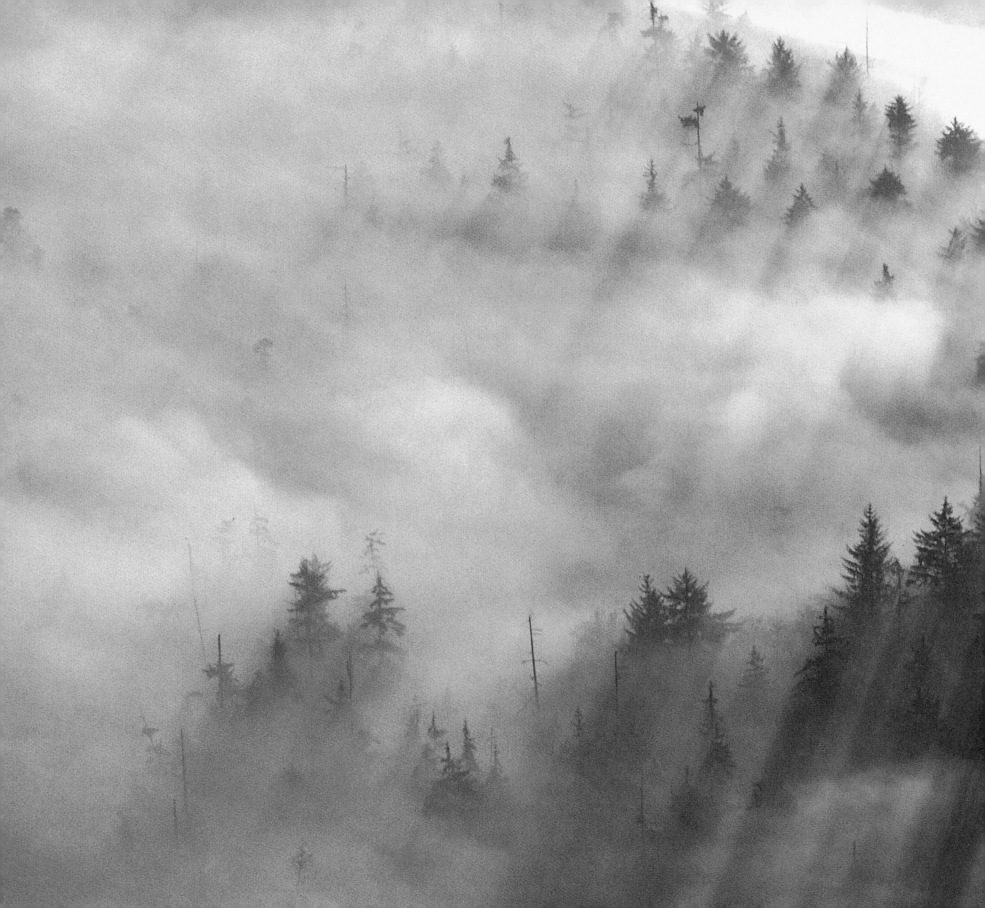

RIVER & DELTA

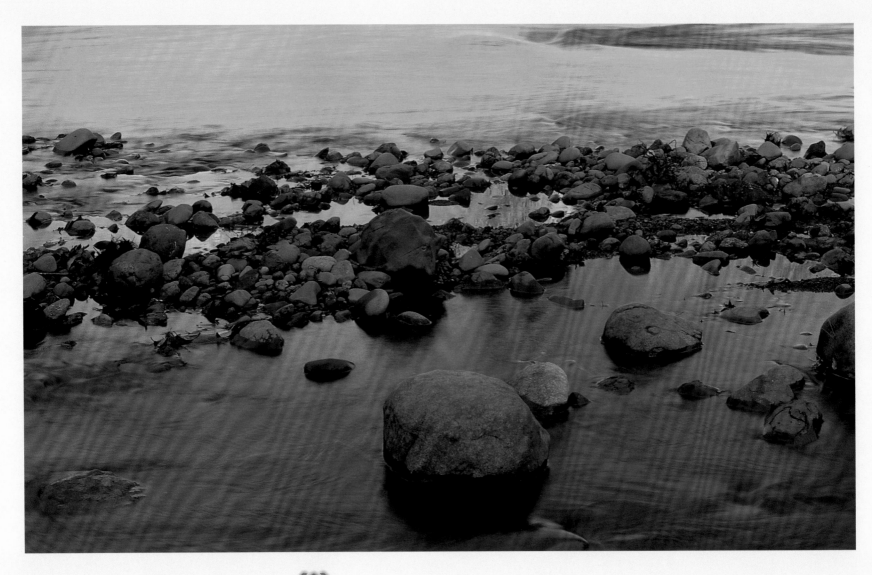

PLACE OF THE SALMON

THROUGH MILLIONS of years and molten lava, the Columbia River carved a basin and sculpted serpentine canyons in bedrock and basalt. Crashing over glacial dams during the Ice Age, it flooded valleys and channels in a torrent ten times the volume of all the rivers in

the world. World-shaper, this river, Continent-Changer. Before mountains were made, the Columbia ran wild for some twenty million years.

Of the great rivers of the Pacific Northwest, the Columbia River most shapes our homeland. Once more than fifteen million wild salmon swam up the Columbia to spawn, making this roaring colossus the greatest salmon river in the world. Salmon, some as big as one hundred pounds each, were so plentiful that Northwest native peoples tell of stepping across streams on the bright, red backs of these brave "Salmon People." Perched precariously on high wooden-plank platforms above swirling rapids, the Yakama and Quinault tribes, using strong ropes wrapped around their waists, fished with spears and dip nets. According to the native myths of the Pacific Northwest coast, a tribe of under-water people live in unseen symmetry with us

land dwellers. To keep that balance, some humans would volunteer to exchange places with their salmon kin every fishing season, thus symboli-cally assuring the survival and return of the Salmon People.

After thousands of years of living off these sacred fish and their rivers, we are all related to the Salmon People. But the balance is off, for we are losing the scarlet fish—symbol of all that is wild and natural in the North-west, and an indicator of the health of our whole eco-system. The overfishing of our oceans and the hydro-electric dams that harness our rivers have con-tributed to their demise. There are over fourteen dams on the Columbia River. It took the world's largest dam, Grand Coulee, to doom the Columbia's role as the world's mightiest salmon river. This five-story cement monolith is too

high for even the stalwart salmon. Now the Columbia returns less than two million of the fish in their heroic upstream struggle home. The Columbia and Snake Rivers are ranked second on the list of our country's endangered rivers, and the Columbia is among the world's most polluted and radioactive rivers.

Long before we invented electricity or dams, nature taught us that water was synonymous with power. What happens when we mistake the river's power for our own and fail to honor the water source or its creatures? What within us is truly illumined when we light up a room, a city, a night desert—and not our own souls? Like the salmon, we won't find our way home if we are cut off from our native waters. And like the birds, bears, and orcas who also live off the salmon, our human fate will follow the flow of our rivers. Oregon's native American writer Elizabeth Woody writes, "The Indian people say, 'When the salmon are gone, that is the end of life as we know it.'"

On my own homeward journey to the Pacific Northwest, I entered this lush, far-flung land through the Columbia River Gorge. I followed the Columbia—the fourth largest river on Earth—which once inspired awe and fear in Lewis and Clark and led many migrations of early explorers and settlers westward along the Oregon Trail. Near the Bridge of the Gods, I explored the Columbia River Gorge—its massive chasms, ancient forests of maple and Douglas fir, and Bridal Veil Falls, with its long green gown of moss, delicately shy camas

Left: *Yellow skunk cabbage flower* (Lysichitum americanum), *an early sign of spring*

lilies, and cliff-dwelling osprey.

Gazing down this gorge, I knew I had at last found my own lifelong dwelling place—fed by a great river, peopled by salmon, bears, eagles, and blue-winged teal, and protected by a watershed more ancient than anything humans have made. For two decades, I have witnessed the salmon heroically hurling themselves up fish ladders—from the Ballard Locks in Seattle to the Bonneville Dam. And I have said prayers, not only for their yearly return to Northwest rivers, but also for their return as the mighty Salmon People.

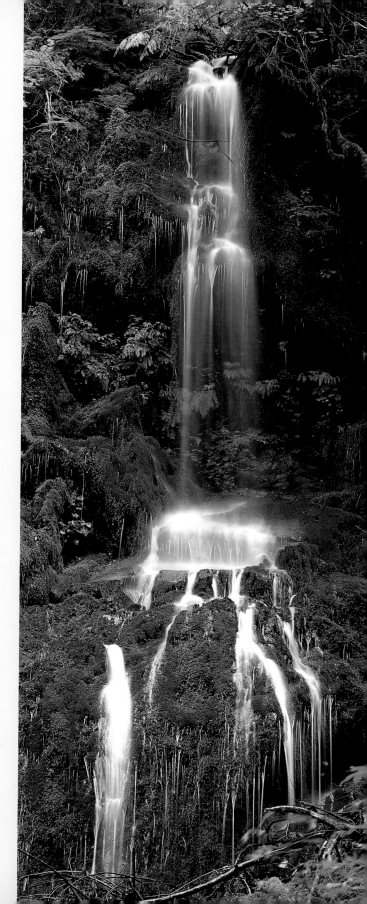

Right: *Waterfall in the lush Quinault River Valley, Olympic National Park*

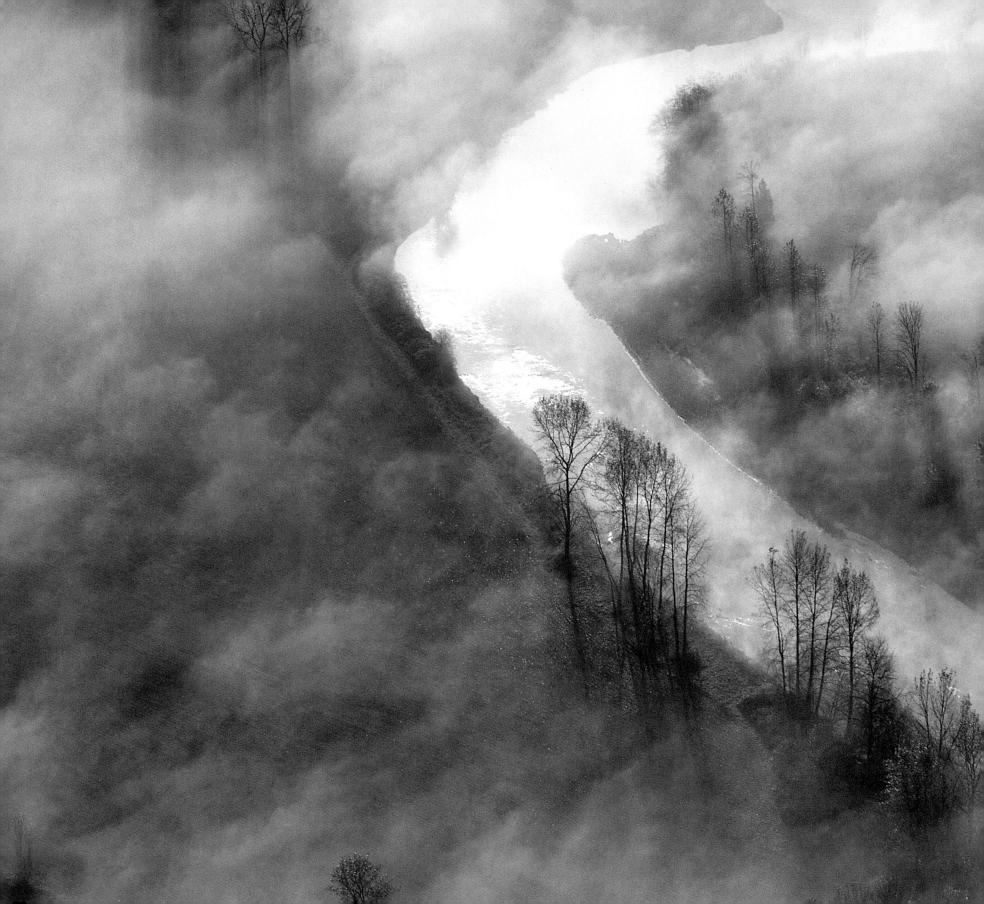

Left: *The Skykomish River, flowing west from the Cascades to Puget Sound*

Right: *Dewdrops decorating the web of an orb weaver spider* (Araneus diadematus)

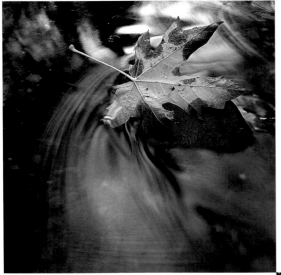

Left and below: *Waterscapes from small rainforest streams, Olympic Peninsula*

Right: *Autumn on the Quinault River, Olympic National Park*

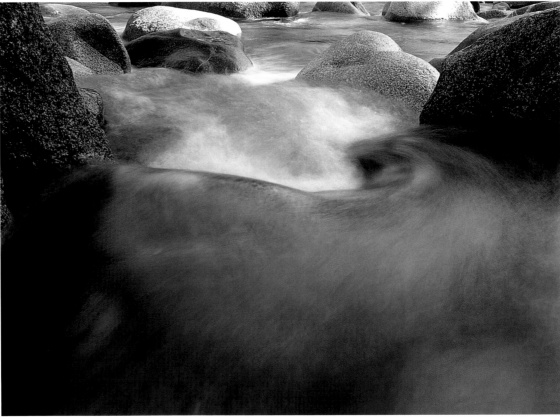

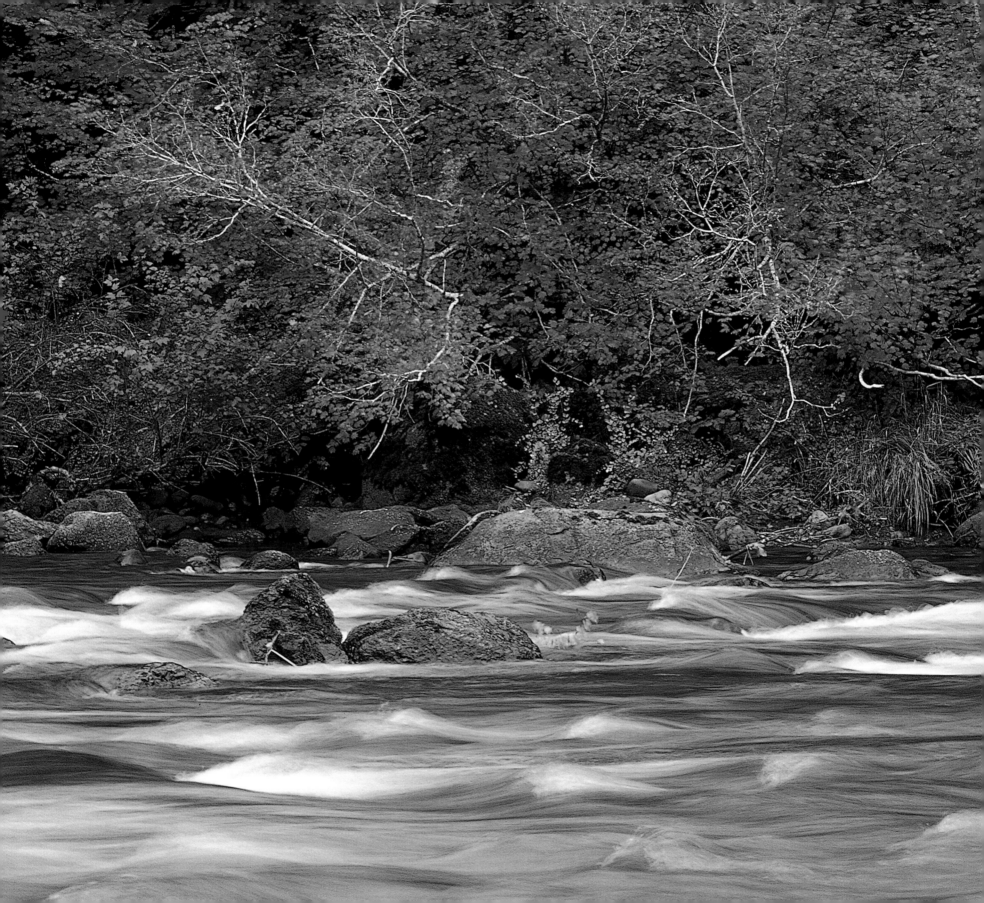

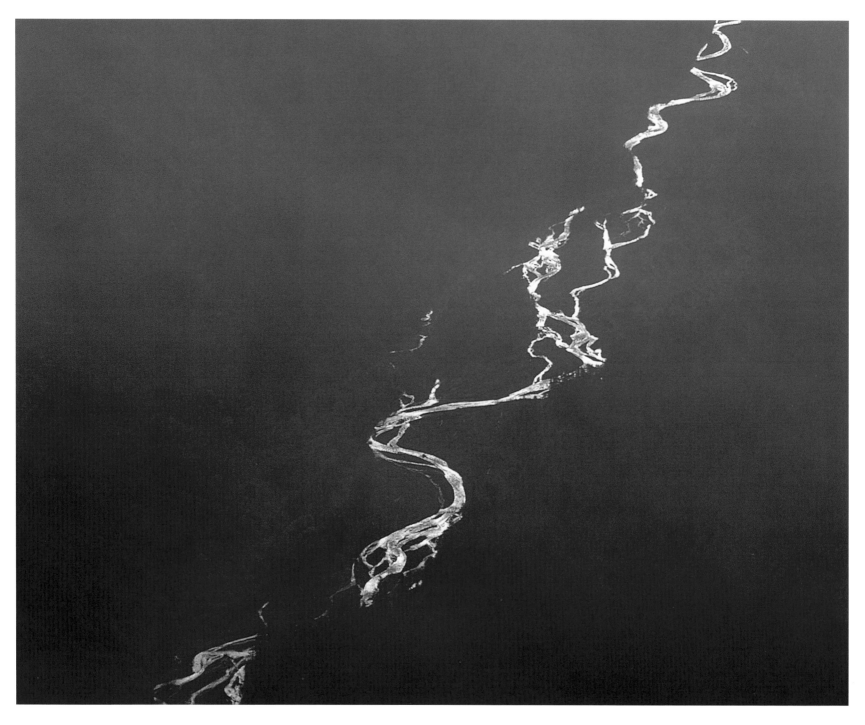

The White River, Glacier Peak Wilderness,
Washington

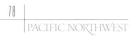

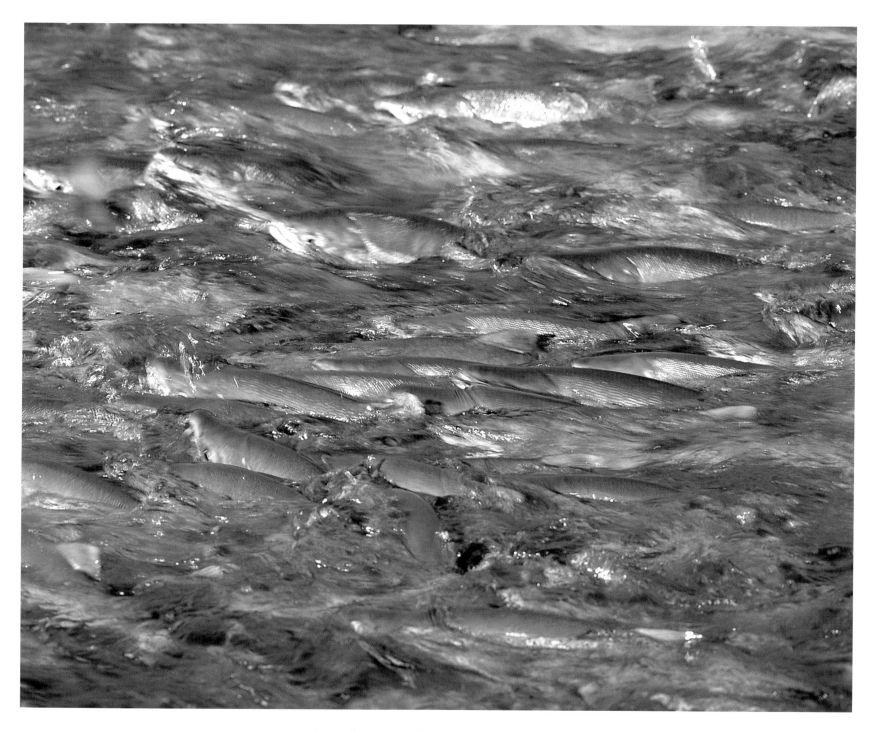

Sockeye salmon (Oncorhynchus nerka) *returning*
from the Pacific Ocean to spawn

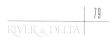

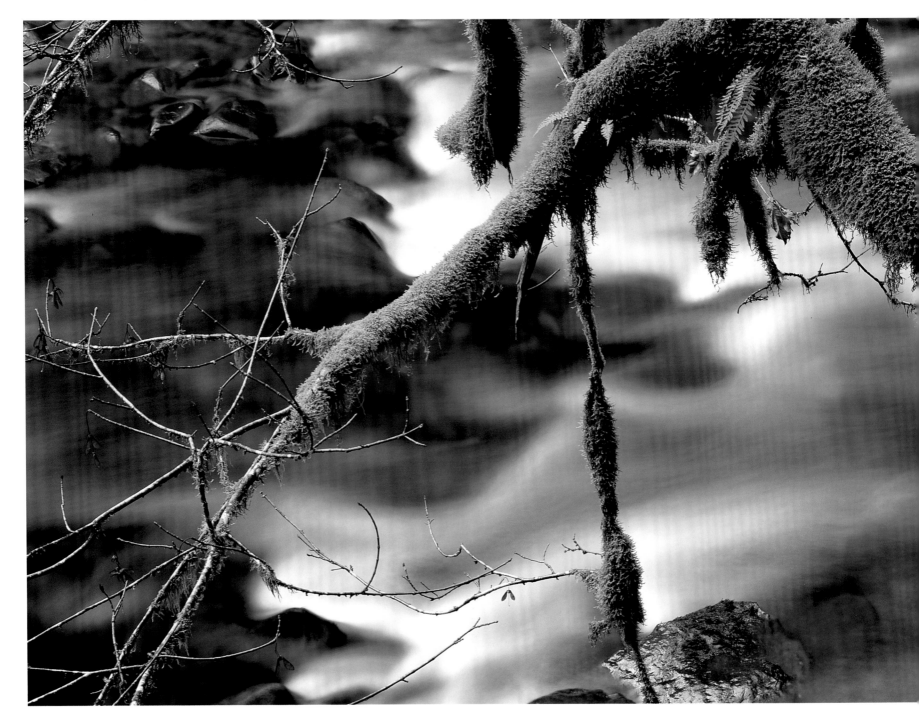

Eagle Creek, Columbia Wilderness, Oregon

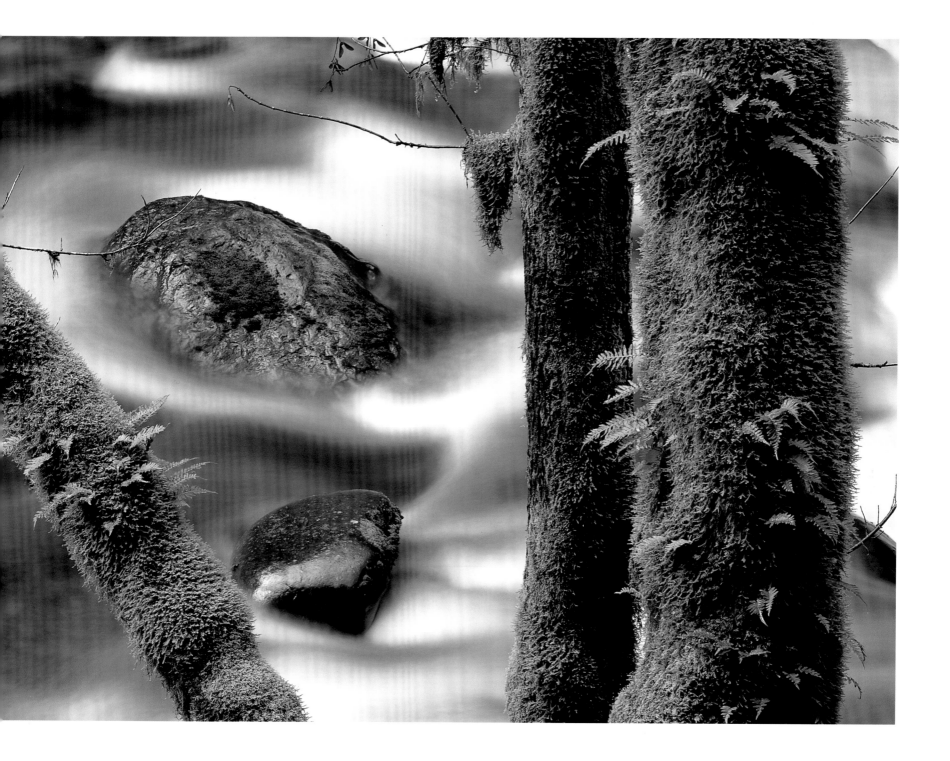

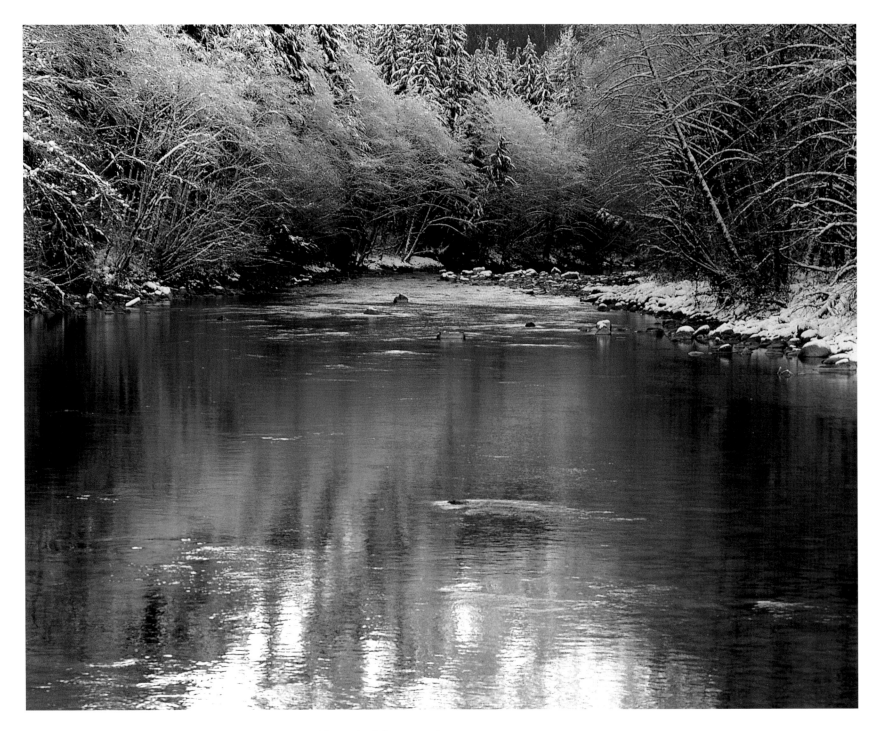

Middle Fork of the Snoqualmie River in
winter, Washington

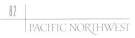

Above: Trumpeter swan (Cygnus cygnus) *sleeping on the Skagit River estuary, Puget Sound*

Right: Red alder leaf (Alnus rubra) *on the frozen surface of a mountain stream*

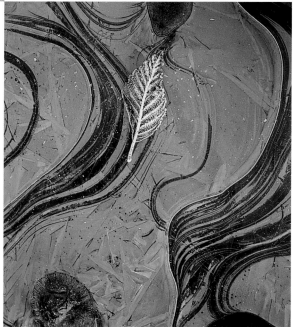

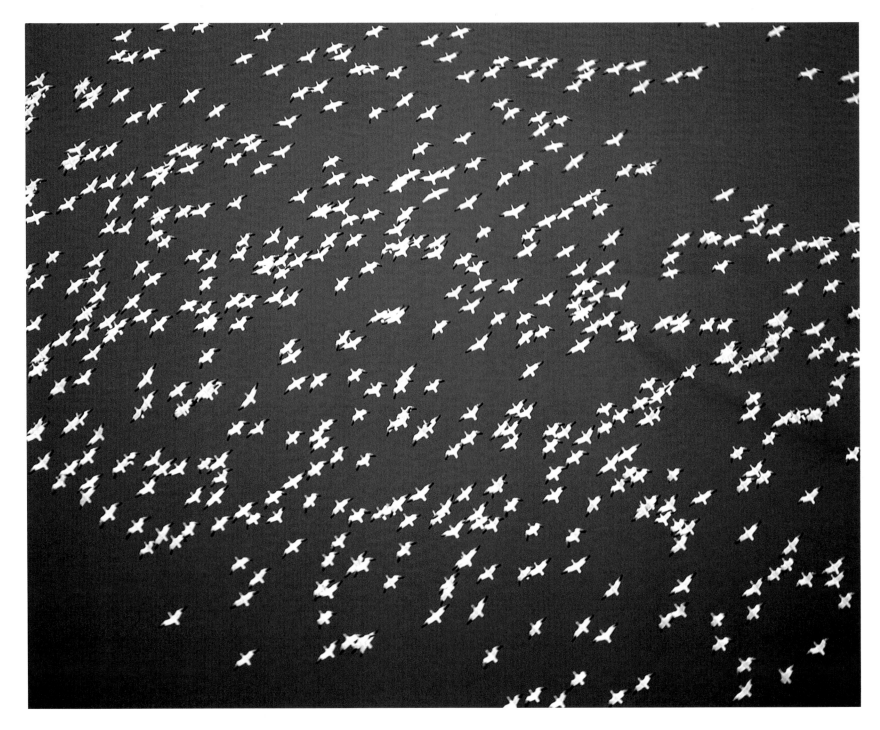

Snow geese (Chen caerulescens) *in flight over the*
Skagit River estuary, Washington

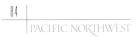

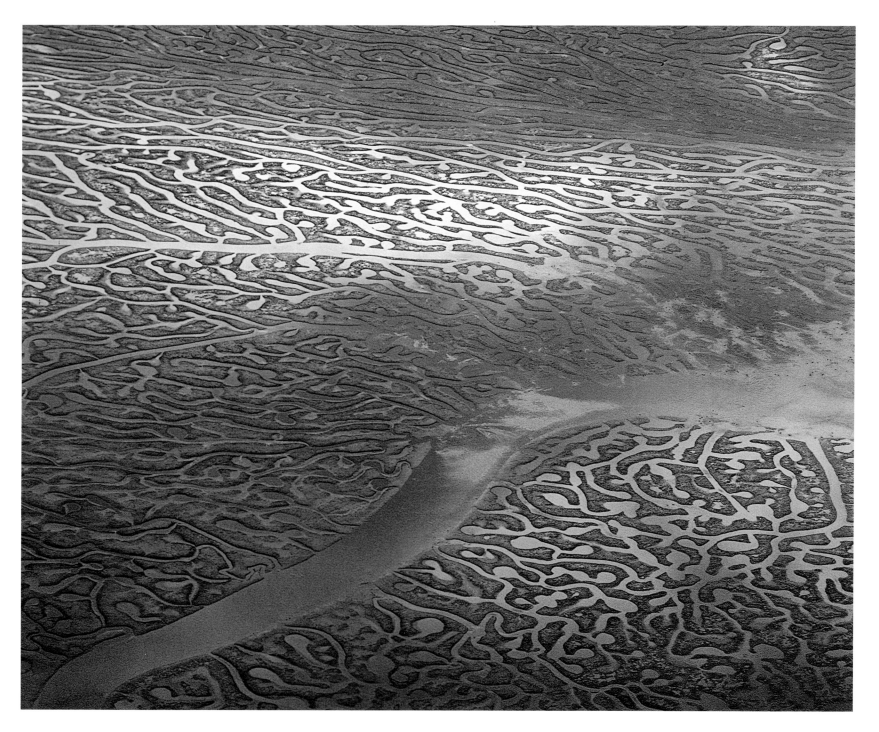

Aerial view of low tide on the Skagit River estuary

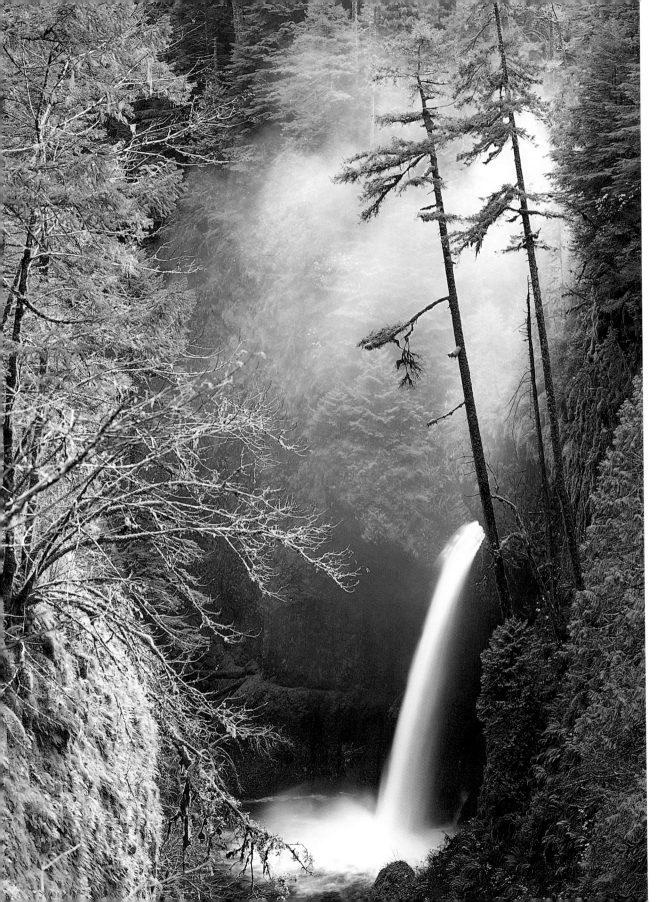

*Waterfall, Eagle Creek, Columbia River
Gorge, Oregon*

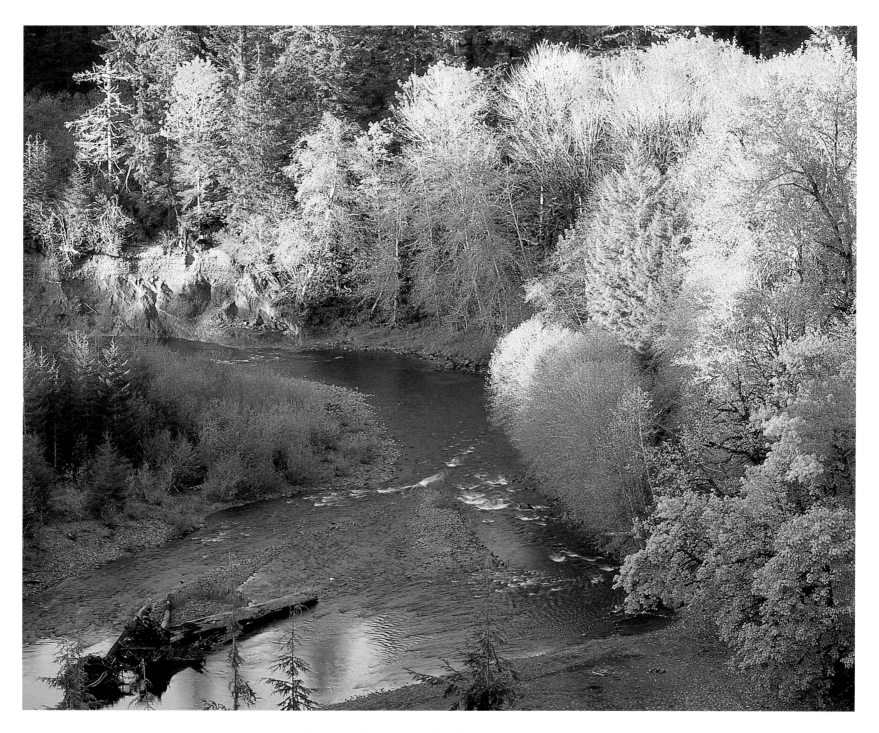

The Wynoochee River on the Olympic Peninsula

Right: Mallard ducks (Anas platyrhynchos) *taking flight, Rifle Wildlife Refuge, British Columbia*

Below: Broadleaf cattails (Typha latifolia) *going to seed, Yakima River, central Washington*

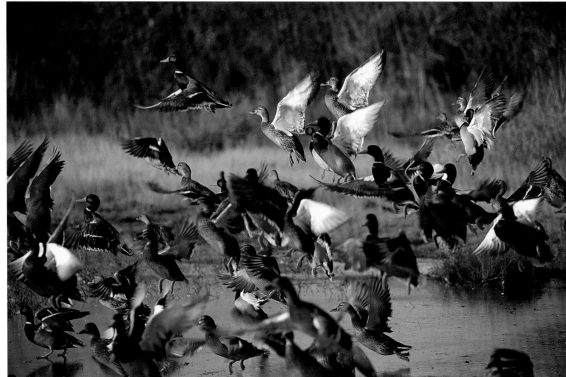

Right: *Canada geese* (Branta canadensis),
Seattle

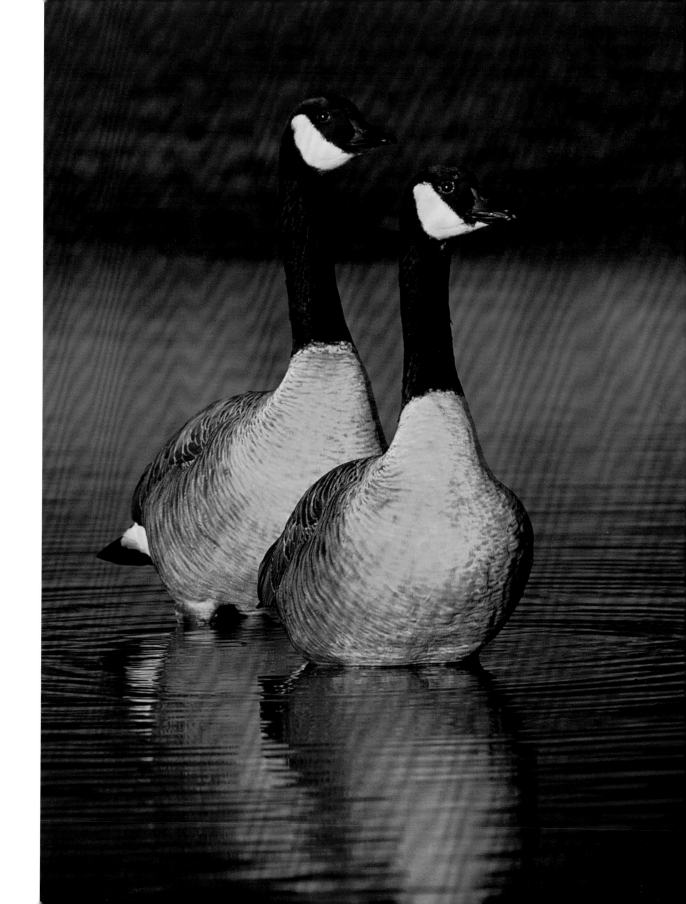

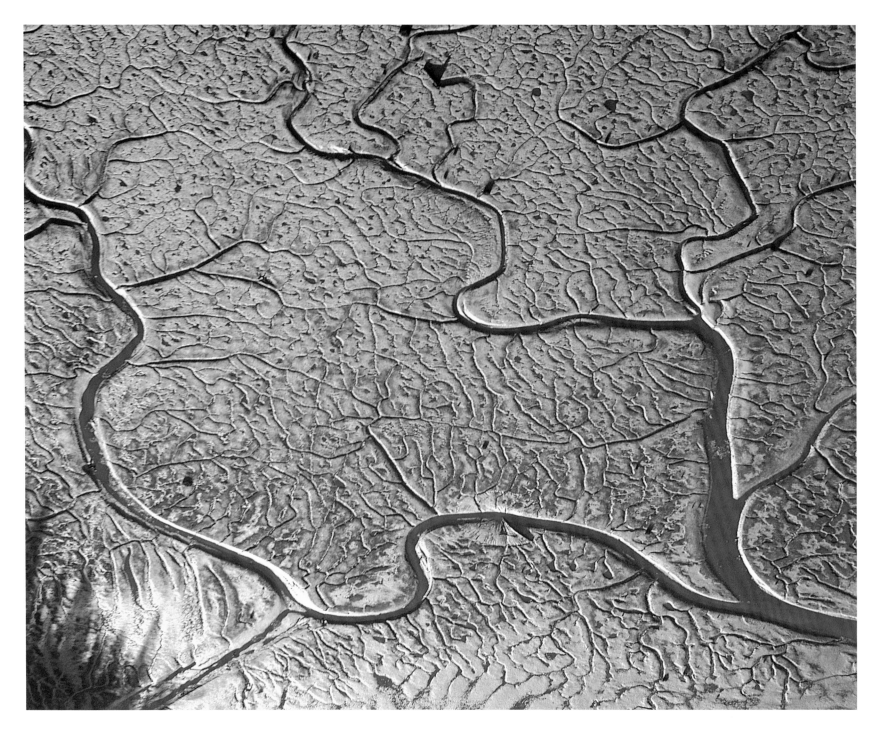

Mud flats in the Skagit River estuary at low tide, Puget Sound

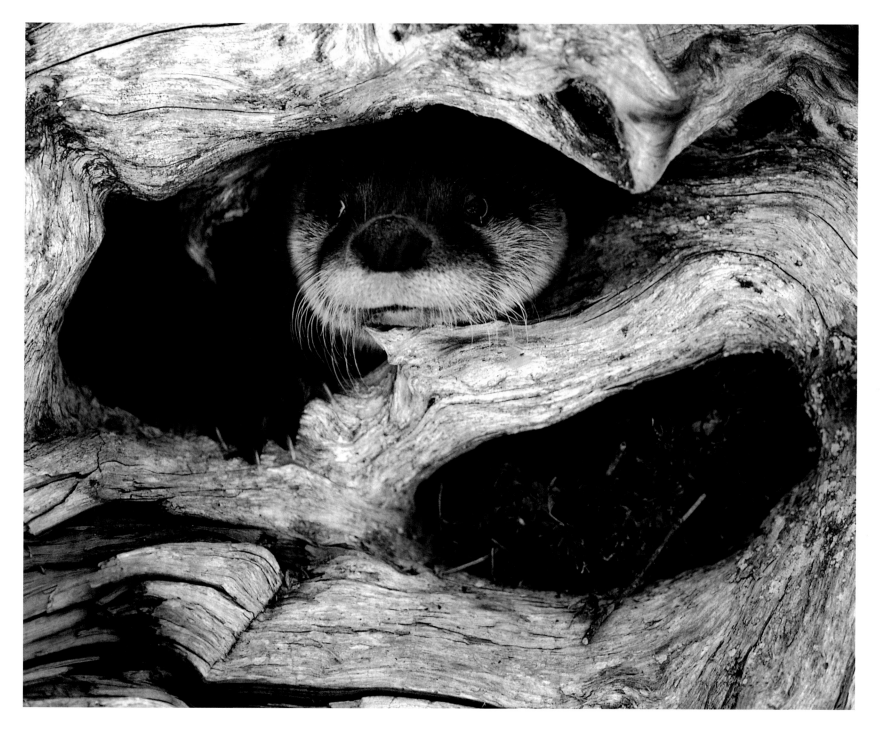

A playful river otter (Lutra canadensis),
Skagit River

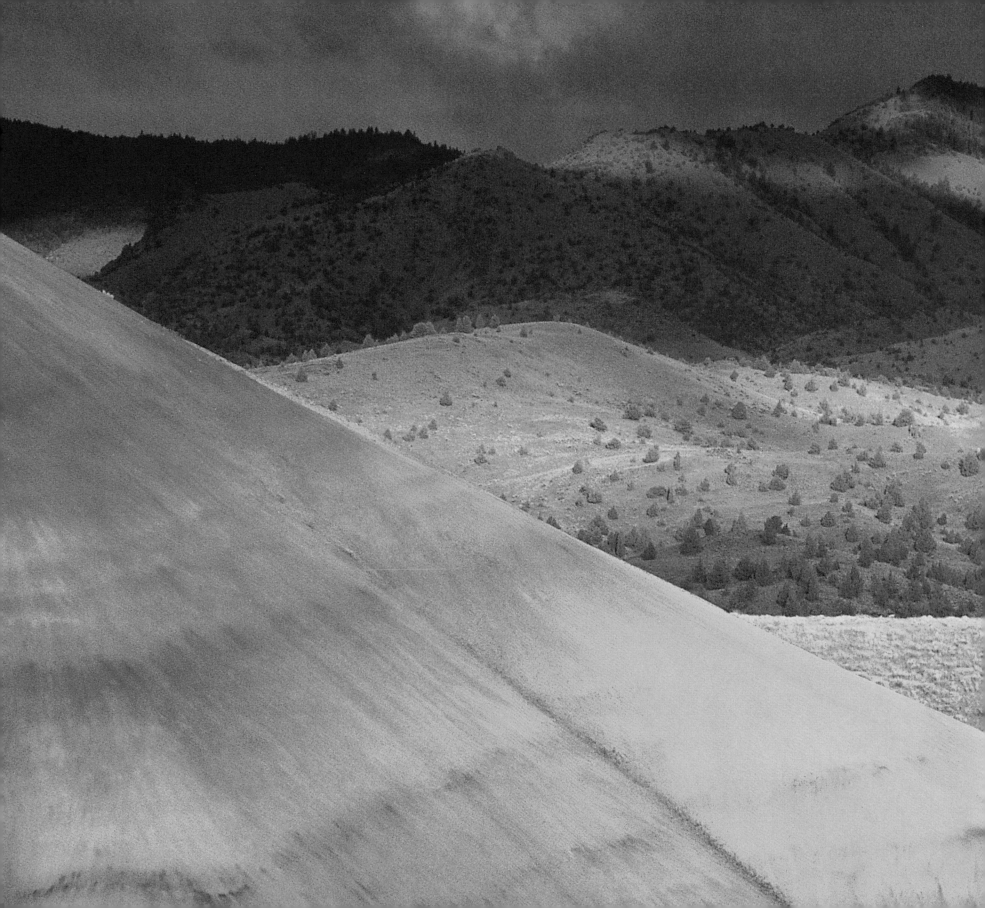

HIGH DESERT

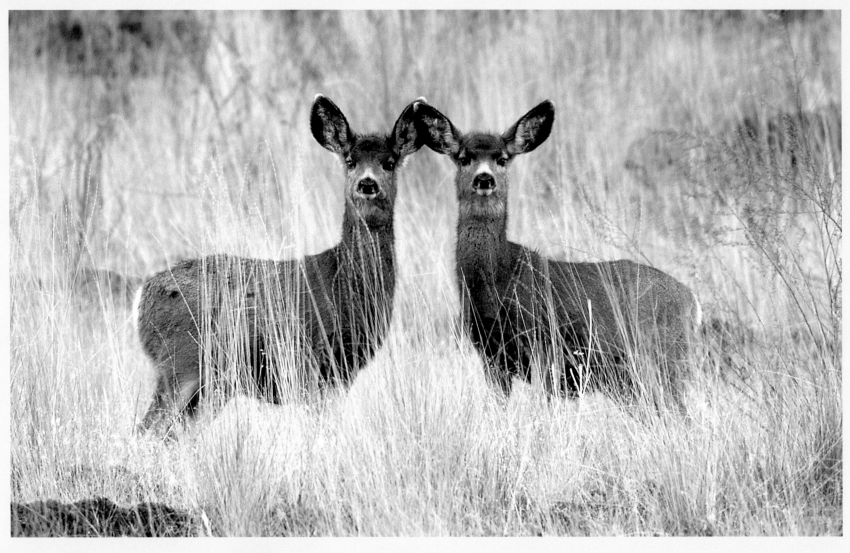

HIDDEN CHANGES

MY RETURN TO the Pacific Northwest was a circuitous journey, as meandering as the Snake River, as hallucinatory as high-desert mirages in Oregon's Painted Hills. Expecting only a rocky coast and marine mists, my first surprising glimpse of the Northwest was of desert.

But this desert was different, with its purple sagebrush and wheatgrass, mule deer and pronghorn, prairie falcon and bighorn sheep. Here in the arid, high-altitude desert of the Columbia Plateau, I barely fathomed the diversity of the complex Northwest territory I'd known as mountain, forest, and tempestuous coastline.

When outsiders imagine our Pacific Northwest, they rarely picture desert; yet the river-basin plateaus of eastern Oregon, Washington, and Idaho prairies are very much a part of our landscape. This dry country is full of life, from the waving grasses and buckwheats to the bald and golden eagles, burrowing owls, coyotes, and bobcats.

On my first visit to this high-desert country east of Bend, Oregon, I encountered rattlesnakes. Hiking near Hole-in-the-Ground, that massive, mile-wide crater created by exploding steam vents, I met up with first one, then two, then almost a dozen northern Pacific rattlesnakes, all coiled along dry coulees. I stood absolutely still, listening for the warning sound of hiss or rattle, but I heard only the desert wind with its rough whisper through withered sagebrush. It was then I remembered a story told me by a friend who had once camped here. Exploring, she and her boyfriend discovered a huge mound of earth with a pungent, feral smell. They climbed up each side of the hummock to peer inside holes carved in its round belly, only to find that here was a hibernaculum, a wintering den for snakes. Hundreds of translucent outer snake skins lay shed inside this sod house of serpents.

Once on a road trip to Walla Walla and Juniper Dunes Wilderness, I passed near the Hanford Nuclear Reservation, with its unexpected arid-lands refuge. The Rattlesnake Hills

Research Natural Area is the Northwest's largest reserve of this kind, uninfluenced by humans for the past fifty years. After enduring a nuclear power plant that once made plutonium for the Nagasaki bomb, this land has at last been left to heal itself. But these 560 miles of high desert are far from solitary. The shrub-steppe ecosystem is home to communities of native grasses and plants, to reptiles and jackrabbits, to deer and coyote. And in the Hanford Reach of the nearby Columbia River there are still salmon and soaring bald eagles. The desert animals and plants are slowly redeeming the devastation once waged here in the name of the Cold War.

I am always astonished at the eerie lunar landscapes of the Northwest's high deserts, particularly the John Day Fossil Beds National Monument in eastern Oregon. With its other-worldly painted hills that hide ancient fossil records 30 million years, this could well be another planet. Volcanic hummocks are aswirl in surreal colors: cinnamon, sepia, mauve and silver green, striated rose and coral sands, blue-violet, nutmeg, and yellow-ochre. These extravagant hills of the John Day Fossil Beds reveal time layered in volcanic ash deposits, they show us how recently we humans have arrived, and they offer some reminder of a world enduring before and beyond our presence.

For a little over ten thousand years, our species has inhabited the Pacific Northwest—from high desert to sea. Like the plant and animal species who survive here, we, too, will transform, shedding our skins into the earth that holds us, hides us, until we can change again. It is no wonder that the early fathers of the Christian tradition went into deserts to seek visions; it is no coincidence that many native American vision quests occur in the desert.

High in this spacious, clean-aired country, there are so few of us and so many millions of years of other life to contemplate, to understand that we have never been here all alone.

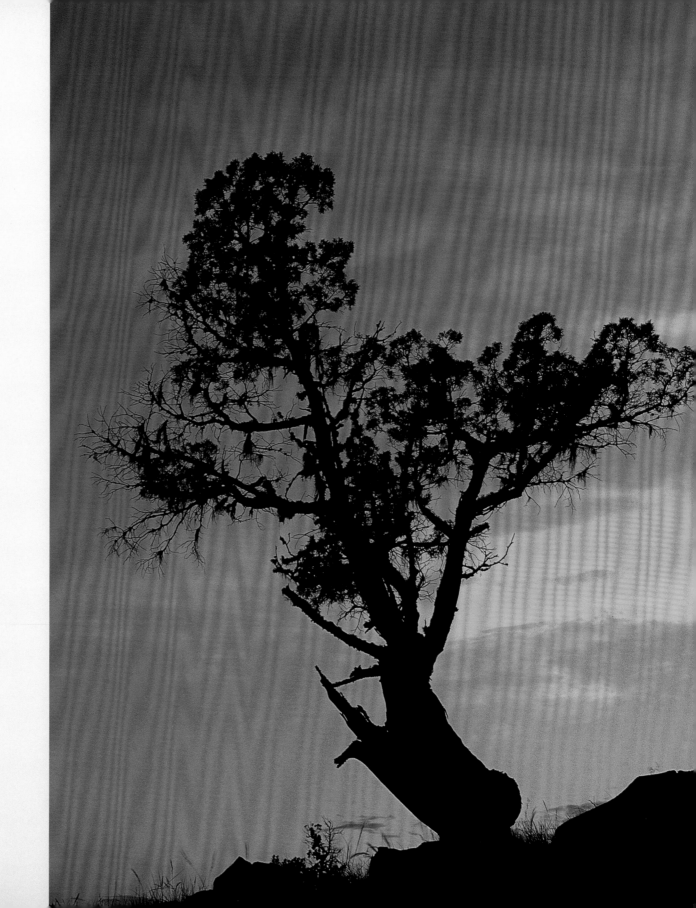

Western juniper (Juniperus occidentalis),
Umatilla National Forest, Oregon

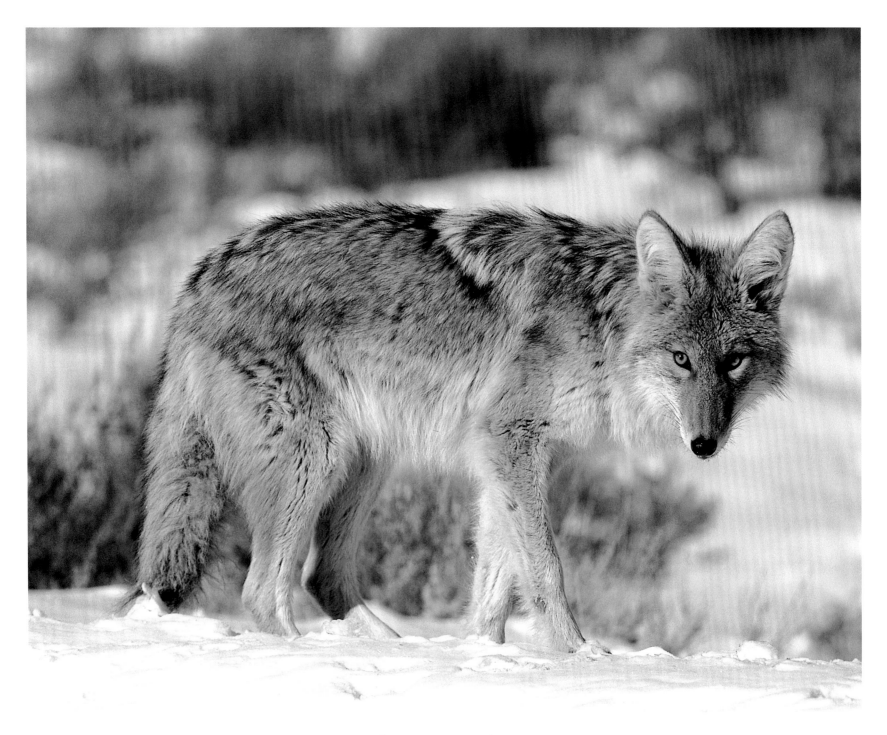

Coyote (Canis latrans), eastern Washington

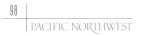
PACIFIC NORTHWEST

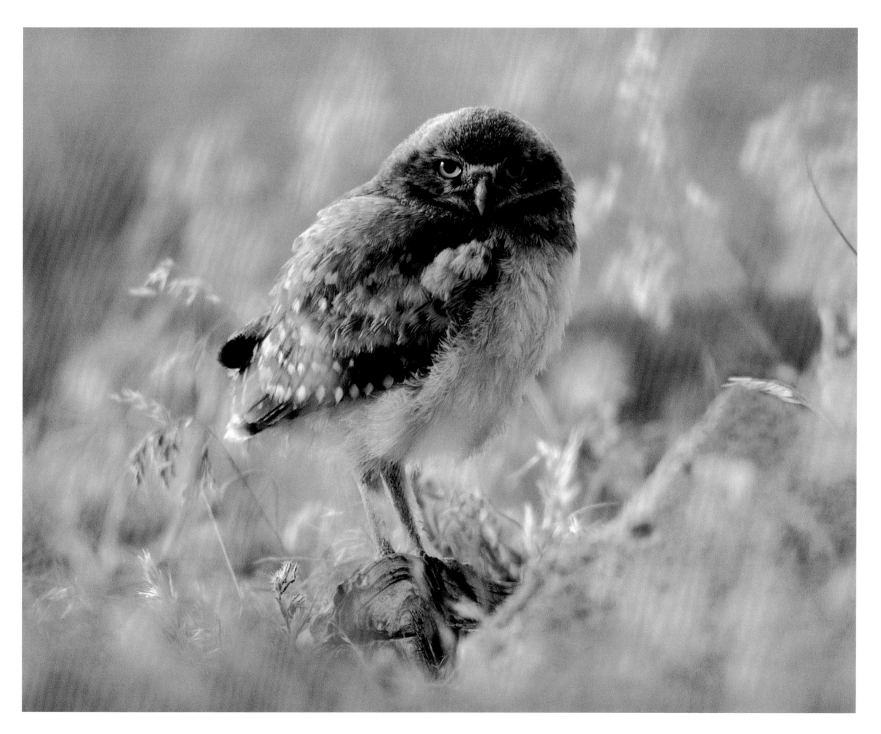

Burrowing owlet (Athene cunicularia), *eastern Oregon*

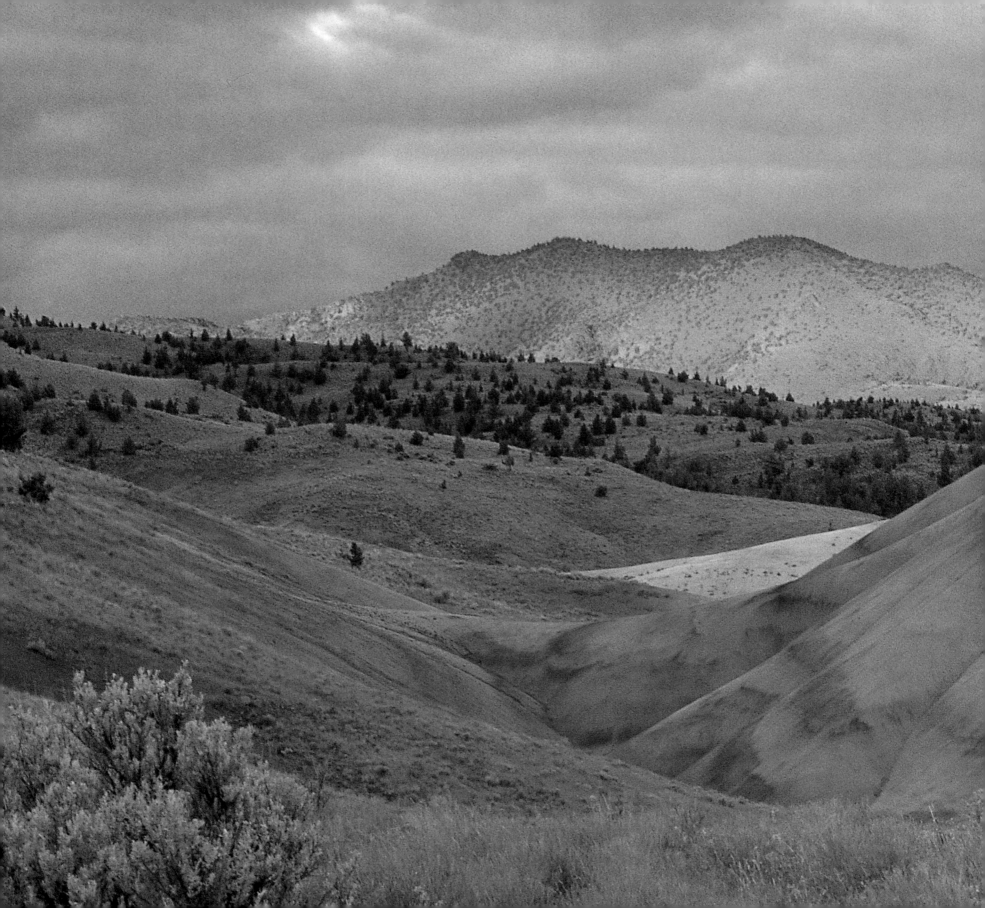

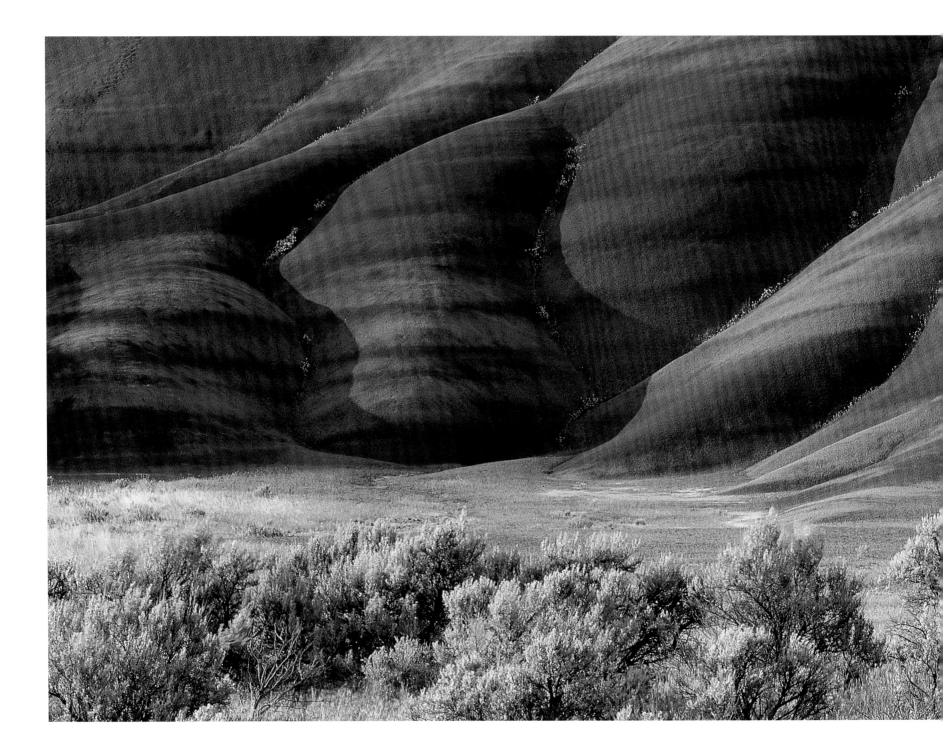

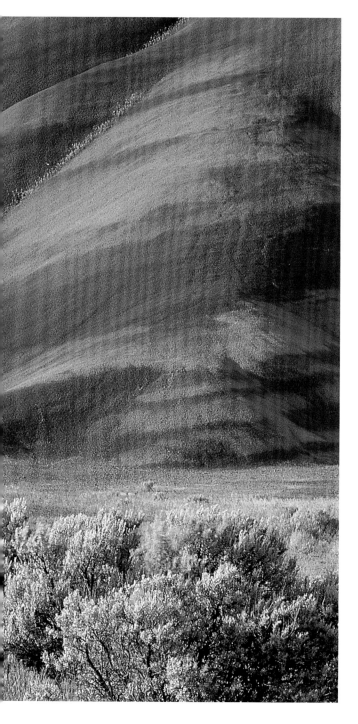

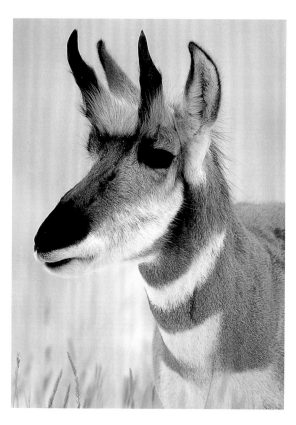

Overleaf: *Sunrise at the John Day Fossil Beds National Monument*

Left: *The Painted Hills, John Day Fossil Beds*

Right: *Pronghorn antelope* (Antilocapra americana), *Idaho*

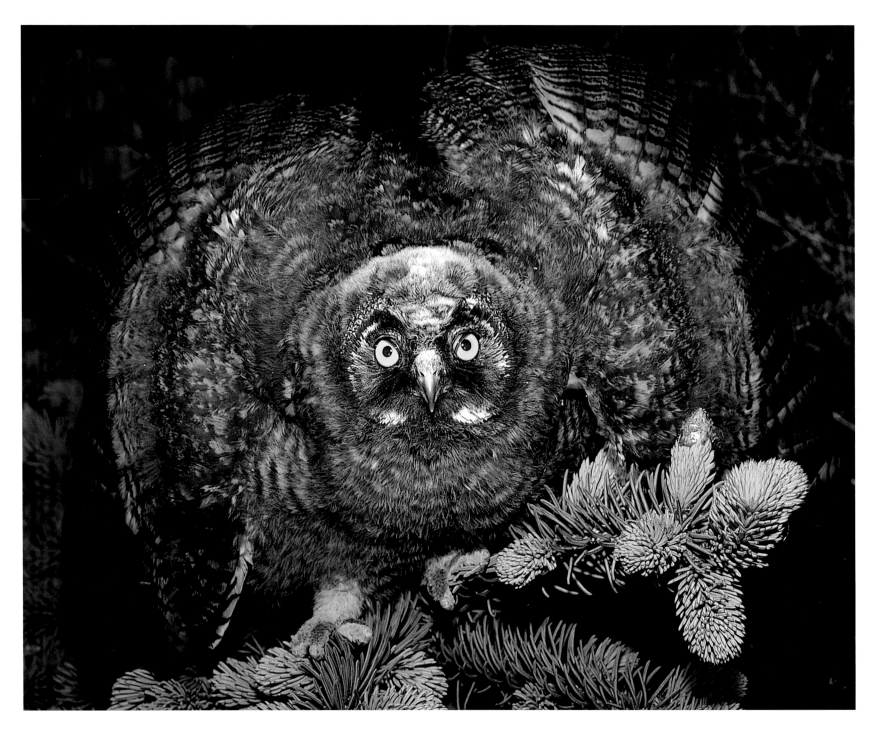

Long-eared owlet (Asio otus), Columbia Plateau, Washington

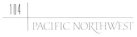

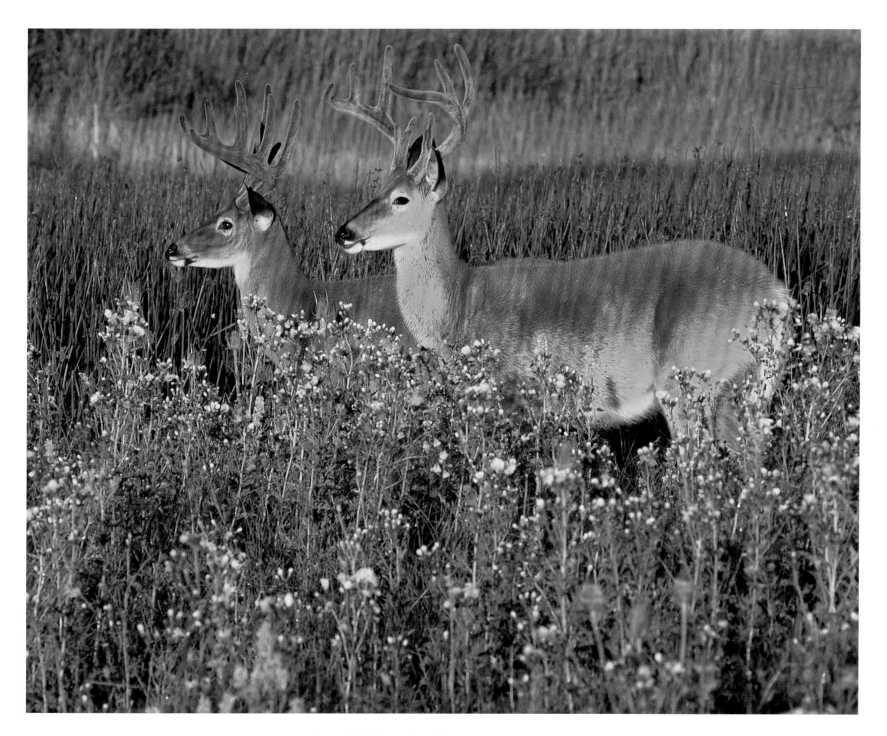

White-tailed deer (Odocoileus virginianus),
inhabitants of the high deserts of the Northwest

Striking colors of the Painted Hills, Oregon

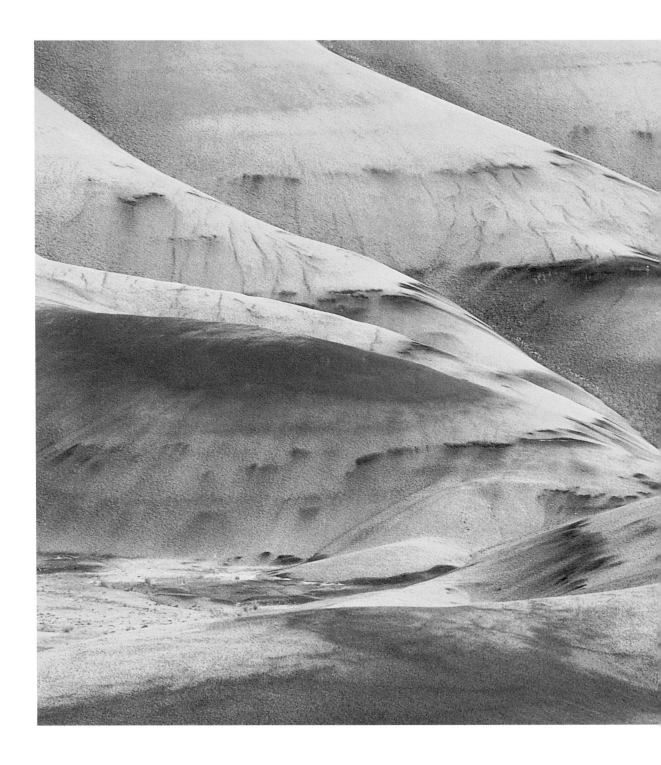

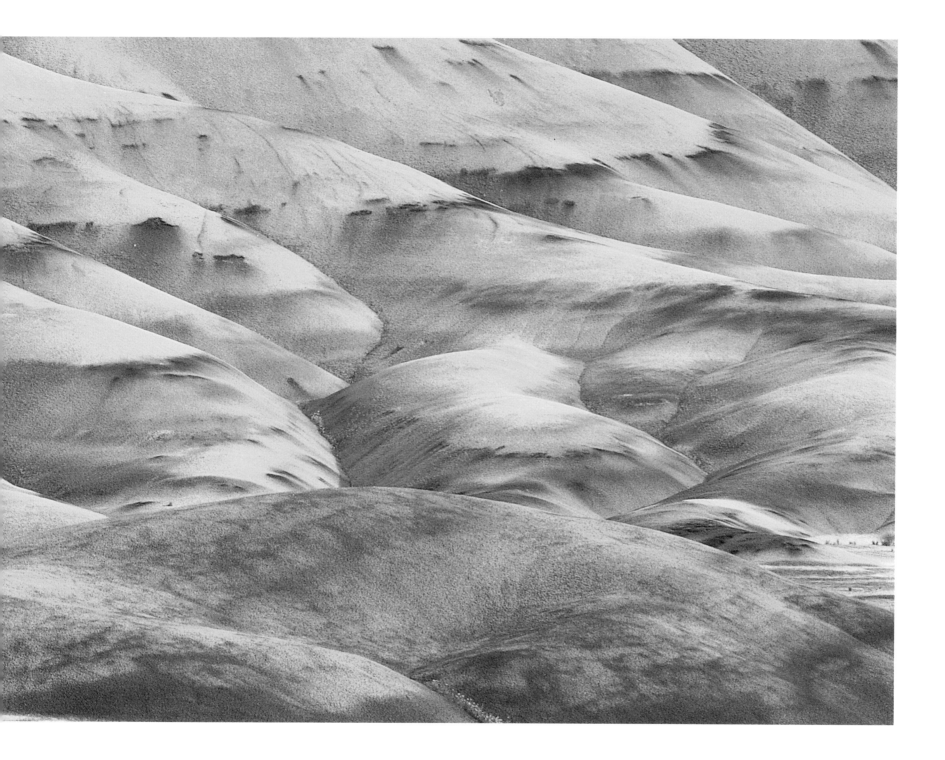

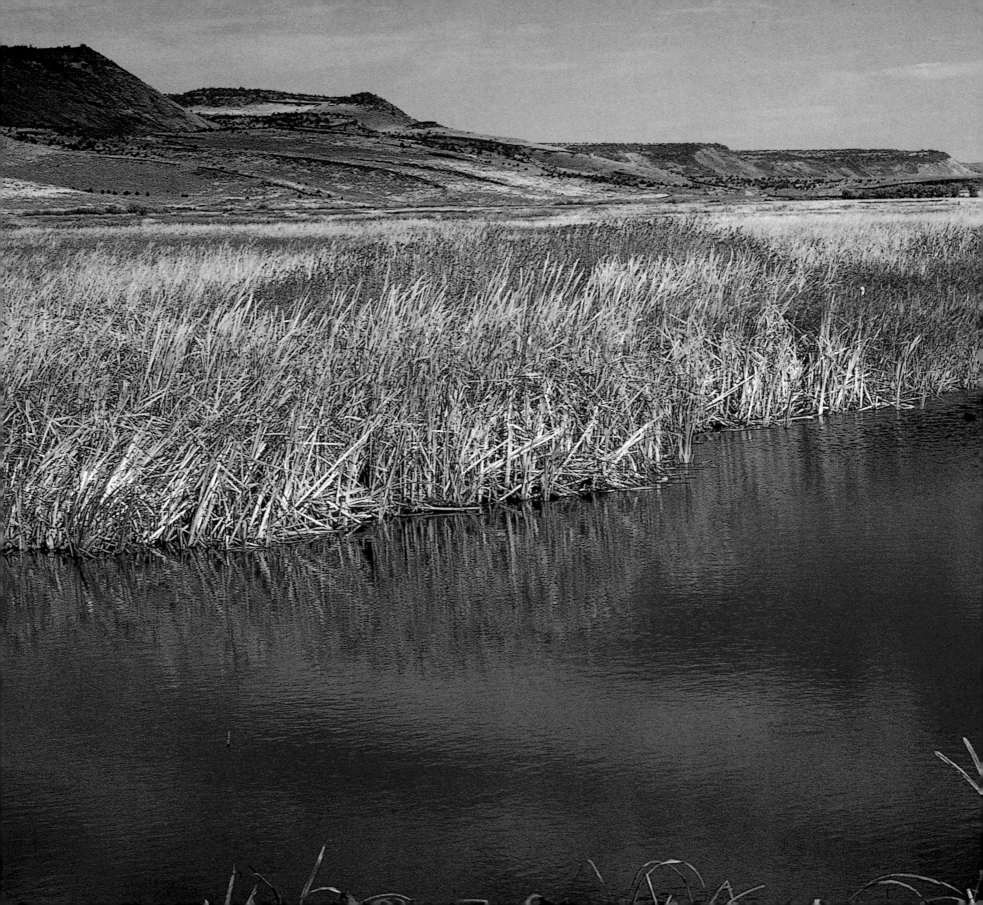

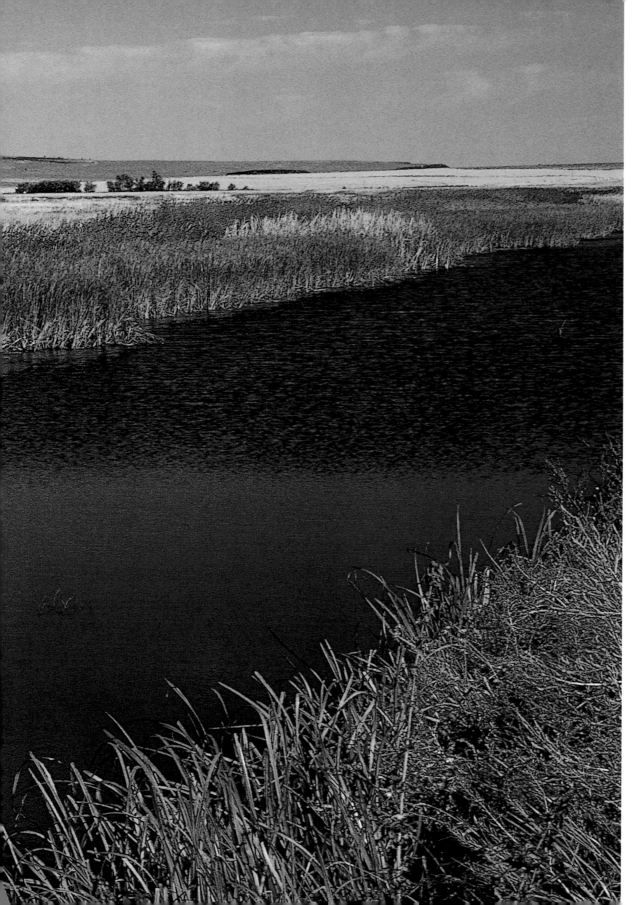

Marsh along Crab Creek, eastern Washington

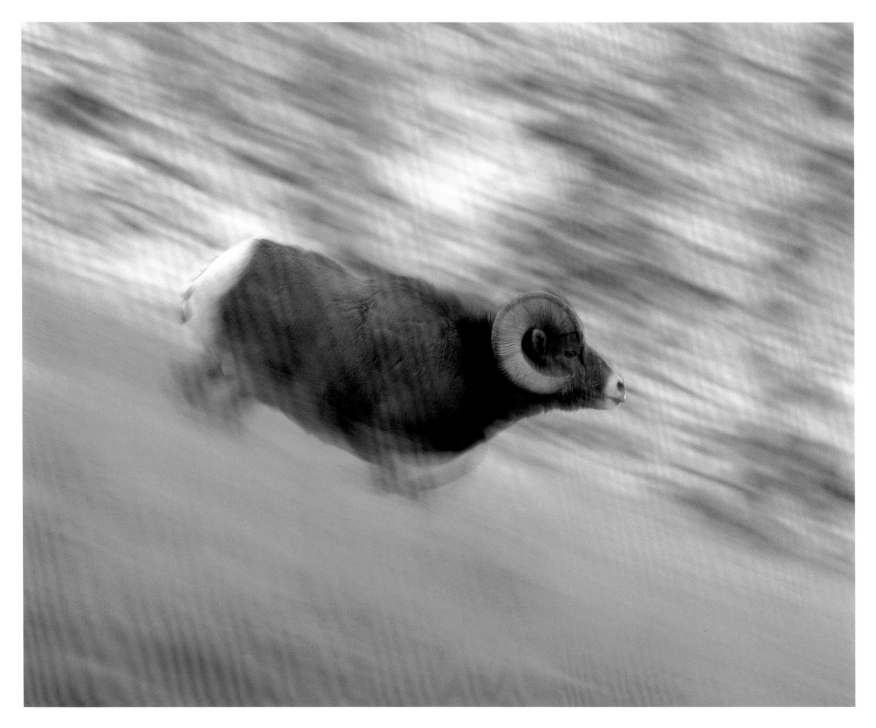

Bighorn sheep (Ovis canadensis), Colville National Forest, Washington

Badger (Taxidea taxus), *powerful burrower and predator of small mammals, eastern Washington*

Right and below: Lichens growing on basalt columns, Columbia Plateau, Washington

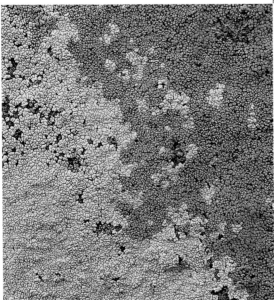

Right: *Golden spider flower* (Cleome platycarpa), *Painted Hills, Oregon*

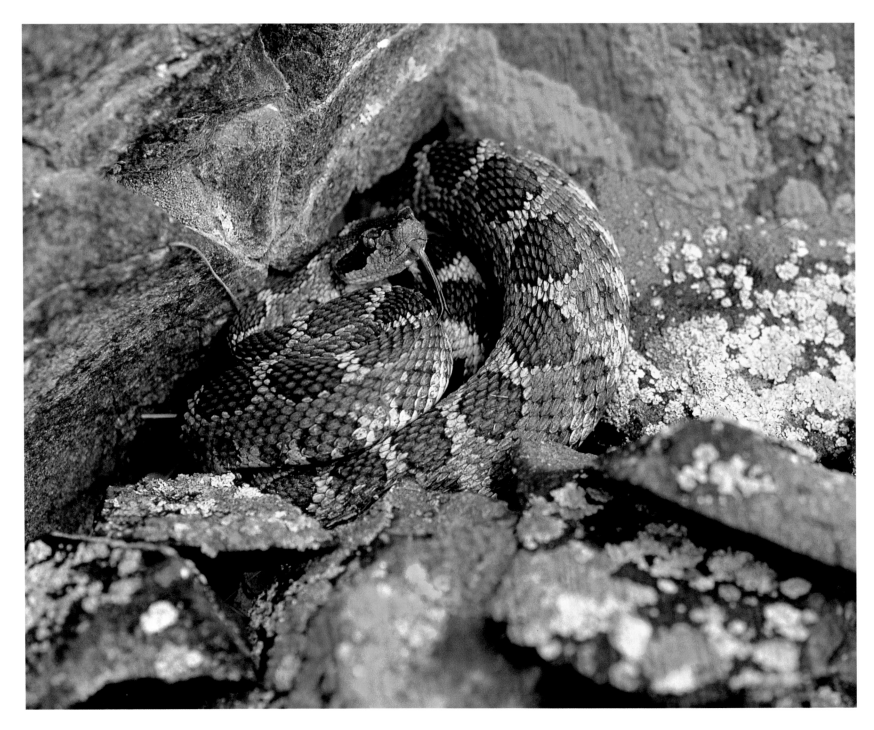

Western rattlesnake (Crotalus viridis) *hiding among rocks, Columbia Plateau*

 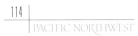

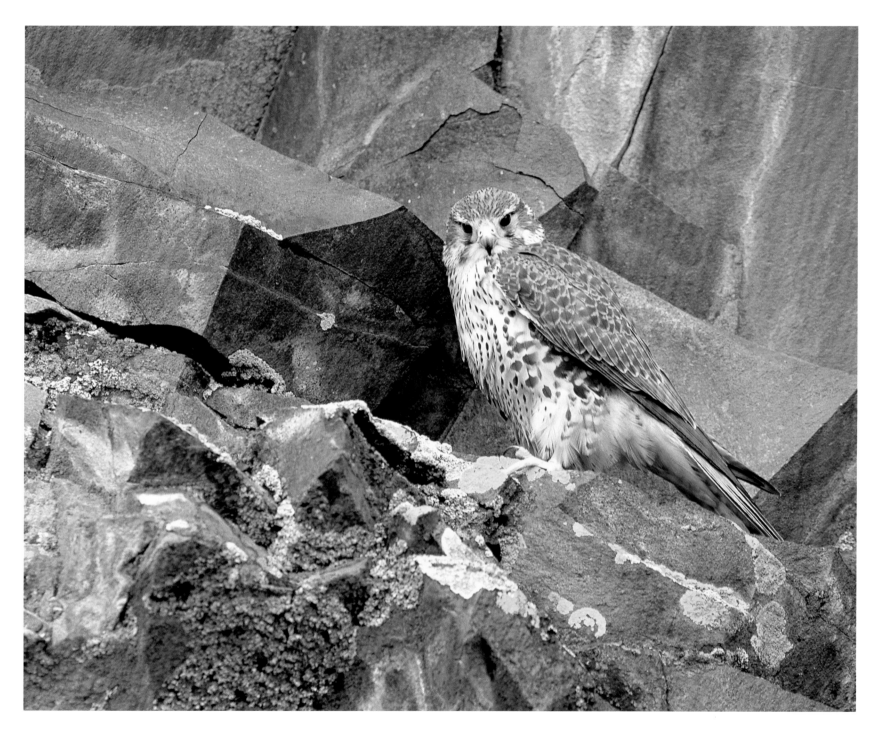

Prairie falcon (Falco mexicanus) *perched on rock ledge, Columbia Plateau*

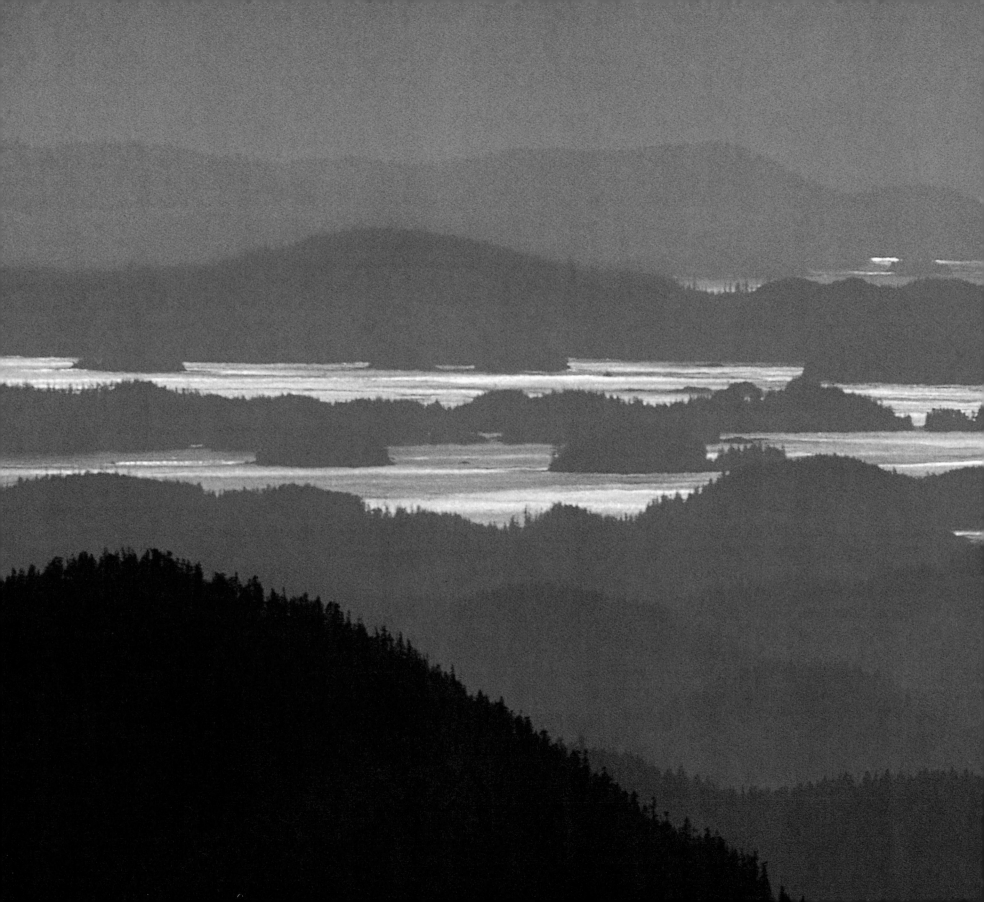

ISLAND

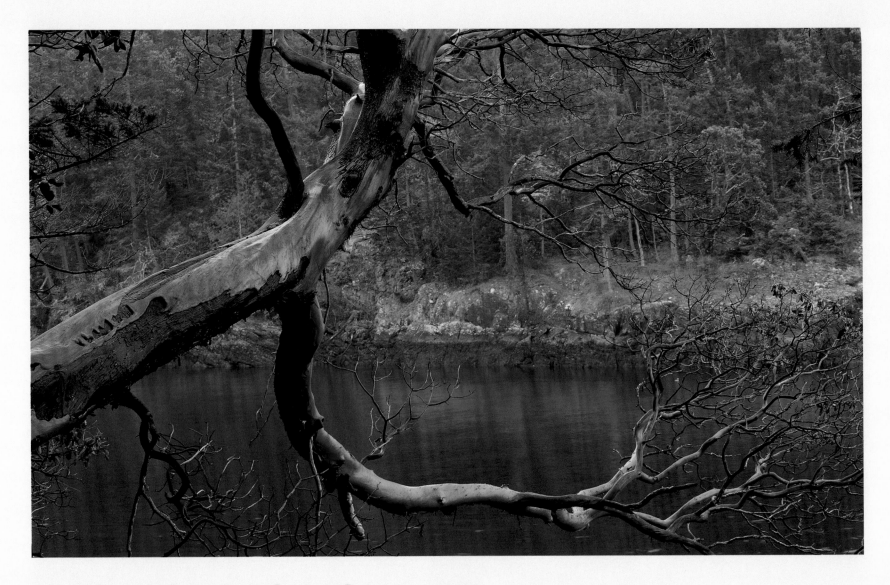

BETWEEN WORLDS WITH WHALES ⌘

ONE WINTER MORNING, lost in the gray embrace of marine mists aboard the ferry, *Walla Walla*, I sailed among the humpbacked islands of Bainbridge and Vashon. Naming the multitude of fertile islands in the Northwest is like reciting a litany—Fox, Hartstene,

Tatoosh, Destruction, Orcas, San Juan, Lopez, Queen Charlotte, Lasqueti, Vancouver, Gossip. This lovely chain of islands drapes the Northwest coast from Washington to British Columbia and on to Alaska. Here we are defined as much by water as by mainland, peninsula, and island.

There were schoolchildren aboard the ferry on a field trip to Chief Sealth's grave, with its brightly painted monument of cedar dugout canoes sailing in perfect stillness above a spirit whose name and vision still walk his beloved land. He once said, "There is no death, only a change of worlds." Every time we take island-bound ferries, we change worlds; we step into island time. To live on an island is to know our planet on its own watery terms: eighty percent of the planet is water, eighty percent of our bodies is water. Island life restores to us the fact that land is lent us by the sea, that life is more than what we can see from any mainland.

Suddenly a schoolchild yelled out, "Look! Over there."

Everyone ran to one side as the captain announced, "Starboard, looks like J or L pod. They journey down here every winter to feed. They're like our Christmas presents."

The cloudbanks of marine air blended with the foggy exhalations of orcas as at least six whales swam near us, their black dorsal fins tall as masts of an animal armada. Sleek and steady, they surfaced for air and then dove deep, tail flukes slapping the waves. I had not been this close to orcas for several months, not since my autumn journey to Hanson Island on the rugged coast of British Columbia. Dr. Paul Spong, with his research partner and wife, Helena Symonds, had ferried me in a motorboat across Johnstone Strait to their island home.

Overleaf: *Johnstone Strait, east coast of Vancouver Island, British Columbia*

Left: *Pacific madrone tree* (Arbutus menziesii) *and shoreline of Salt Spring Island, British Columbia*

Right: *Immature Sitka spruce cones* (Picea sitchensis), *Vancouver Island, British Columbia*

Uninhabited except for the Spong family and other research assistants, Hanson Island is the site of OrcaLab, famous for its innovative and noninvasive study of the whales. I had traveled there at the invitation of Kelly Balcomb, who, along with his father, Ken Balcomb of the Friday Harbor Center of Whale Research, has studied the southern resident orca pods around San Juan Island for decades. Kelly has literally lived the life of the *Free Willy* boy. As nature photographers, he and his father have documented individual orcas in a comprehensive photo identification scientific study.

The northern orca pods accompanied our motorboat as it chugged through turbulent Johnstone Strait, while Kelly and Helena caught up on news. In between talk of a new all-whale-sounds Vancouver, B.C., radio station—ORCA-FM—they spotted familiar orca families.

"Oh, there's A16," Helena said, pointing to the matriarch as she surfaced with her sons and daughters alongside. "That's Strike, she's Corky's mother," Helena explained to me.

I asked how she could tell the orcas apart. "Long study," she laughed, "and decades of really listening."

In their island lab, hydrophones echo with the sweet mewling and rusty-hinge vocalizations of orca dialect at any hour of the day or night. For the past seventeen years, Symonds and Spong have lived on this island, studying orcas and listening to what Helena calls "sound sculptures."

From every room of their sprawling cabin, they listen and record orca vocalizations. Hydrophones even hang from the moss-slung trees and the outhouse roof. Known as "the Jane Goodall of orcas," Helena can identify hundreds of orcas simply by hearing their signature calls.

Left: *Blood stars* (Henricia leviuscula) *and a six-ray sea star* (Leptasterias hexactis), *Barkley Sound, west coast of Vancouver Island*

Right: *Harbor seal* (Phoca vitulina), *San Juan Islands, Washington*

"The dialect of any clan or pod is so distinct, and the pod's signature whistle comes from the mother—a matrilineal acoustic heritage," she explained.

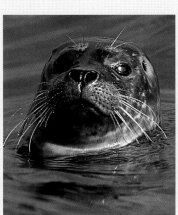

"Remember how big-brained these orcas are, how sophisticated their societies, language, and strategies for survival. Theirs is an utterly nonviolent society . . . the matriarchs really keep control of any aggressive urges or acting out by their offspring. The female offspring will eventually form their own subpod, but the males stay with their mothers all their lives—and in the wild that can be up to seventy years."

As the orcas surrounded us, our little boat was sometimes lost in the mist of their steady breaths—huge, explosive exhalations and their fast intake of air. Like us, these orcas form strong family bonds and complex societies based on cooperation. While they are misnamed "killer whales" because they prey on other mammals such as seals and sea lions, there has never been an incident of a wild orca harming a human. And they do not make war on their own kind—unlike us.

"We just don't see displays of dominance," Helena said, as the boat rocked with the waves made by breaching orcas. "Orcas are self-contained, self-aware, and self-confident. Their identities are strongly developed—the matriarchs make sure of that. What strikes me about orcas is how focused they are, despite all our disturbances. They have the power to maintain themselves, their own society." She waved a hand to again include Strike and her offspring, then laughed. "I suspect it doesn't take a lot of energy on their part to take us humans in. They can easily grasp us and keep on going."

The splendor of these orcas, these island commuters who sometimes join us on our ferry trips to and fro, from land to matriarchal sea, is a mystery made of the elements of solitude and community. As islands belong to sea, as we belong to each other and our families, as the orcas belong in their pods, all that is living longs to connect after long separation. Islands, like orcas, teach us how to cast off from the mainland, to surface, breathe deeply, and sail securely between a change in worlds. ☙

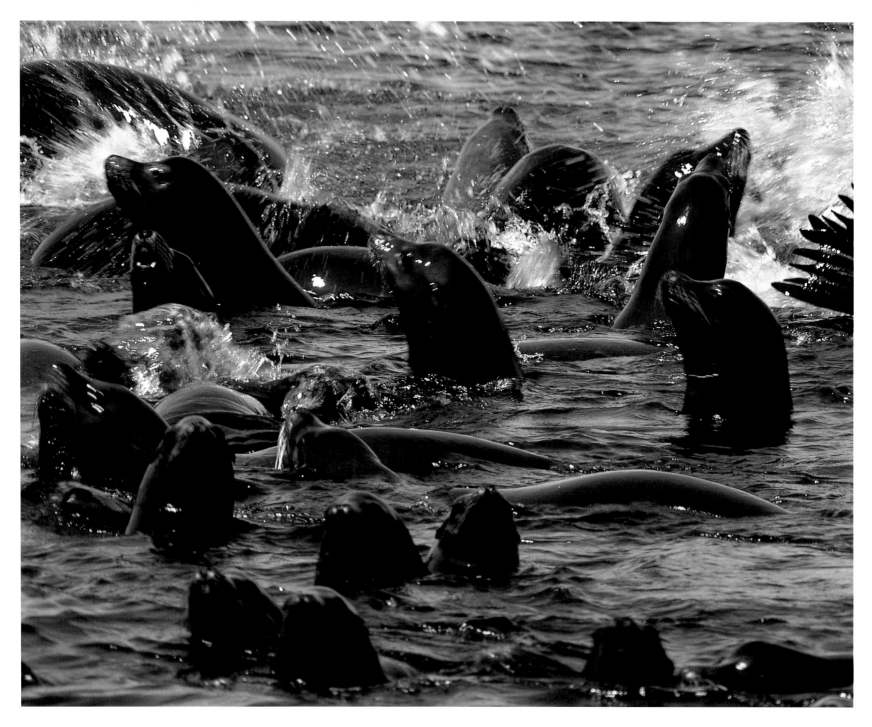

Steller sea lions (Eumetopias jubatus),
Barkley Sound, Vancouver Island

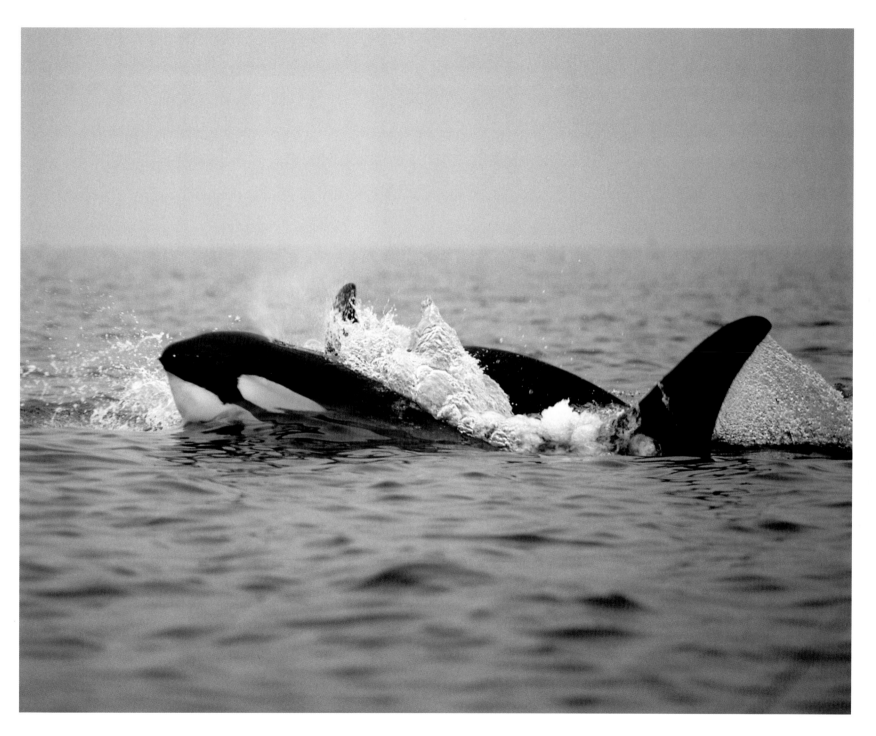

Orcas (Orcinus orca), San Juan
Islands, Washington

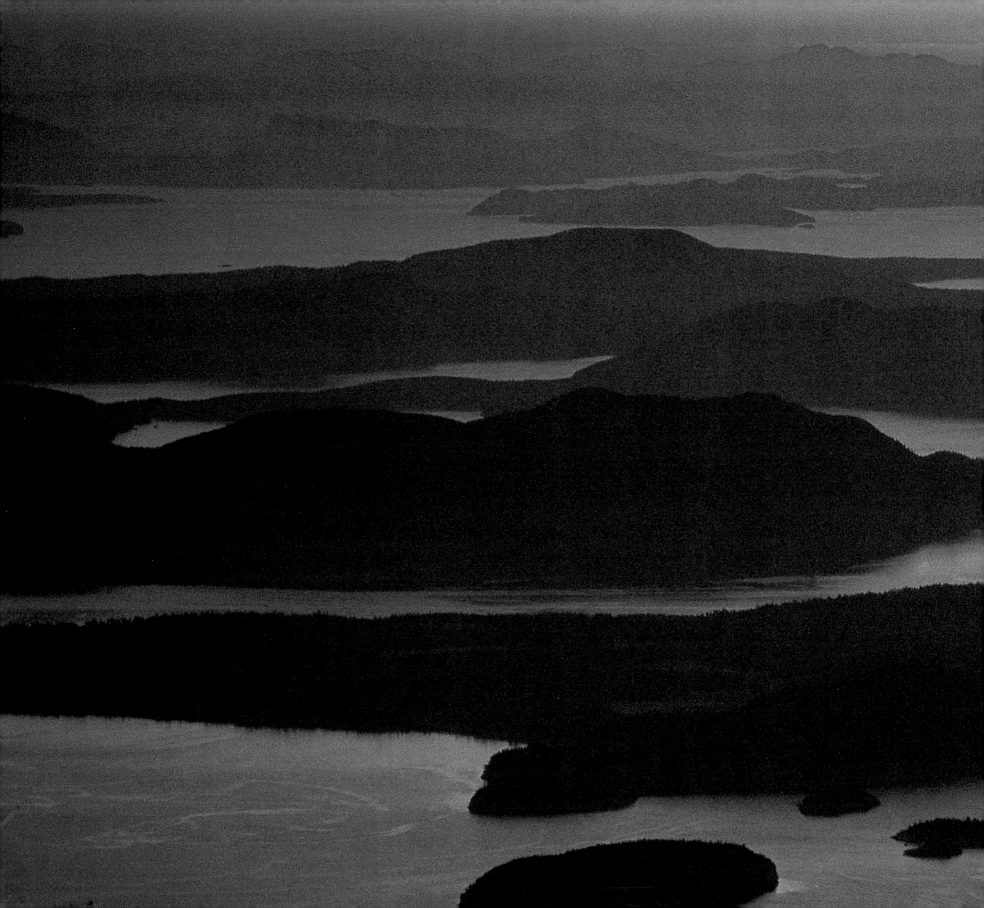

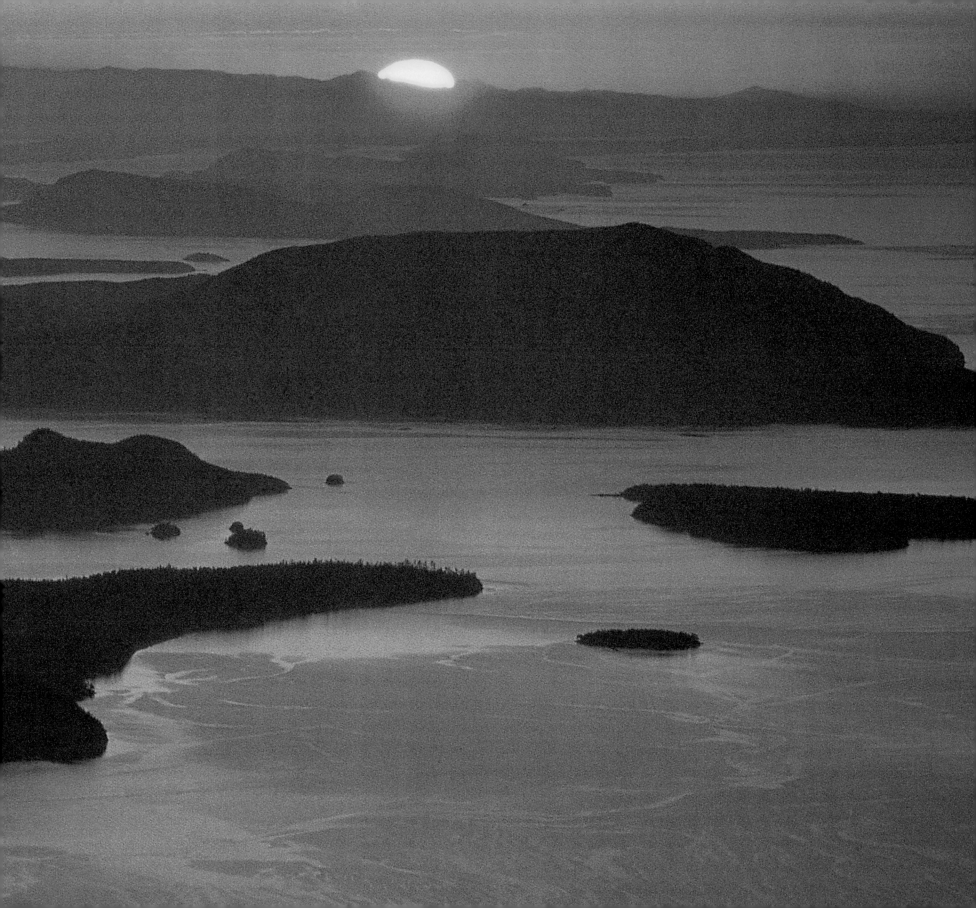

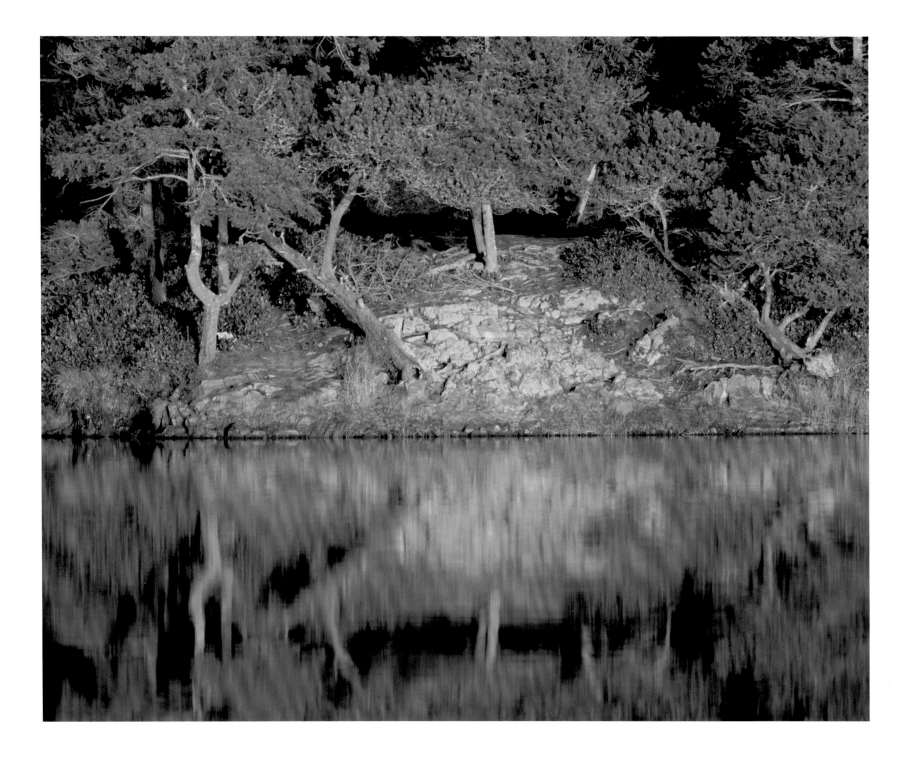

PACIFIC NORTHWEST

Left: Windswept Pacific madrone trees (Arbutus menziesii), *Orcas Island, San Juan Islands*

Below: Pacific madrone tree bark, San Juan Islands

Overleaf: Sunset over the San Juan Islands, Vancouver Island on the horizon

Left: Cranberry Lake on Whidbey Island, Puget Sound, Washington

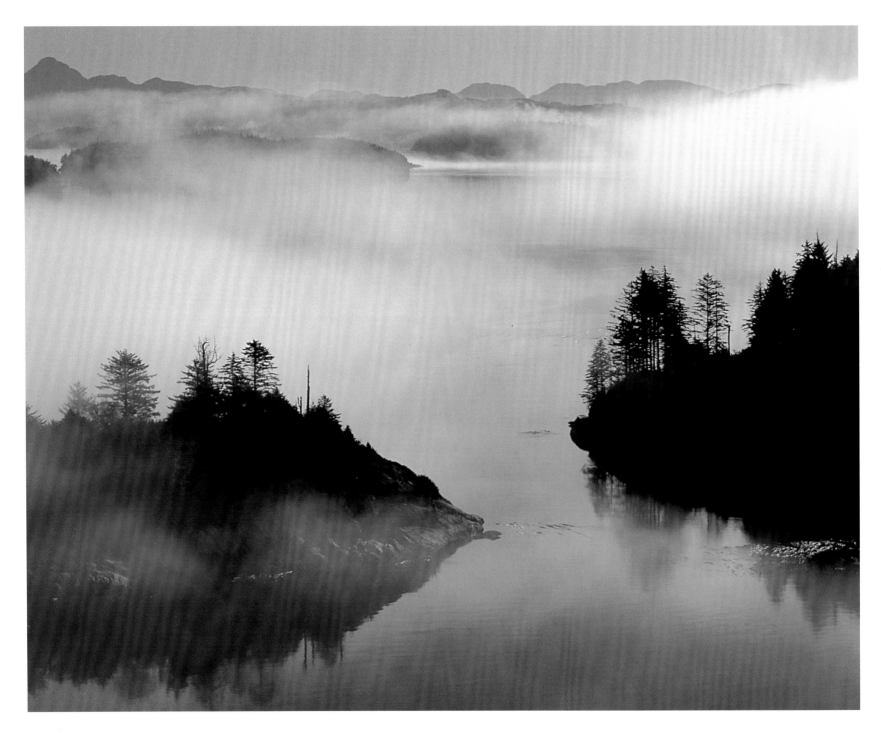

Johnstone Strait in the Inside Passage, east coast of Vancouver Island

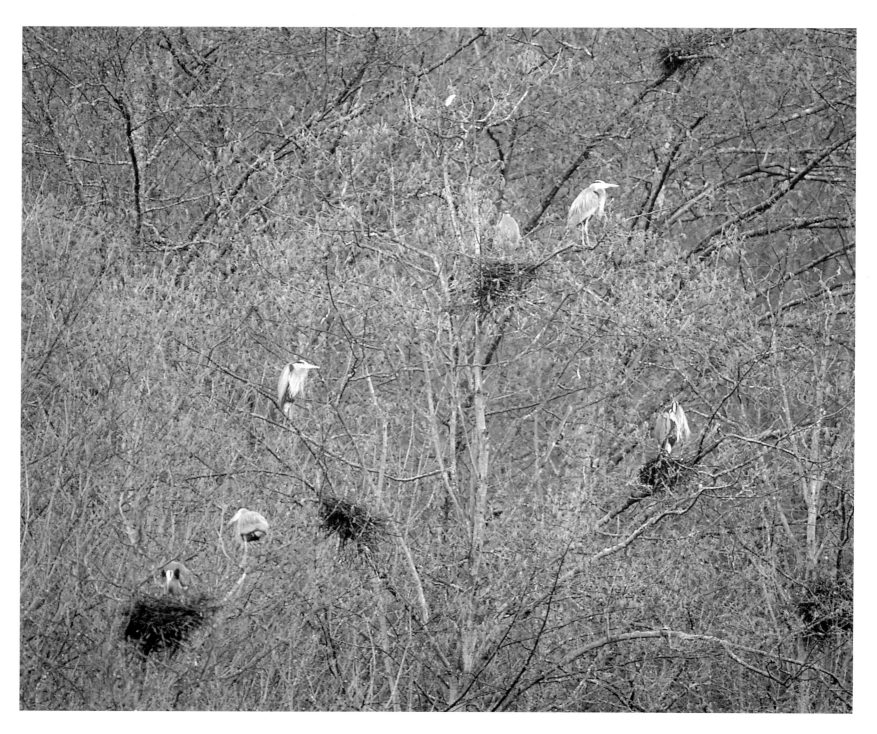

Great blue heron (Ardea herodias)
rookery, Fidalgo Island, San Juan Islands

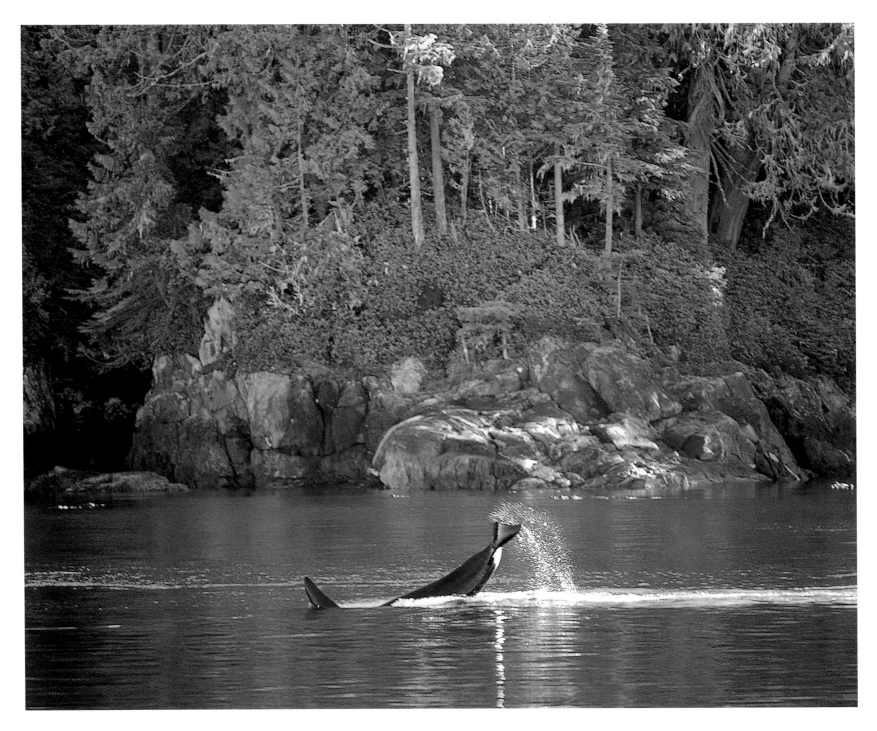

Orca (Orcinus orca) showing tail-slapping behavior, Johnstone Strait

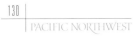

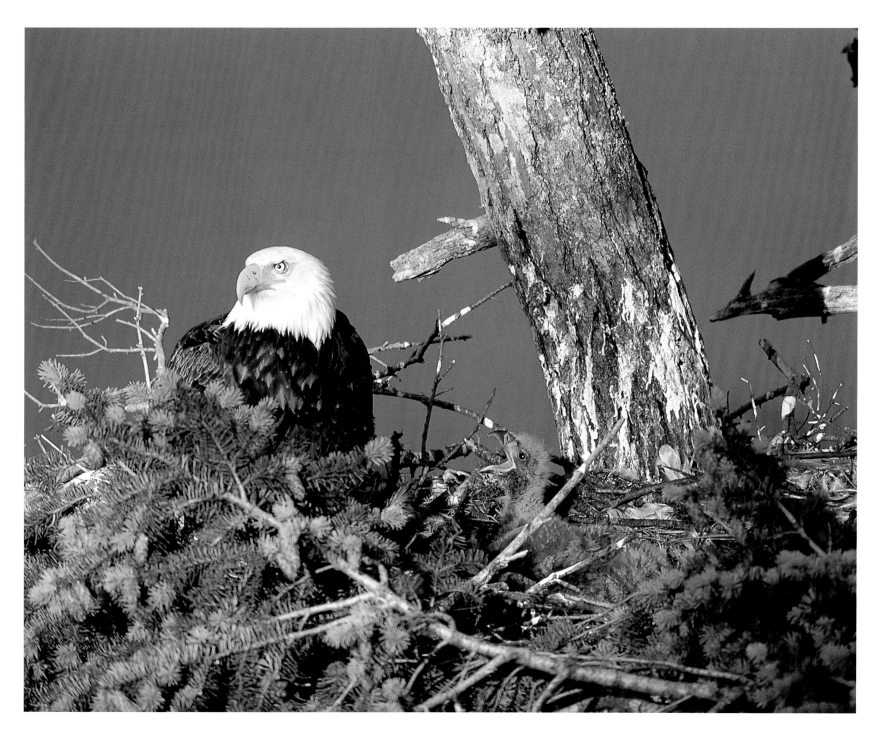

Bald eagle (Heliaeetus leucocephalus) *adult and nestling, San Juan Islands*

Right: *Male wood duck (Aix sponsa), San Juan Islands*

Below: *Great blue heron (Ardea herodius), Fidalgo Island*

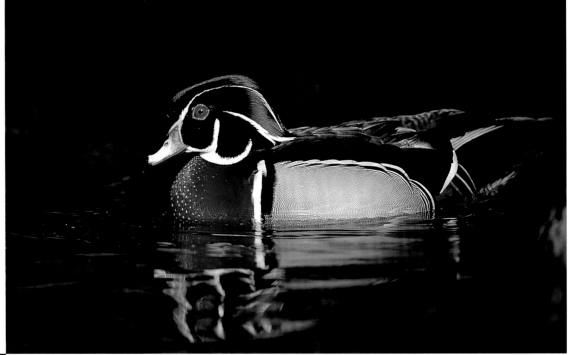

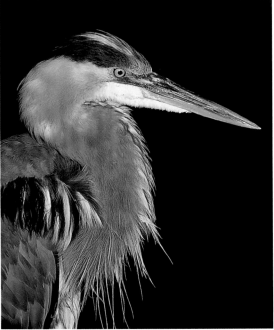

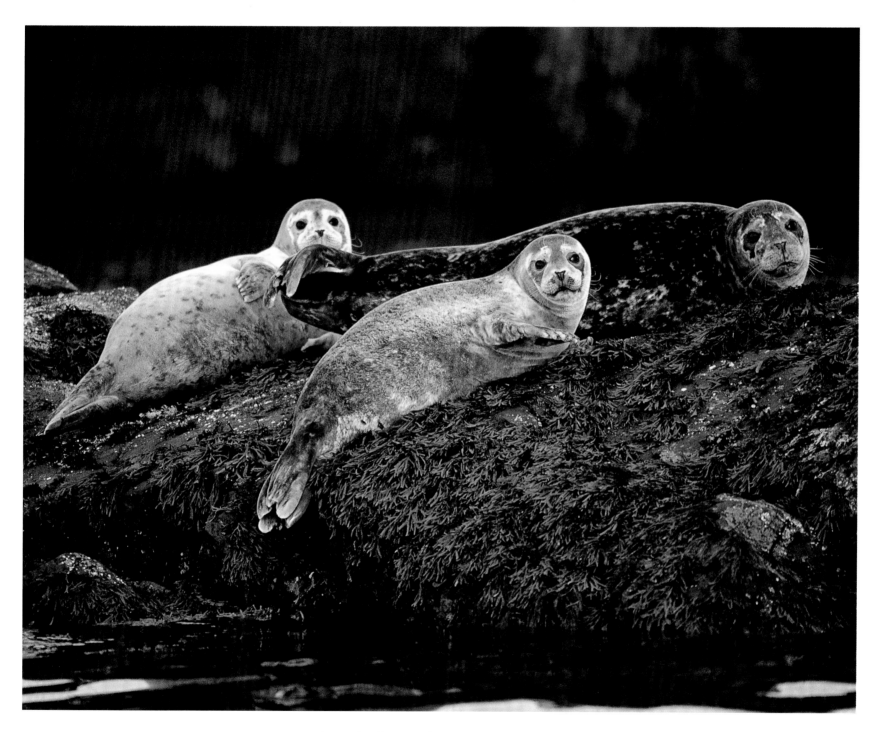

Harbor seals (Phoca vitulina), *Vancouver Island*

Aerial view of an alpine lake in the northern Cascades, looking west toward Puget Sound and the San Juan Islands

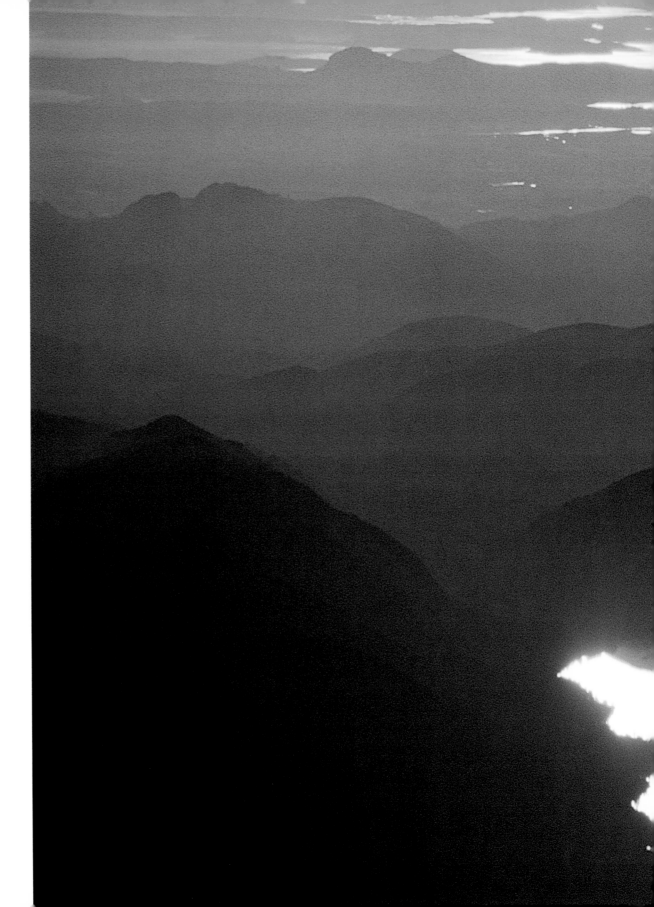

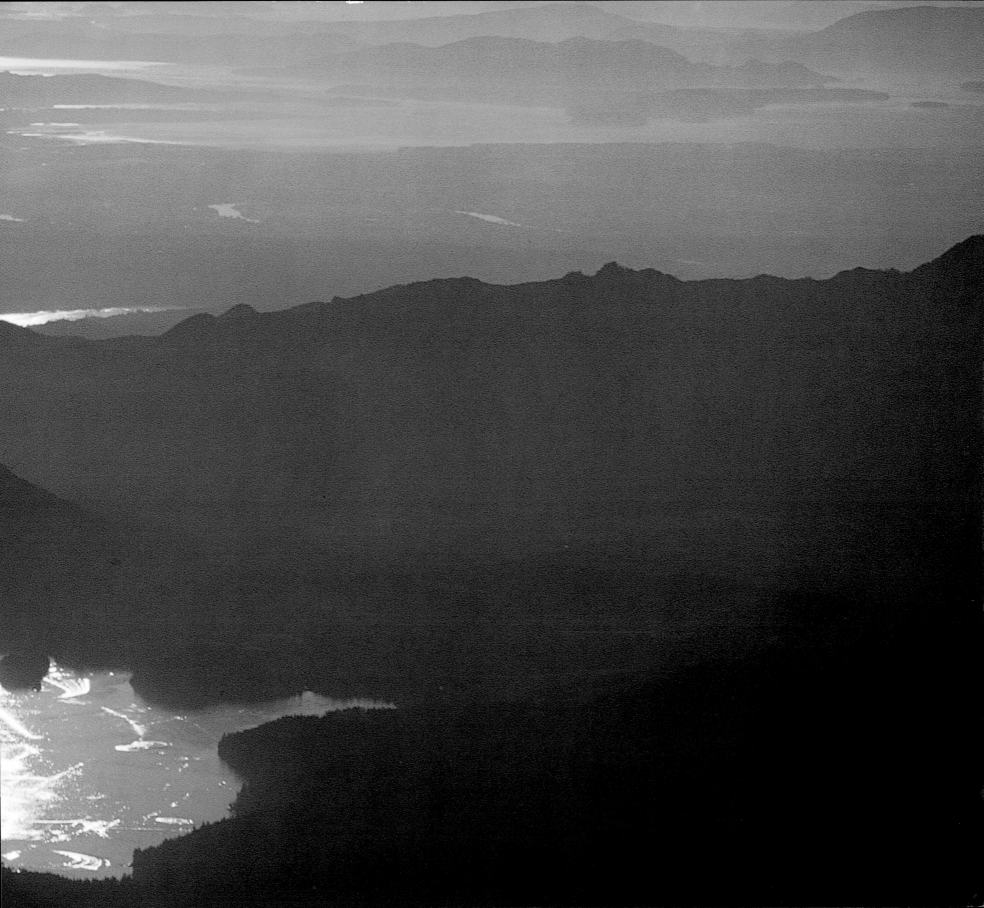

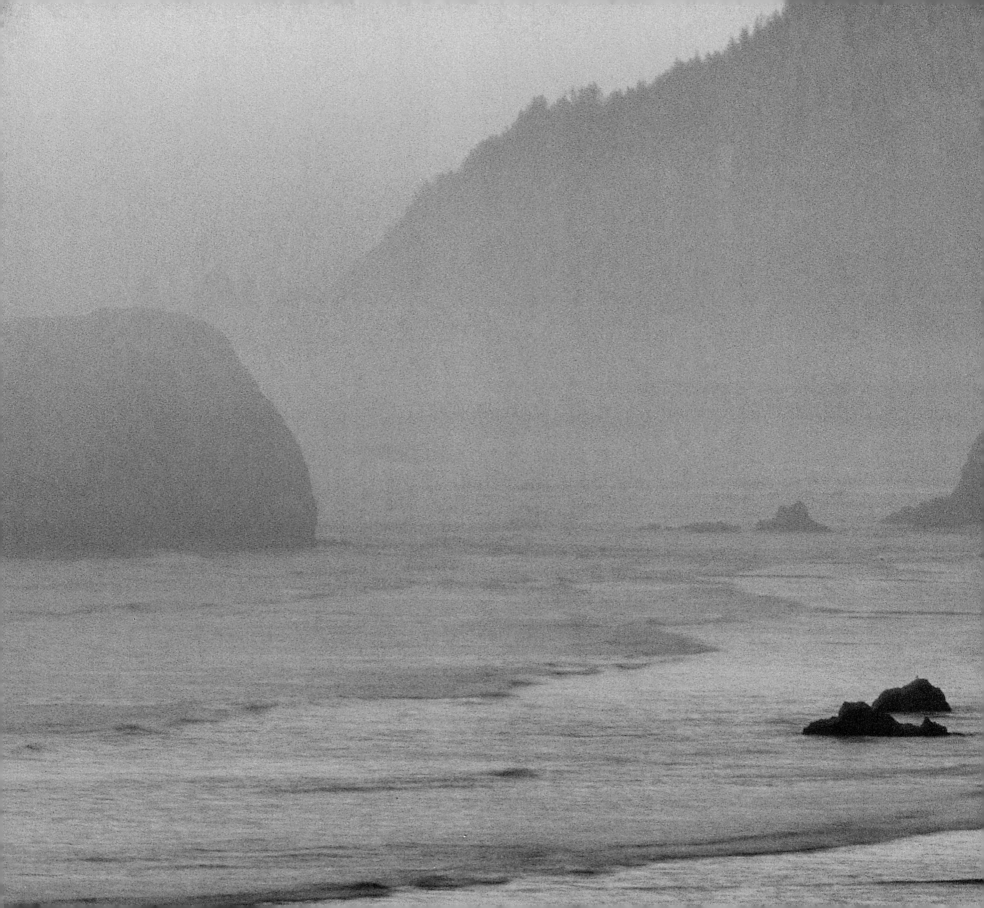

OCEAN & SOUND

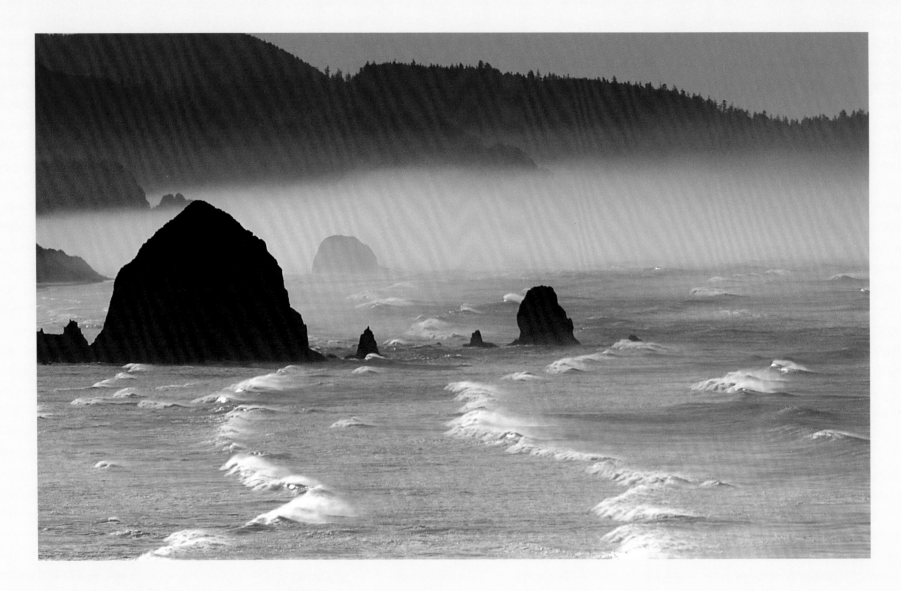

WATER IS OUR WAY ∞

IMAGINE THAT YOU are on the wind-swept, sibilant shores of Puget Sound. It is high tide and the late summer light slants along the waves to make a shining path, which the old amphibian in us longs to follow—if only our land legs could remember the balance and flow

Right: *Nesting peregrine falcon (Falco peregrinus), eastern shoreline of Puget Sound*

Below: *Wave-washed rocks, Skagit Bay, Puget Sound*

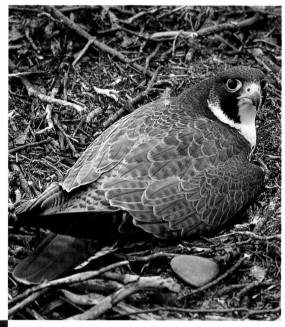

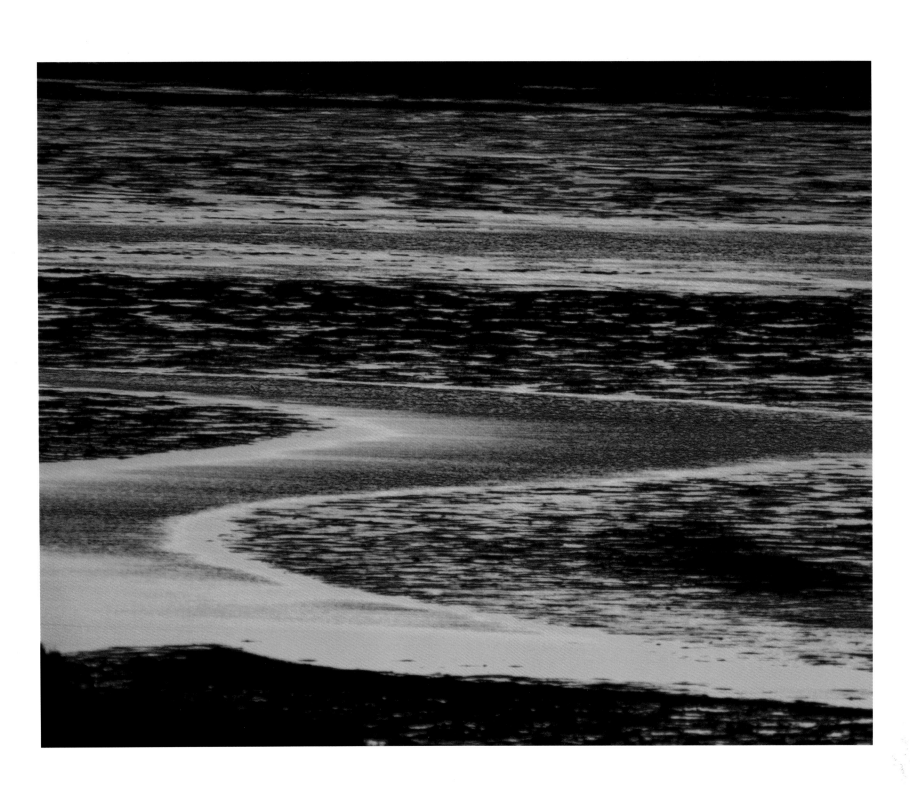

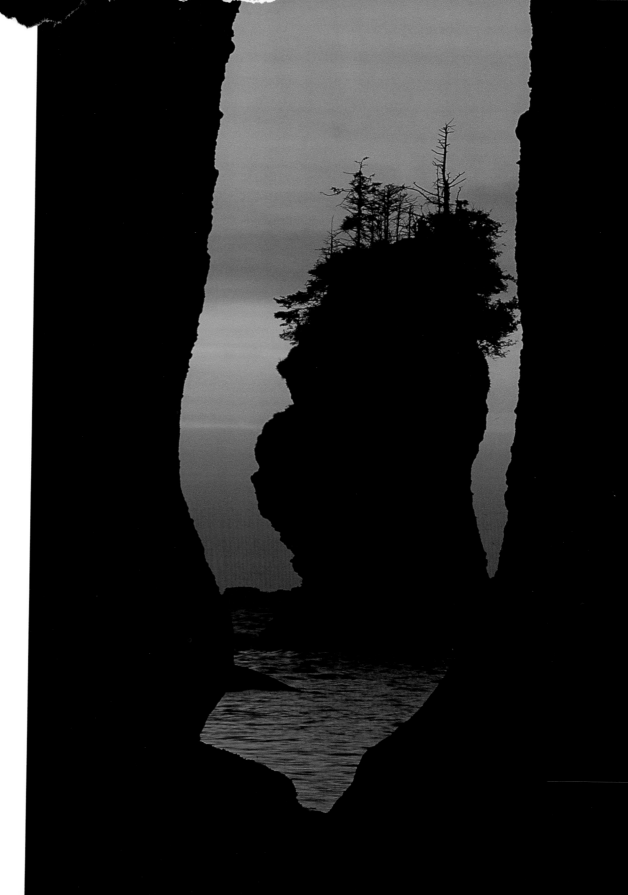

Left: *Tidal flats catching the last light of day, Washington*

Right: *Sea stack on Cape Flattery, the farthest northwest point in Washington*

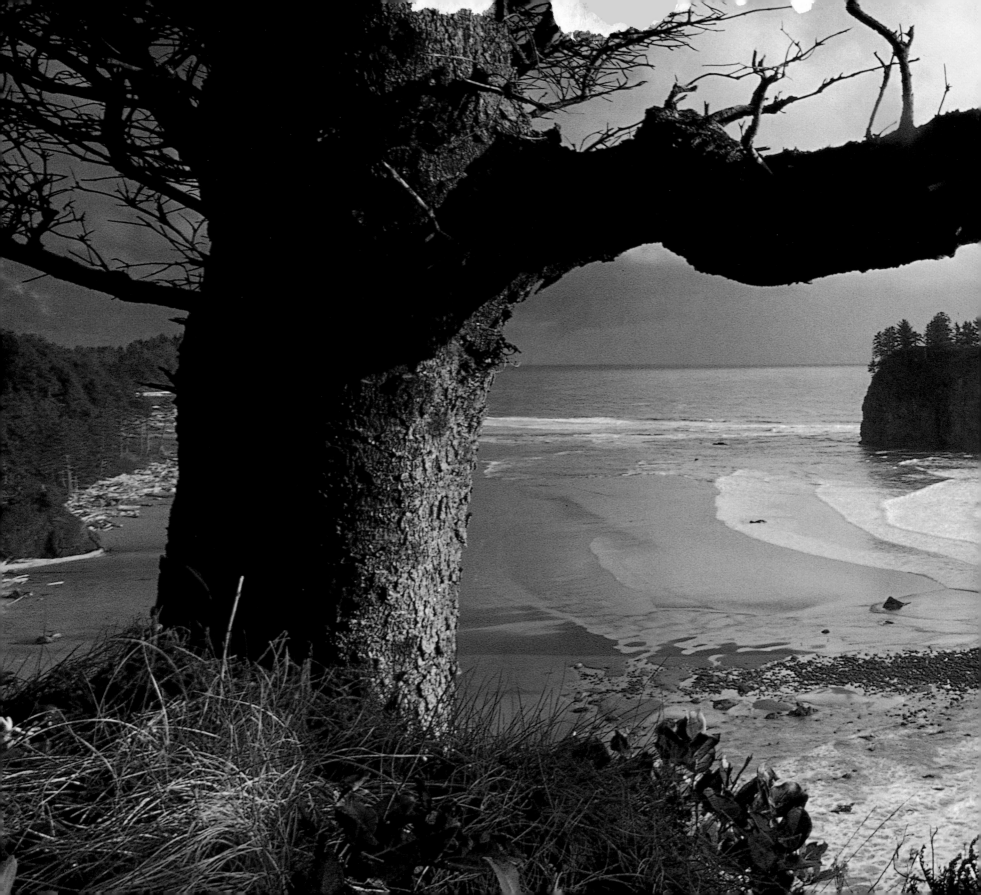

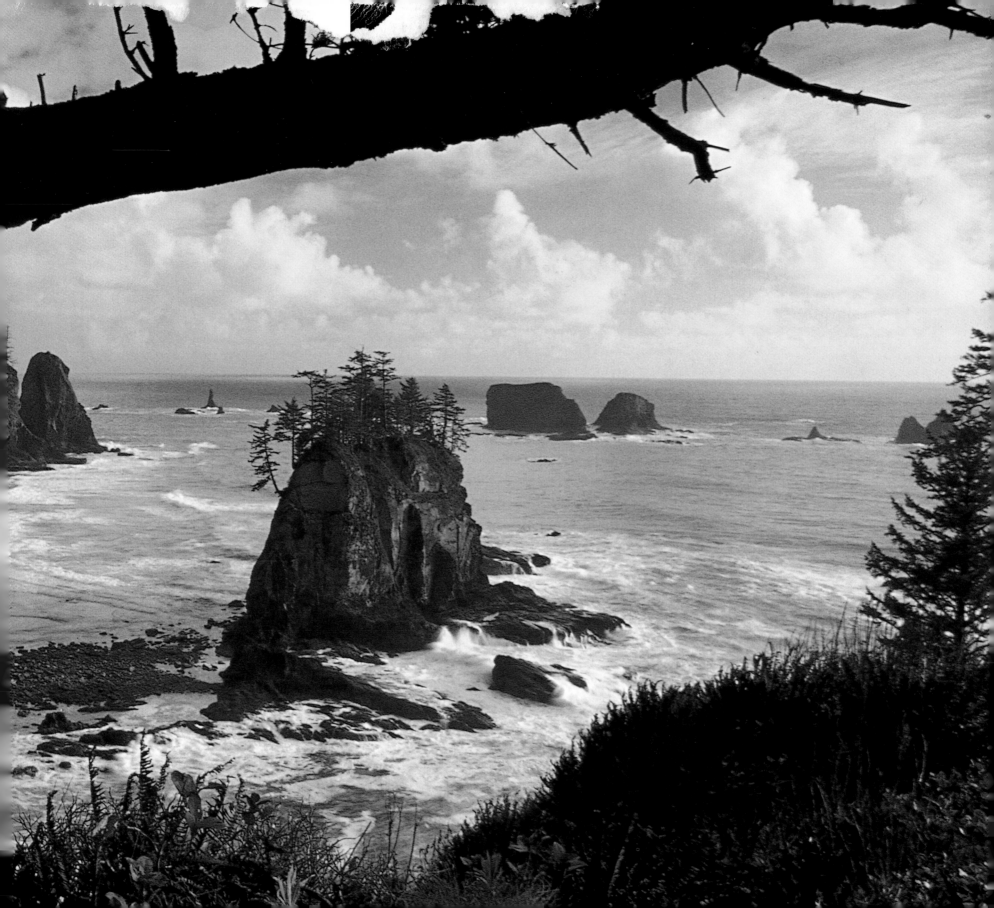

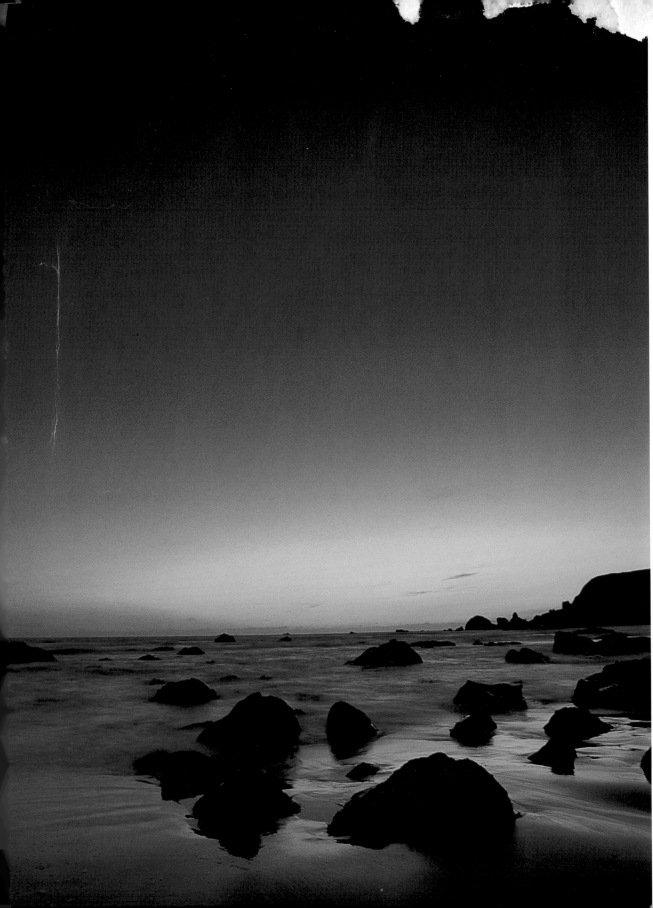

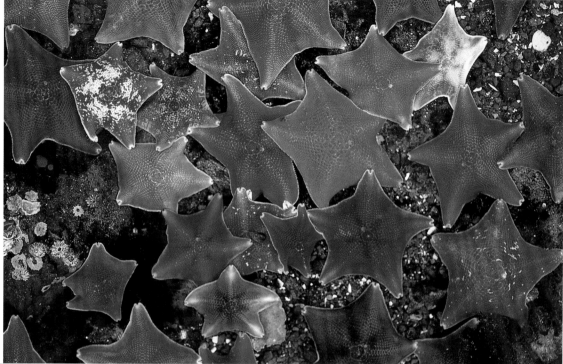

Above: Bat stars (Patiria miniata) *populating a tide pool, Vancouver Island*

Left: Lining of a northern abalone shell (Haliotis kamtschatkana), *Washington*

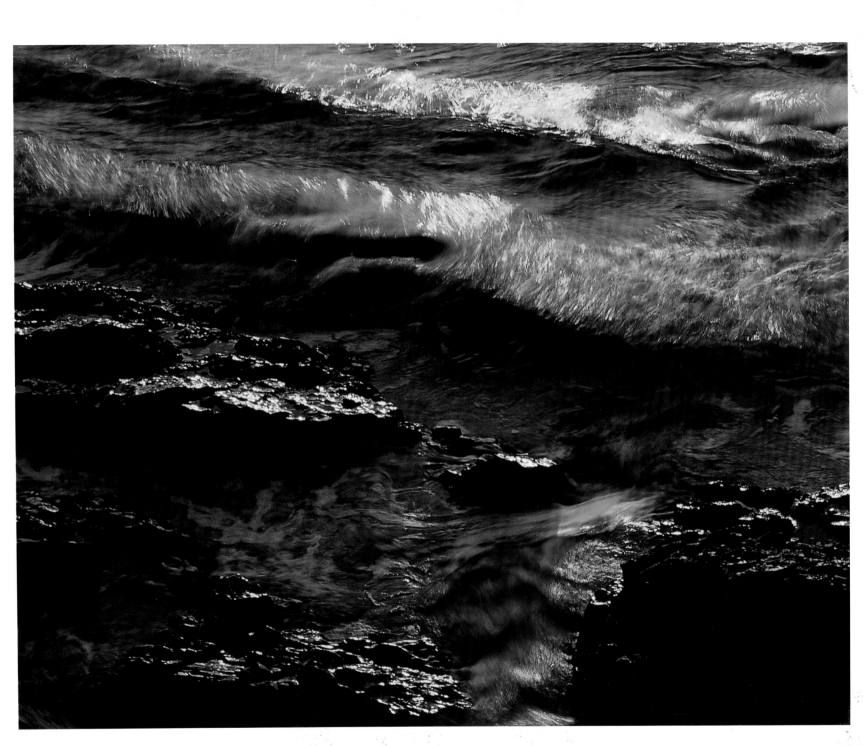

Rocky shoreline, Ruby Beach, Olympic Peninsula

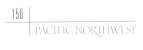

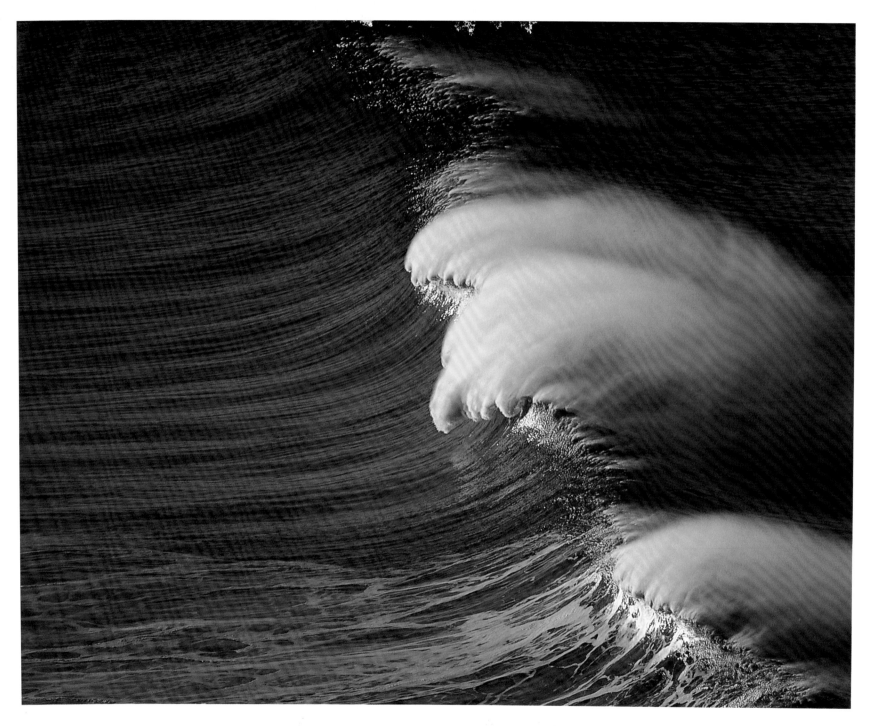

Windswept waves, Cannon Beach, Oregon

RESOURCE LIST

We hope that this book will increase your appreciation of all that the Northwest has to offer. We also hope that it will stimulate concern, and in turn lead to action to ensure a sound future for such a varied and special place. In support of this, we are including a partial list of Northwest organizations that have dedicated themselves to this future.

IDAHO

Alliance for the Wild Rockies
PO Box 8731
Missoula, MT 59807
406.721.5420
awr@wildrockies.org
www.wildrockies.org

Boulder-White Clouds Council
PO Box 6313
Ketchum, ID 83340
208.726.8262
bwcc@micron.net

Golden Eagle Audubon Society
PO Box 8261
Boise, ID 83707
208.345.8777

Idaho Conservation League
PO Box 844
Boise, ID 83701
208.345.6933
icl@wildidaho.org
www.wildidaho.org

Idaho Rivers United
PO Box 633
Boise, ID 83701
208.343.7481
iru@desktop.org.
www.desktop.org/iru

Idaho Wildlife Federation
PO Box 6426
Boise, ID 83707
208.342.7055
IWFBOI@cyberhighway.net

Nature Conservancy
PO Box 165
Sun Valley, ID 83353
208.726.3007
www.tnc.org

Pacific Rivers Council
PO Box 925
Eagle, ID 83616
208.939.8697
cdwill@cyberhighway.net
www.pacrivers.org

Palouse Clearwater
Environmental League
PO Box 8596
Moscow, ID 83843
208.882.1444
pcei@pcei.org
www.moscow.com/pcei

Peregrine Fund
566 Flyinghawk Lane
Boise, ID 83709
208.362.8687

Sawtooth Wildlife Council
PO Box 92
Stanley, ID 83278
208.774.3426
swc@desktop.org

Sierra Club: Idaho-Northern
Rockies Chapter
PO Box 552
Boise, ID 83701
208.384.1023
www.sierraclub.org

The Wilderness Society
413 W Idaho Street
Suite 102
Boise, ID 83702
208.343.8153
www.wilderness.org

Wolf Education and Research
Center
PO Box 917
Boise, ID 83701
208.343.2248
wolfcenter3@rmci.net
www.wolfcenter.org

WASHINGTON

1000 Friends of Washington
1305 Fourth Avenue
Suite 303
Seattle, WA 98101
206.343.0681
friends@eskimo.com

Alt-Trans
(Washington Coalition for
Transportation Alternatives)
PO Box 131
Seattle, WA 98111
206.298.9306
alt-trans@alt-trans.org

Friends of the Earth:
Northwest Office
4512 University Way NE
Seattle, WA 98105
206.633.1661
foewase@igc.org
www.desktop.org/foenw

Friends of the San Juans
PO Box 1344
Friday Harbor, WA 98250
360.378.2319
friends@sanjuans.org
www.sanjuans.org

Inland Empire Public Lands
Council
517 S Division Street
Spokane, WA 99202
509.838.4912

Inland Northwest Land Trust
315 W Mission Avenue
Suite 5A
Spokane, WA 99201
509.328.2929
inlt@sisna.com
www.sisma.com/inlt

Land Conservancy of Seattle &
King County
615 Second Avenue
Suite 525
Seattle, WA 98104
206.292.5907
infor@tlc-skc.org

Land Trust Alliance Northwest
15810 NE Leary Way
Redmond, WA 98052
425.702.8139
eabltanw@aol.com

The Lands Council
517 S Division Street
Spokane, WA 99202
509.838.4912
msolomon@desktop.org
www.ieplc.org

League of Conservation Voters
Education Fund
3610 24th Avenue S
Seattle, WA 98144
206.760.0067
lcv@lcv.org
www.lcv.org

The Mountaineers
300 Third Avenue W
Seattle, WA 98119
206.284.6310
clubmail@mountaineers.org
www.mountaineers.org/climb

National Audubon Society
PO Box 462
Olympia, WA 98507
360.786.8020
rshultz@audubon.org
www.audubon.org/audubon/
washstate.html

The Nature Conservancy of
Washington
217 Pine Street, Suite 1100
Seattle, WA 98101
206.343.4344
www.tncwashington.org

North Cascades Intitute
2105 State Route 20
Sedro Woolley, WA 98284
360.856.5700
nci@ncascades.org
www.ncascades.org/nci

Northwest Ecosystem Alliance
1421 Cornwall Avenue
Suite 201
Bellingham, WA 98227
360.671.9950

Northwest Energy Coalition
219 First Avenue S
Suite 100
Seattle, WA 98104
206.621.0094
www. oz.net/ncan/home.html

Pacific Rivers Council
705 Second Avenue
Suite 203
Seattle, WA 98104
206.447.4186
kboyles@seanet.com
www.pacrivers.org

People for Puget Sound
1402 Third Avenue Suite 1200
Seattle, WA 98101
1.800.People-2
206.382.7007
People@pugetsound.org
www.pugetsound.org

Puget Soundkeeper Alliance
1415 West Dravus Street
Seattle, WA 98119
206.286.1309
pskeeper@halcyon.com
www.halcyon.com/pskeeper

Rivers Council of Washington
1731 Westlake Avenue N Suite
202
Seattle, WA 98109
206.283.4988
riverswa@brigadoon.com
www.riverscouncilofwa.org

San Juan Preservation Trust
PO Box 327
Lopez Island, WA 98261
360.468.3202
sjptrust@rockisland.com
www.rockisland.com/
~sjptrust/

Save Our Summers from Grass
Smoke
PO Box 142043
Spokane, WA 99214
509.928.2417
tricia@ior.com

Save Our Wild Salmon
975 John Street, Suite 204
Seattle, WA 98109
206.622.2904
sos@wildsalmon.org
www.desktop.org/sos

Seattle Audubon Society
8050 35th Avenue NE
Seattle, WA 98115
206.523.8243
info@seattleaudubon.org
www.seattleaudubon.org

Sierra Club: Cascade Chapter
8511 15th Avenue NE
Room 201
Seattle, WA 98115
206.523.7188
www.sierraclub.org

Trout Unlimited
30202 W Glass Avenue
Spokane, WA 99205
509.482.4185
djames@wwpco.com

Vashon-Maury Island Land
Trust
PO Box 2031
Vashon Island, WA 98070
206.463.2644
vmilt@wolfenet.com

Washington Conservation
Voters
300 Lenora Street
Suite B 364
Seattle, WA 98121
206.374.0760
info@wcvoters.org
www.wcvoters.org/wcvoters

Washington Environmental
Alliance for Voter Education
(WEAVE)
300 Lenora Street
Suite B 364
Seattle, WA 98121
206.374.0634
info@weavw.org
www.weave.org

Washington Environmental
Council (WEC)
615 Second Avenue
Suite 380
Seattle, WA 98104
206.622.8103
greenwec@aol.com
www.greenwec.org

Washington Environmental
Council: Spokane Office
3 East 6th Avenue, Unit B
Spokane, WA 99202
509.747.3663

Washington Native Plant
Society
PO Box 28690
Seattle, WA 98118
206.760.8022
wnps@blarg.net
www.wnps.org

WashPIRG
5200 University Way NE Suite
201
Seattle, WA 98105
206.523.8985
washpirg@mindspring.com

Wilderness Society
1424 Fourth Avenue
Suite 816
Seattle, WA 98101
206.624.6430

OREGON

1000 Friends of Oregon
534 SW 3rd Avenue
Suite 300
Portland, OR 97204
503.223.4396
info@friends.org

Audubon Society of Portland
5151 NW Cornell Road
Portland, OR 97210
503.292.6726
audubon@agora.rdrop.com

Columbia Basin Institute
222 SW Harrison Street
GO #9
Portland, OR 97201
503.222.6541
cbi@igc.apc.org

Defenders of Wildlife
1637 Laurel Street
Lake Oswego, OR 97034
503.697.3222
svickerman@defenders.org

Desert Trail Association
PO Box 34
Madras, OR 97741
541.636.1373

Eco Trust
1200 NW Naito Parkway
Suite 470
Portland, OR 97206
503.227.6225
www.ecotrust.org

Environmental Federation of
Oregon
PO Box 40333
Portland, OR 97240
503.223.9015

Friends of the Columbia Gorge
319 SW Washington Street
Suite 301
Portland, OR 97204
503.241.3762
focg@teleport.com

Headwaters
PO Box 729
Ashland, OR 97520
541.482.4459
headwtrs@mind.net
www.headwater.org

National Wildlife Federation
2031 SE Belmont
Portland, OR 97214
503.230.0421
frost@nwf.org

Nature Conservancy
821 SE 14th Avenue
Portland, OR 97214
503.230.1221
rhoeflich@tnc.org

Northwest Environmental
Advocates
133 SW 2nd Avenue
Suite 302
Portland, OR 97204
503.295.0490
nbell@advocates.nwea.org

Northwest Environmental
Defense Center
10015 SW Terwilliger Portland,
OR 97219
503.768.6673

Oregon Conservation Network
111 SW Naito Parkway
Portland, OR 97204
503.224.4011
ocn@olcv.org

Oregon Environmental Council
520 SW 6th Avenue
Suite 940
Portland, OR 97204-1535
503.222.1963
oec@orcouncil.org

Oregon League of Conservation
Voters
111 SW Naito Parkway
Portland, OR 97204
503. 224.4011
olcv@olcv.org
Oregon Natural Desert
Association

16 NW Kansas Street
Bend, OR 97701
541.385.6908
coec@empnet.com

Oregon Natural Resources
Council
5825 N Greeley Avenue
Portland, OR 97217
503.283.6343
onrc@teleport.com

Oregon Shores Conservation
Coalition
PO Box 1344
Depoe Bay, OR 97341
541.267.4615

Oregon State Public Interest
Research Group
1536 SE 11th Avenue
Portland, OR 97214
503.231.4181
ospirg@ospirg.org

Oregon Trout
117 SW Naito Parkway
Portland, OR 97204
503.222.9091
www.ortrout.org

Oregon Water Trust
111 SW Naito Parkway
Suite 404
Portland, OR 97204
503.226.9055
info@owg.org

Pacific Rivers Council
PO Box 10798
Eugene, OR 97440
541.345.0119
pacificriver@igc.apc.org

River Network
PO Box 8787
Portland, OR 97207
503.241.3506
rivernet@igc.org

Salmon for All, Inc.
1300 SW 5th Avenue
Suite 3500
Portland, OR 97201
503.224.4100

Sierra Club: Oregon Chapter
3701 SE Milwaukie Avenue
Suite F
Portland, OR 97202
503.238.0442 (Oregon)
503.231.0507 (Columbia
Group)
orsierra@spiritone.com.

Sustainable Ecosystem Institute
0605 SW Taylors Ferry Road
Portland, OR 97219
503.246.5008
sei@sei.org

Trout Unlimited: West Coast
Office
213 SW Ash Street
Suite 211
Portland, OR 97204
503.827.5700
tuwest@teleport.com

Wetlands Conservancy
PO Box 1195
Tualatin, OR 97062
503.691.1394
wetlands@teleport.com

Willamette Riverkeeper
PO Box 11606
Portland, OR 97211
503.223.6418
wrkeeper@teleport.com
www.willamette-riverkeeper.org

BRITISH COLUMBIA

British Columbia Field
Ornithologists
PO Box 8059
Victoria, BC V8W 3R7

BC Wildlife Federation
19292 60th Avenue
Suite 303
Surrey, BC V3S 8E5
604.533.2293
bcwf@istar.ca

Federation of British Columbia
Naturalists/
Land for Nature
1367 West Broadway
Suite 425
Vancouver, BC V6H 4A9
604.737.3057
fbcn@intergate.bc.ca

The Nature Trust of British
Columbia
100 Park Royal South
Suite 808
West Vancouver, BC
V7T 1A2
604.925.1128
naturebc@istar.ca

Sierra Club of Western Canada
1525 Amelia Street
Victoria, BC V8W 2K1
250.386.5255
scbc@islandnet.com

The Valhalla Wilderness Society
PO Box 329
New Denver, BC V0G 1S0
250.358.2333
vws@vws.org

Western Canada Wilderness
Committee
20 Water Street
Vancouver, BC V6B 1A4
604.683.8220
info@wildernesscommittee.org
www.wildernesscommittee.org

Published by Sasquatch Books
Distributed in Canada by Raincoast Books Ltd.
Printed in Hong Kong
02 01 5 4

The author gratefully acknowledges Ballantine Books, a division of Random House, Inc., for permission to reprint excerpts from *Living by Water, True Stories of Nature and Spirit,* and *Nature and Other Mothers, Personal Stories of Women and the Body of Earth.*

Cover and interior design by Karen Schober.
Photographs on top back cover and on pages 15, 92–93, 97, 100–101, 102–103, 106–107, 113 copyright ©1998 by Gavriel Jecan. All other photographs by Art Wolfe.
Map by Jane Shasky.

Cover photograph: Mount Baker, Cascade Mountains, Washington. **Back cover photographs:** *(top)* Painted Hills, John Day Fossil Beds National Monument, Oregon; *(middle)* Johnstone Strait, British Columbia; *(bottom)* Hoh River Valley, Olympic Peninsula, Washington. **Photograph on page 1:** Northern spotted owl; **pages 2–3:** Rainforest stream, Soleduck River Valley, Olympic Peninsula, Washington; **page 6:** Fog-enshrouded Douglas fir *(Pseudotsuga menziesii),* Olympic National Park, Washington.

Library of Congress Cataloging in Publication Data
Wolfe, Art.
 Pacific Northwest / photographs by Art Wolfe ; text by Brenda Peterson.
 p. cm.
 1. Northwest, Pacific—Pictorial works. 2. Northwest, Pacific—Description and travel. 3. Natural history—
Northwest, Pacific—Pictorial works. 4. Natural history—Northwest, Pacific. I. Peterson, Brenda, 1950- . II Title.
F852.3.W65 1998
779'36795—dc21 98-6129

Sasquatch Books
615 Second Avenue
Seattle, Washington 98104
206-467-4300
books@SasquatchBooks.com
http://www.SasquatchBooks.com

Sasquatch Books publishes high-quality adult nonfiction and children's books related to the Northwest (Alaska to San Francisco). For more information about our titles, contact us at the address above, or view our site on the World Wide Web.

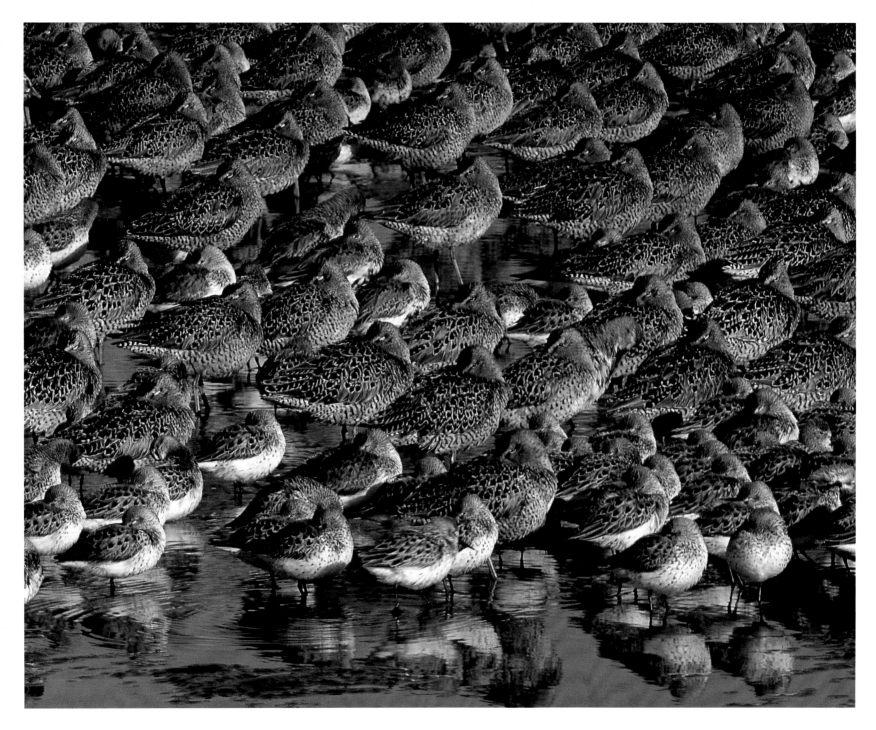

Short-billed dowitchers (Limnodromus griseus) *and*
dunlins (Calidris alpina), *Grays Harbor, Washington*

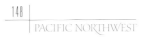

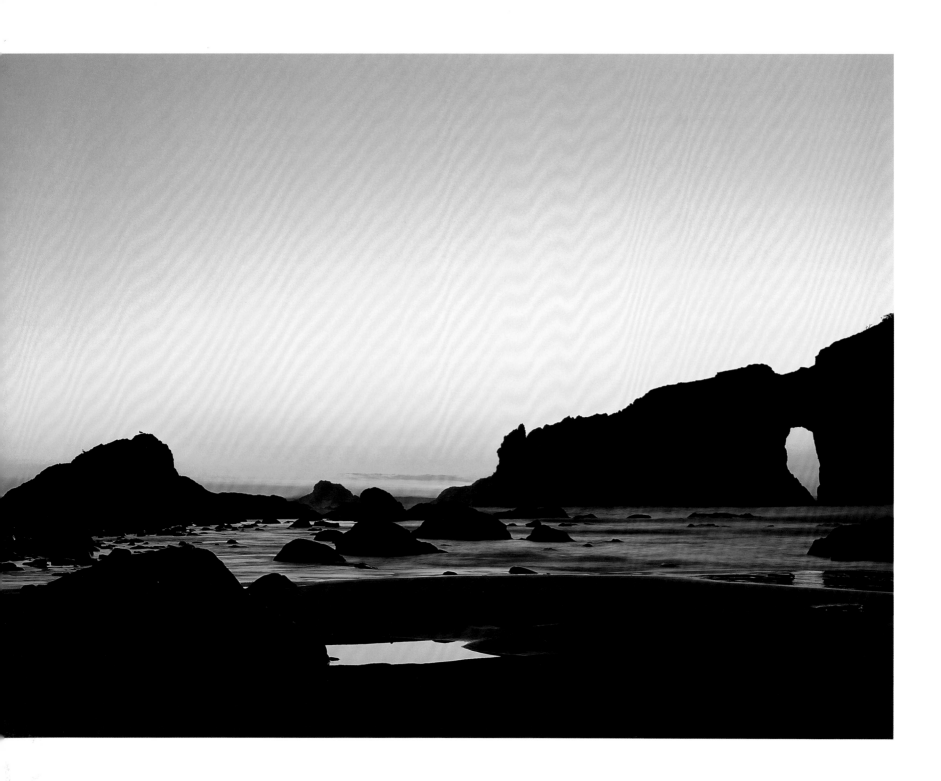

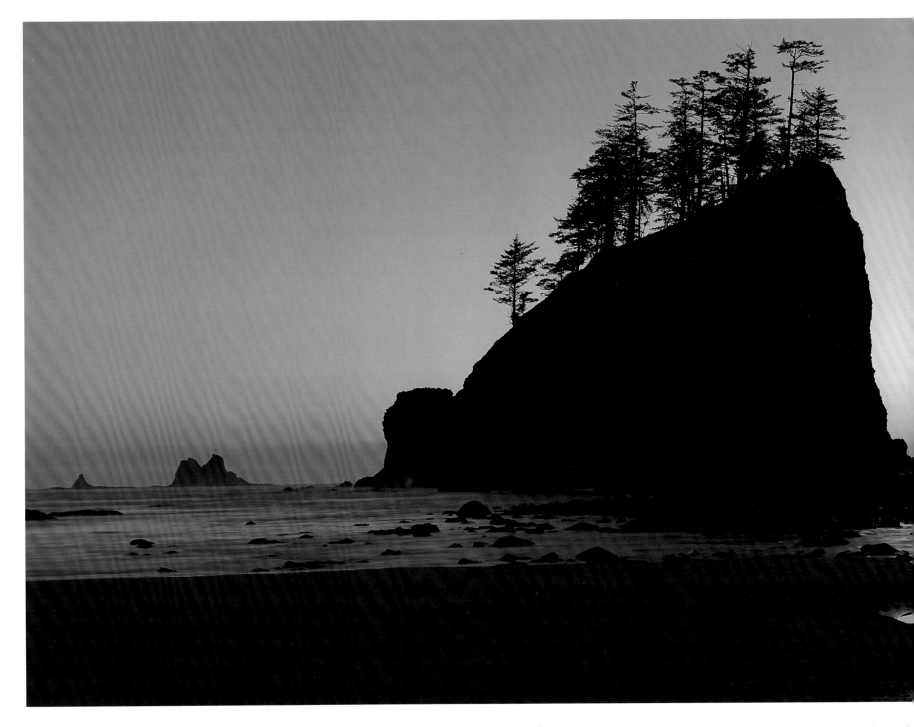

Sunset at Second Beach, Olympic National Park

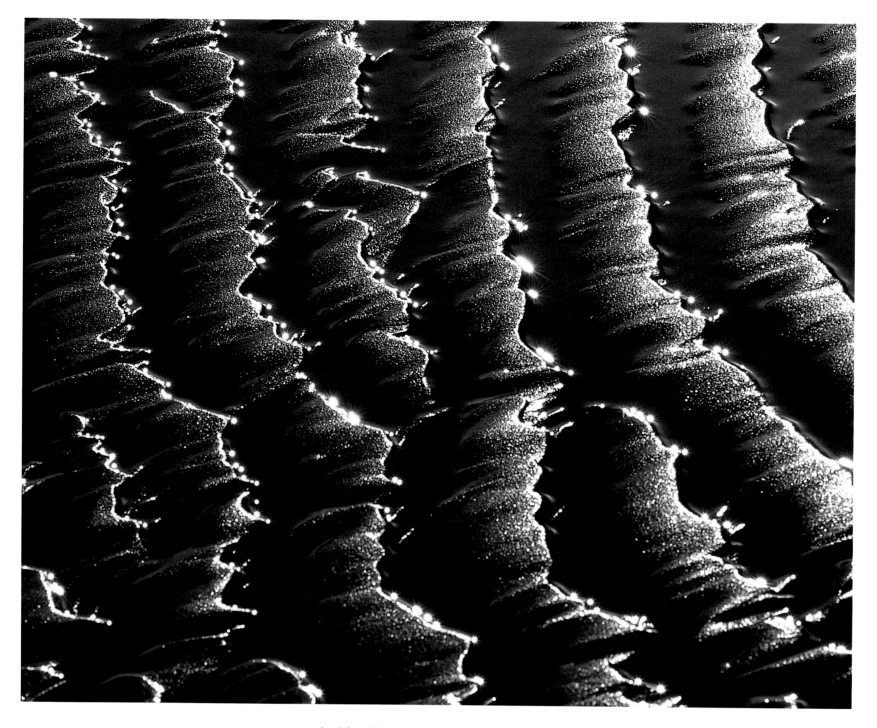

Ripples left in the sand by the receding tide, Second Beach, Olympic National Park

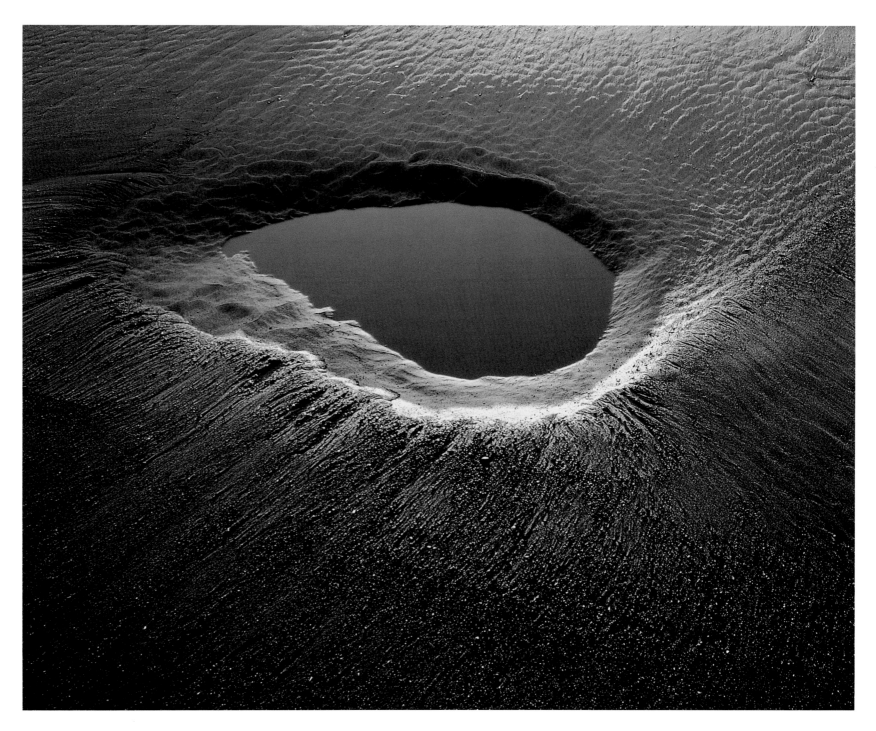

Tidepool catching the sunset, Olympic Peninsula

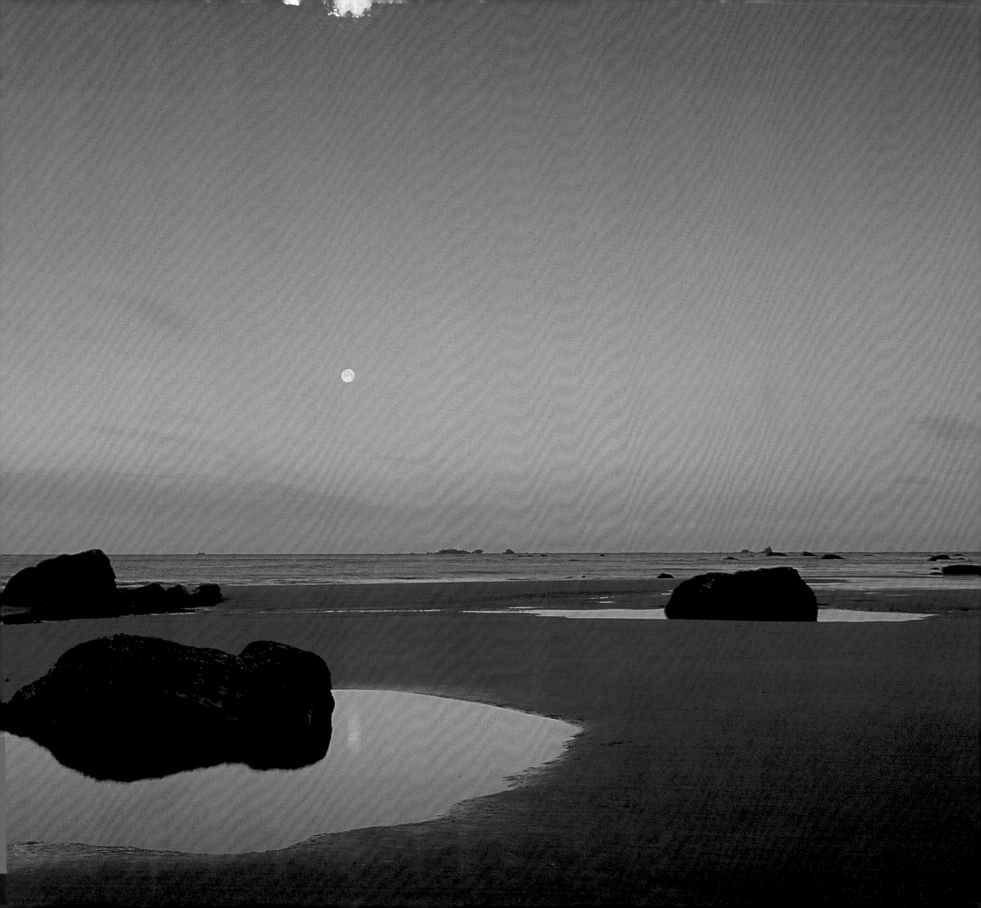

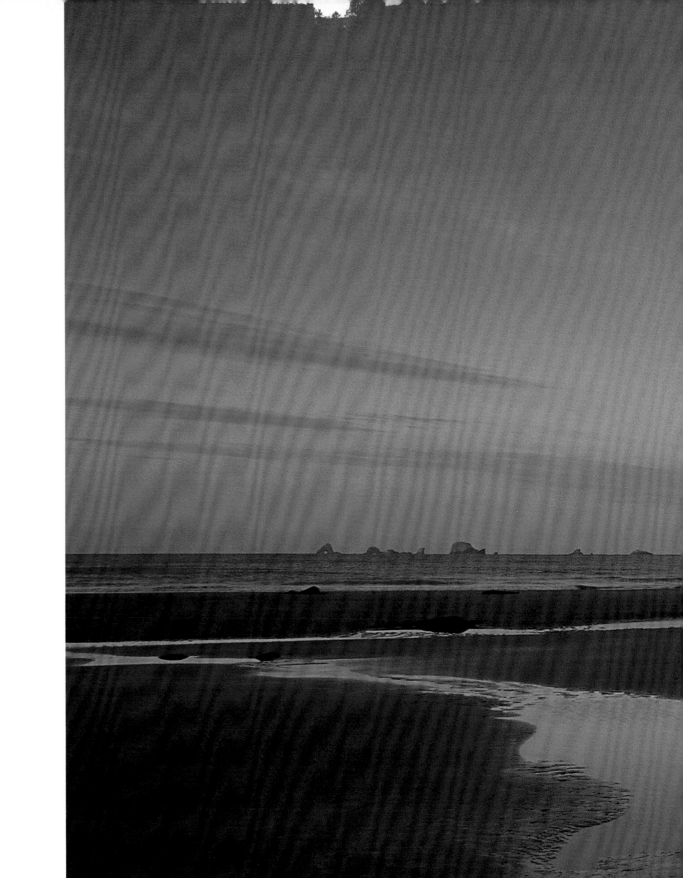

Sunrise and moonset at Cape Blanco,
southern Oregon

from a childhood story—an Indian girl plays atop the round, hard green shell of a sea turtle that is really the whole world. One day the turtle wakes up, pokes out its sleepy head, and spots the little girl on its big back. They strike a simple bargain: The girl can stay on the turtle's back if she will always remember to sing to the turtle as it sleeps. If the singing stops, so will the sacred symbiosis.

For thousands of years, Northwestern indigenous peoples have found not only their sustenance but also their spiritual songs and rituals in the sea and her creatures. At the far tip of the Northwest coast on Neah Bay, the Makah tribe has long linked their lives to the sea. The recently excavated Makah village at Ozette dates back two thousand years. This pristine coast is also the seasonal home of a population of gray whales. Every year gray whales make their ten-thousand-mile migration from Arctic feeding grounds to birthing lagoons in Baja, Mexico. All along the Pacific Northwest coast, from British Columbia through Washington State and down along Oregon's famous whale-watching mecca of Oregon Dunes National Recreation Area, the great gray whales journey south in winter and north in spring.

This sojourn is one of the world's natural wonders, and we in the Northwest are fortunate to be able to witness it. The gray whales still swim the waters of the Strait of Juan de Fuca between Washington and Vancouver Island. I am on the strait with a family of the Makah tribe as our boat spots several of the giants rising. The grandchildren of these traditional whale hunters call out with delight; these are the first whales they've ever seen from the water. They are awestruck. Eagles, gulls, and cormorants sail around us. Sleeping sea lions and diving osprey define the stony beach as we sail between the monoliths of Seal and Sail Rocks. Scrawled with Makah petroglyphs of human faces and whales, the ancient rocks once signaled this sea-faring people that their home coast was in sight.

As we floated in the strait, I watched the synchronized movement of every living thing around us, from gray whale to sea otter to kelp bed. There is only one dance in the sea, one pulsing movement of all that exists, one law. Living alongside this natural and divine law is to accept that we all come from the sea. We live here by water. As the Chinese Taoist master Lao Tzu wrote:

The highest good is like water,

for the good of water is that it nourishes everything

me to walk carefully—there are squirting sea anemones, scarlet-bright blood stars, pale sea dollars, purple shore crabs, feisty barnacles, ghost shrimp and snails, blue mussels, sponges, slick sea urchins, and swaying forests of kelp.

Sometimes in the summer when I stand knee-deep in this chilly Sound, whose temperature varies little from forty-six to forty-eight degrees in any season, I feel the heart of this inland sea. One midnight in early June, under a full moon, I walked my beach, bare feet slapping wet sand, then sucked in if I stood still. Treading carefully in the dark to avoid cutting my feet on shells and barnacles, I was about to make my bed on the seawall to sleep. It was low tide, a minus 3.2 feet. We had been scuttling all evening to dig butter clams and a geoduck I put back because as it spat its last grit in the bucket, I swear I heard the misshapen creature screaming for the sea.

Suddenly it happened: A shift in the sand, a trembling that began in my feet and shuddered up my legs and swirled in my belly like radiant heat. Then deep, rhythmic jolts of electricity as if I were plugged into an invisible socket. Wave after wave of energy flowed up through my body.

I plunged my hands into the Sound, palms flat against the grainy, falling-away sand, and let the pulses pass through me. I had never before felt anything like that. And yet it was strangely familiar, like the memory of being within a bigger body. Bent double, my whole body filled with this strange force, I at last recognized its source: Puget Sound herself.

I stood unsteadily, my palms indented with tiny seashells that adorned my skin like barnacles. Never again would the earth feel separate from me. I remembered then that I live on a vibrant, breathing being that encompasses me. Images came to mind

Left: Giant perennial kelp (Macrocystis integrefolia), *common to the Pacific Northwest coast*

of tail and gill.

This inland sea embraces our Pacific Northwest islands and peninsulas like a green dragon that coils north from Olympia and finally comes to lick at the docks of Vancouver and Victoria. Northwesterners have always been water folk, shaped by this Sound and also by the sounds of surf and rain. Early stories told by the natives of the Northwest coast were of sea creatures and underwater tribes that could "shape-shift" into humans. Even the stories we tell today are syncopated with the rhythms of tide and wind, the cries of seagulls, eagles, and great blue herons, and the whooshing breath of whales and distant foghorns.

The abundant Northwest coast holds us together with its cadences of water and weather. Sometimes we feel so blanketed by marine fog and darkening showers that we wonder if our

far-off territory is truly isolated from the remaining, mostly landlocked sprawl of North America. But when we try to share our "rainy day people" intimacies with outsiders, they cannot believe we actually enjoy living for many months of each year in great, flowing gowns of gray mist. Glowingly, I describe for them our subtle shades of winter— the gloaming skies in varying shades of gray with violet streaks, and the water's delicate silver aura—and they wonder if my brain has, indeed, become waterlogged.

The Northwest coastal territories are familiars to mystical rain that feeds our watery souls. For two decades, Puget Sound, with her marine mammals and sea life, has served as my mentor and muse. The daily tides are my meditations, my prayers for this body of water that nourishes us in its long embrace. My backyard beach teaches